Secrets of Hollywood Special Effects

Secrets of Hollywood Special Effects

Robert E. McCarthy

Foreword by Steve Allen

Focal Press
An Imprint of Elsevier
Boston London

Focal Press is an imprint of Elsevier

Copyright © 1992 by Elsevier.
All rights reserved.

 Recognizing the importance of preserving what has been written, it is the policy of Butterworth–Heinemann to have the books it publishes printed on acid-free paper, and we exert our best efforts to that end.

Photo credits:

Figures 2–7a through d reprinted with permission of the Coca-Cola Company.

Figure 7–2 reprinted with permission of Leonard Nimoy.

Sections from the *Film Industry Fire, Life and Safety Handbook* in Chapter 11 reprinted with permission of the Californa State Fire Marshal.

Figures 12–5a and b and 12–6a and b reprinted with permission of Hollywood Breakaway ™.

Figures in Chapter 13 reprinted with permission of the Gleason Family Partnership.

Figures 14–1 through 14–6 and cover photograph reprinted courtesy of Tri-Star Pictures, Inc.

Photographs of pyrotechnic devices and Squib Chart (back cover) reprinted with permission of De La Mare Engineering, Inc.

Photographs of firearms and other equipment reprinted with permission of Stembridge Gun Rentals.

Library of Congress Cataloging-in-Publication Data

McCarthy, Robert E., 1931–
 Secrets of Hollywood Special Effects /
by Robert E. McCarthy.
 p. cm.
 Includes index.
 ISBN-13: 978-0-240-80108-7 ISBN-10: 0-240-80108-3
 1. Cinematography—Special effects. I. Title
 TR858.M34 1992
 791.43'024—dc20 91—25088
 CIP

British Library Cataloguing in Publication Data

McCarthy, Robert E.
 Secrets of Hollywood Special Effects.
 I. Title
 778.5345

ISBN-13: 978-0-240-80108-7
ISBN-10: 0-240-80108-3

Elsevier
200 Wheeler Rd.
Burlington, MA 01803

15 14 13 12

Printed in the United States of America

During the first printing of this book one of the dedications was mistakenly omitted. This dedication was to my son, Kevin Francis McCarthy; for my mistake I sincerely apologize.

I dedicate this book to my son Kevin who has followed the tradition of four generations of the McCarthy family, starting with his great grandfather in 1883. As a member of the IATSE you have made me very proud to say you are one of the best Special Effects men in the business, far surpassing many of the effects I have accomplished in my career. Thank you Kevin for all the help and support you gave me, without you this book would never have been written.

I dedicate this book to my wife of 32 years, Carol, who has never been able to put her car in our three-car garage because there was always a special effects project going on in it; who has put up with the horrible smells of chemicals that I have used in the backyard and garage; whose dishes, pots, and pans I have destroyed; and who at times hasn't even been able to use our pool because of an air cannon or experiment being conducted in it. For putting up with all the noise and mess that I've left behind for her to clean up and for having the patience of a saint and not throwing me out of the house all the times that I've deserved it. Dearest, you can now have your dining room table back, after years of having scripts, blueprints, drawings, and gimmicks on it. Most importantly, thank you for giving me the encouragement, support, and love that enabled me to write this book.

And to "The Great One."

Also to my daughter Karen and my little love—my granddaughter Sabrina.

Contents

Contents

Foreword

The simple fact that during my forty-plus years of working in the comedy field I have frequently become involved in the performance of physically dangerous stunts is not especially noteworthy except, perhaps, for the fact that I am very poor casting for the role of macho stuntperson.

My natural interests are humor, music, poetry, and philosophy. During my school days, although I became proficient at baseball pitching and table tennis, I was by no means a natural athlete. Against that social background, it is still something of a mystery as to how I became involved in many instances of risky business for the alleged entertainment of TV audiences over the years.

Part of the explanation, I suppose, is that I've always specialized in spontaneous or ad-lib comedy and, secondly, that early on my writers and production people discovered the funny possibilities of placing me in a dangerous situation just to see what my verbal responses would be.

Over the years I have been bitten by out-of-control animals, swarmed over by tarantulas and ants, taken a tub-bath while suspended high above Vine Street in Hollywood, packed into a small box that was then blown to smithereens by dynamite charges, flown above the Los Angeles area while standing on the upper wing of a World War I biplane, driven at high speed into flaming fences, and exposed my general incompetence at fencing, mud-wrestling, horseback riding, and flying suspended in mid-air a la Peter Pan.

One factor all such peculiar exhibitions had in common was that while I generally had only the vaguest notion as to what I was doing or how to do it properly, there were those present whose professional expertise enabled them to conduct and control the routines.

During the 1991–1992 television season, it has been possible for young viewers to see for the first time, and veterans to review, a four-year comedy series I did for NBC-TV in the late 1950s. This was the delightful show featuring Louis Nye, Don Knotts, Bill Dana, Tom Poston, Pat Harrington, Gabe Dell, Dayton Allen, and other gifted comedy performers who were members of our regular troupe.

During the original period of the series' production, I had the pleasure of meeting and working with Bob McCarthy, the best qualified puppet-master, so to speak, whose invisible strings enabled me to become involved with what, even to the present day, is one of the most impressive stunts, tricks, or illusions known to theatrical science.

News columnist Ed Sullivan was then the host of a variety program that aired at the same 8 p.m. Sunday night time on CBS. I didn't know that Mr. McCarthy was a regular employee of Ed's, or I might have had paranoid suspicions when he proposed placing my life in at least a certain degree of danger with a stunt he had devised.

The first evidence that such a thing could actually be accomplished was a photograph of an attractive young lady seated at a grand piano, her hands on the keyboard. The unusual factor was that the instrument was at the time apparently about a dozen feet in the air, executing what in

aeronautical terms could be described as an outside loop. When producers Bill Harbach, Nick Vanoff, and other members of our production staff proposed that I submit myself to the same maneuver, I assumed, on the basis of the photograph, that doing so would be a simple matter. What I have learned only recently was that McCarthy had put the 8 × 10 photo together only to illustrate how the finished stunt would look and had, in fact, never actually put anyone through such paces. Be that as it may, about two weeks later, one Sunday evening, I seated myself at a grand piano and began to play a melody of my own composition, looking for all the world like the scores of musicians we have all seen playing piano on television.

But after the first few bars, the instrument, including the bench on which I was seated, began to rise into the air. This, I assure you, was no camera-trick or illusion. I was actually ascending, soon to be, in my opinion, much too high, over the stage floor and thoroughly uneasy about everything that was happening.

When, earlier that afternoon, the stunt had been rehearsed, I perceived immediately that the viewers at home would probably think that camera-gimmickry was involved. To forestall that interpretation, I ordered that a Spanish shawl, a framed photograph and a medium-sized vase of flowers be placed on the instrument.

The point was that when the piano-top began to tip from the horizontal plane these objects would fall to the floor, which would presumably clarify that what the in-studio and at-home audience thought they were seeing was actually taking place.

I had also suggested that several attractive young dancers move under the instrument as it floated above their heads and pantomime fears for their personal safety once the routine began.

Over the years Bob and I have done that stunt (along with a number of others) several times with never a hitch. To my knowledge he's the only special effects person in the business with the reputation of never having had a serious accident or injury on any F/X job he's directed during the thirty-odd years he's been in the business.

I don't pretend to be an expert on the technical aspects of special effects, but Bob McCarthy certainly is, having done countless shows with some of the top entertainers in TV: twelve years with Jackie Gleason and services to Ernie Kovacks, Garry Moore, Ed Sullivan, "Saturday Night Live," and me.

He has provided technical services to scores of Broadway shows, such as "The Diary of Anne Frank" and "The Rocky Horror Show," plus dozens of rock and roll concerts for such groups as Kiss and Bon Jovi, and countless motion pictures, the most recent involving the creation of the F/X for the Red Knight in Terry Gilliam's *The Fisher King.* If you want to learn the ins-and-outs, the real hands-on technique, I can't think of anyone in the business more knowledgeable.

Steve Allen

Preface

The field of special effects (F/X), which can be financially, emotionally, and artistically rewarding, is also the most demanding and exhausting of all the artistic crafts in the entertainment industry. No other work requires such a thorough technical knowledge in so many areas. In most businesses, being a jack-of-all-trades, you're a master of none. But when it comes to special effects, being a jack-of-all-trades makes you a master of one: special effects.

The following is a list of talents, skills, and trades that are needed by a good special effects person.

Air/Hydraulics
Animal Trainer
Armorer
Artist
Automobile mechanic
Boats and sailing
Booby traps and devices
Bookkeeper
Bridge builder
Camera and camera effects
Carpenter
Alchemist
Deep-sea diver
Draftsperson
Driver/equipment/trucks
Electric motors and gears
Electrician
Electronic timing devices
Engineer
Explosives
Fiberglass
Fiber optics
Fire extinguishers and equipment
Firefighter
Flyman
Personnel manager
Glazier
Gunsmith
Harnessmaker
Illusionist
Lighting effects
Machinist

Makeup
Marksman
Mason
Mechanical timing devices
Miniature maker
Model maker
Mold maker
Mountain Climbing
Painter
Plasterer
Plastics
Plumber
Projectionist
Props
Pyrotechnician
Radio operator
Repairman
Researcher
Rigger
Safety expert
Scaffolding
Sculptor
Second unit director
Snakes and spiders handler
State and federal laws
Static electricity
Stunt person
Tinsmith
Weapon maker
Welder
Last, but not least, creativity
 and imagination!

To everyone except the F/X person, movies are make-believe. For only the F/X person is directly responsible for other people's lives. During the last 30 years many professionals, myself included, have argued for the most stringent safety requirements. Gratifyingly, the codes are being upgraded constantly. With newer and improved chemicals, hardware, and techniques, F/X has become safer than ever.

There is and probably will always be, however, an element of danger in special effects. There are unavoidable accidents. Special effects require a higher standard of accountability to ensure that accidents are not the result of incompetence or inattention.

Someone once said, "Being tired is being in show business." I've been on productions for 50 or 60 straight hours, and 8 hours later, after a snack and shower, I was back on the set. I mention this for only one reason: When you're tired, you can make mistakes. Don't let exhaustion lead you into an avoidable error. Leave nothing to chance. Plan ahead. Don't give accidents an opportunity to occur. If you remember but a single word from this book, let that word be *safety*.

Enjoy and study the information contained in this book. Remember, however, that the special effects described here are of a professional caliber and should not be attempted by individuals unfamiliar with the materials, processes, and safety techniques involved.

The black and white images in this book were taken from years of accumulated tape. They are, therefore, not quite as clear as photographs.

In order to provide a better visual package to accompany this book, we have created a set of five videotapes: *Secrets of Hollywood Special Effects Videos.* Each is approximately two hours long and is available from Focal Press, individually or in the set of five.

Acknowledgments

Obviously no book of this intensely complex and technical nature could possibly have been written without the aid and encouragement of literally dozens of people specializing in all aspects of the business. If I have committed any error of omission in my acknowledgments, I humbly apologize. It was certainly nothing deliberate, but rather because I have drawn from such a plethora of information and sources, and from hundreds of friends and other professionals over the years.

I want to give a special thanks to Louis Simmon for his diligence, dedication, and endless hours of work in making this book understandable to the layperson and assisting me in overcoming my grammatical shortcomings. I am deeply thankful for his support, understanding, and attention to detail.

Artwork, drawings, and sketches for this book were particularly difficult and complex. To Aaron Lerner who toiled and puzzled over them for hours, I am much appreciative. To Gloria Rich, a special thanks for her uncanny ability to translate my mumbled dictation and paw-print writing into print. To Barbara Russiello for following the manuscript through page proof and into camera copy.

Halfway through my work on this manuscript, a young man, Scott Nathanson, aided me in putting all this into my computer and assembled it chapter by chapter. As a computer expert, Scott saved my life. Since then he has worked extraordinarily hard to collate and generally shape this material. For this and his hundreds of helpful suggestions over and above the line of duty, I am grateful.

I would be remiss in not thanking James F. McMullen, California state fire marshal, for his kind permission to reproduce portions of *The Film Industry Fire, Life and Safety Handbook* and for his recommendations and explanations of some of the more subtle aspects of the regulations. I'd also like to give a special thanks to Manny Chevez for his help and cooperation in obtaining much of the safety information incorporated in this book.

A very special thanks goes to Gabe Videla and Joe Lombardie of Special Effects Unlimited. Gabe was especially generous with his permission to photograph their in-house equipment and spent many hours over the years sharing his wonderful friendship and knowledge with me, in addition to getting me started in Hollywood. Joe Lombardie is one of the most respected, knowledgeable, and safety-conscious F/X people I've ever known. He is without a doubt one of the premier people in the business.

Thanks to Roger George of Roger George Rentals for providing access to his extensive special effects equipment for illustrations. I wish to extend very special and heartfelt thanks to Marilyn Gleason and The Gleason Family Partnership. The photos, many previously unpublished, were only available through their kind generosity, a generosity only matched by "The Great One" himself, a great friend, talent, and still greater person.

Thanks to Syd Stembridge of Stembridge Gun Rentals who graciously proffered his expertise and photographs for the chapter on weaponry. Ray Vellozzi and Carlos Ramirez of Hollywood Breakaway were most helpful, providing me with their expertise and access to their facilities to help me

write a detailed and accurate description of their very special and unique products. My good friend George Jackman of De La Mare Engineering, Inc., kindly provided dozens of pictures and squib charts illustrating various types of pyrotechnic devices along with invaluable and instructive advice.

The sections on smoke and similar special effects devices would have been much less complete without the invaluable aid and encouragement of Ira Katz and Tri-Ess Science Services. Ira was unstinting in his permission to use information from his company's catalog, probably one of the most extensive in the world.

A special thanks to Ver Sales, Inc., for their engineering and technical expertise concerning cable, rope, and chain. I want to thank Foster Beewwkes and the Coca-Cola Corporation of America for their permission to use excerpts from the 1990 Sprite commercial that we shot for them in California.

These acknowledgments would be most incomplete if I did not thank an old and dear friend, the late Harry (Prince Hara) Gross. Not only did he create most of the chemical effects and formulae as detailed in Chapter 6, but upon his death left valuable information to me. In his memory I pass them on to you.

Finally, I'd like to thank my production camera crew: Craig Bentley, Steve Gavitte, Carol McCarthy, Kevin McCarthy, Mike Newcomb, Gregg (Bruno) Stempel, Brett Travis, and Mark Woodley who assisted me with the photographs in this book. As a perfectionist, I have on occasion been known to be difficult to work with. They are professionals and as such accepted my sometime surliness with gracious understanding and good humor. I could not have done it without them.

In conclusion let me say that any errors contained in this book can only rest with me. Nothing is perfect no matter how hard one tries. I only hope the information I have presented is as accurate as humanly possible given the scope of the subject.

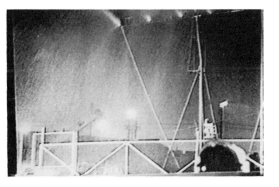

Figure 1–1 1½-inch rain tower or stand

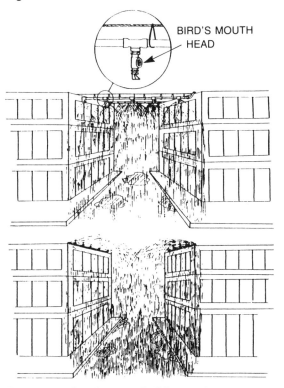

Figure 1–2 Rain between buildings, rain produced by a bird's mouth rainhead above (see detail) and by a Whirlybird rainhead in Figure 1–8

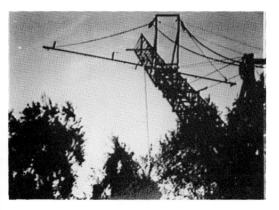

Figure 1–3 Crane rainbar setup

Rain and Water Effects

Rain and water effects have always been used by Hollywood to increase production value inexpensively and to accentuate mood and atmosphere. Gentle spring showers, massive thunderstorms, floods, or a simple dripping icicle on a winter's night have all satisfied the filmmaker's desire to create an individual and particular reality. It is difficult to imagine certain films without their rain or water effects: for instance, *Wuthering Heights* without its constant storms, *The Towering Inferno* with no exploding water tower, *Captains Courageous* minus its blustering seas, or the front nine in *Caddyshack* without the furious rainstorm. Though seemingly so simple, achieving water effects requires touch, taste, and timing in addition to a large extensive variety of highly specialized equipment.

Equipment Needed for Rain Effects

To do an intensive rain scene, you need the following equipment: over-camera (overhead) rainstand, adjustable hose and nozzles, wetdown hoses, rain mats, manifolds, drip pipes, portable rain towers, sandbags or weights (to secure the towers down), and extra hoses, pumps, mops, and buckets.

Rainstands

Preconstructed rainstands come in ¾-inch, 1½-inch, and 2½-inch sizes. Normally, ¾-inch rainstands rise 30 feet high; 1½-inch and 2½-inch rainstands are 30 to 40 feet tall. They are designed to put out tremendous amounts of water covering large areas. The ¾-inch stand covers an area 50 feet deep by 100 feet wide; a 1½-inch stand blankets an area 80 feet deep by 150 feet wide. The 2½ inch exceeds even that, covering 120 by 200 feet; a considerable area to douse with torrential rain. The stands use about 90 to 110 pounds of pressure on the 2½ inch, 65 pounds on the 1½ inch, and about 60 to 70 pounds on the ¾ inch. By adjusting the pressure on the individual rainstands, you can control the size of the raindrops. The lower the pressure, the larger the drops, and it's just the reverse for a fine mist.

A good example of rain effects in operation (using ¾-inch and 1½-inch rainstands) appears in the film *The Return of the Living Dead*. If you watch the scenes closely, you'll be able to detect the use of overhead rainstands. These were positioned above and parallel to the camera, and cast a water-wall from it out to a distance of 20 to 30 feet in front of the lens. The areas beyond the waterfall were wet down with hoses to maintain the illusion of an overall rainstorm. You'll see everything from drops dripping to torrential rains employed in all kinds of indoor and outdoor situations (Figure 1–1).

Outdoor Overhead Rainheads In many cases, especially outdoors, you cannot place rainstands on the ground because they will be seen in the shot. A good solution is to stretch cables between buildings or telephone poles and hang your rainheads and hoses from these cables (Figure 1–2). If you

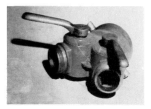

Figure 1-4 Siamese outlet reducer

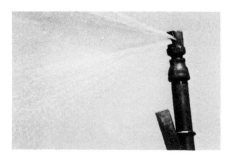

Figure 1-5 Bird's mouth

Figure 1-6 Quick release

Figure 1-7 Boston nozzle

Figure 1-8 Whirlybird head

are shooting a street scene in between buildings, use a spinning head, called a Whirlybird, that covers a 360-degree radius. Most rainheads only give you a 180-degree angle (see Rainheads and Nozzles below).

Rain Mats

Rain mats (also known as horsehair or hoghair mats) are made of a rubberized upholstery padding material. When the water strikes the mat, the sound is dampened, preventing interference with the sound recording.

Caution: Always check with the electrician to make sure all electrical equipment is properly grounded and insulated from water.

Crane Rainbar Setup

A counterbalanced crane ensures a quiet operation and provides good extensions up to 60 feet high. With a rainbar (1½- to 2½-inch pipe with several rainheads on it), add a 1½-inch or 2½-inch water feed line. This design enables the device to move with the shot, covering the actors with water as they move, and eliminating the need for 20 or 30 rainstands (Figure 1-3).

Fitting Hoses

Putting two differently sized hoses together requires a *hose reducer.* They come in various sizes and can even reduce a 2½-inch hose down to ¾ inch. The brass fittings on the ends of hoses are called couplings. They have rubber washers inside the fittings to prevent leakage. Always check this washer before connecting to any device.

Siamese Outlet Reducer

This is a Y-shaped outlet. It connects a single water supply hose or hydrant to two 1½-inch hoses, thus doubling your outlets. Each has its own separate valve control (Figure 1-4).

Pipe Threads

Hoses, pipes, hydrants, manifolds, and so on can all be threaded differently depending on their purpose, tensile strength specifications, and design. For this reason it is important to be aware of the standard pipe thread configurations to be sure your equipment connections are compatible. There are three different types of pipe threads:

1. National standard is a coarse thread and has fewer threads per inch.
2. SIPT stands for straight iron pipe thread.
3. Pacific coast pipe thread is a finer thread and has more thread per inch.

Rainheads and Nozzles

Here is a list of some of the many different types of rainheads:

1. Bird's mouth head (Figure 1-5)
2. Quick-release 1½-inch fog nozzle (Figure 1-6)
3. Boston nozzle (Figure 1-7)
4. Whirlybird heads (because they spin around, they're good for street scenes when the entire street must be covered; Figure 1-8)
5. water rings (on wind machines these give great hurricane effects; Figure 1-9a-c)
6. water wands are used to fill a specific area missed by a rainstand or for foreground rain directly in front of camera (Figure 1-10)
7. 1½-inch Fog nozzle (Figure 1-11)

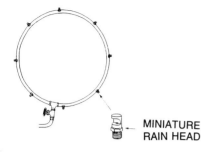
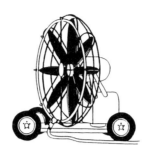

a b c

Figure 1–9 Water ring: (a) Rain ring with miniature rainhead (also known as Bird's mouth), (b) Ritter AC/DC fan with rain ring, (c) Ritter AC/DC fan with rain ring in action

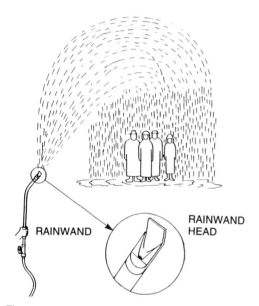

Figure 1–10 Water wand

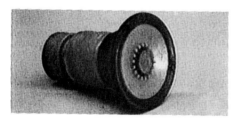

Figure 1–11 Fog nozzle

Figure 1–12 Manifold: 2½-inch input to four 1½-inch output

Manifolds

A *manifold* is a device with a large opening (of 1½ inches or more) that feeds a number of smaller outlets through control valves. For instance, a 2½-inch main on the manifold feeds four outlets of 1½-inches each (Figure 1–12). Then 1½-inch hoses are attached to four 1½-inch manifolds and in turn are further reduced to six ¾-inch valve-controlled outlets on each manifold. Six ¾-inch hoses are then run to individual ¾-inch rainstands.

Setting Manifolds Manifolds have one master valve that controls the flow of water into them. They also have sub-valves that control the flow of water out of the manifold into the individual rainstands or into other manifolds.

Manifolds should be set so they can be individually manipulated. In this way, you can control the water pressure. This is important when you're making rain because different areas of the set may require different types of rain. For example, one area might require a light rain with large drops while another needs smaller drops, but heavier rain. These valves allow you to preset each section to the director's specifications.

Hardware and Tools Needed for Rain Effects

To create various rain effects, these are the types of equipment used most frequently:

1. Eddy valves
2. Gate valves
3. Ball valves
4. Spanner wrenches
5. Universal spanner wrenches
6. pumps
7. hoses

Eddy Valves

When creating water and rain effects, use a valve on the fire hydrant called an Eddy valve. The fire department of the city where you're working can usually supply it. The Eddy valve controls the flow of water from the hydrant to the hoses and manifolds. Usually, the water flow is controlled by a 2½-inch line on one side of the valve and a 1½ inch on the other, with both lines controlled individually by valves. Most fire hydrants have 90 to 150 pounds of pressure per square inch. There are primarily three sizes of hose used for rain and water effects: a 2½, 1½, and ¾ inch.

3

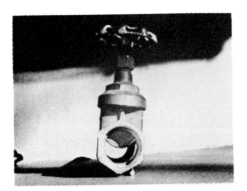

Figure 1–13 Gate valve

Figure 1–14 Ball valve

Figure 1–15 Spanner wrench

Figure 1–16 Universal spanner wrench

Figure 1–17 Protection screen for suction hose on water pump

Gate Valves

You can put as much pressure as you want on a Gate valve, whose mechanism works similarly to a guillotine. It rises up and down, closes the water on and off, and regulates the amount of water going in and out of the hose (Figure 1–13).

Ball Valves

The Ball valve employs a convex ball that rotates left and right to allow water to exit (Figure 1–14). This rotation seals off or opens to a concave inlet adjacent to the inflow. Water must be fed gradually as a sudden pressure surge will damage the seal.

 Caution: When holding a fire hose for wet downs or backup on areas where your rainstands cannot reach, be aware of the tremendous amount of water pressure coming out, anywhere from 100 to 125 pounds. It will take all you've got to hold that hose, and if you let go while it's open, it will whip around like a snake and break your legs. Always put two people on a water line during hosing down, especially if you're using over 80 or 90 pounds of pressure.

Spanner Wrench

The Spanner wrench is a special tool used for tightening or loosening hoses (Figure 1–15). The notch on the end grabs the brass fitting when you turn it. You may need two wrenches, one on each side of each hose you are connecting or disconnecting. By turning them in opposite directions, you tighten or loosen them.

Universal Spanner Wrench

Universal spanner wrenches open and close fire hydrant valves (Figure 1–16).

Pumps

Many situations require a water pump to deliver water to the rain set from a pool, stream, lake, or reservoir. Pumps come in sizes ranging from ½-inch to 6-inch outlets, depending upon your needs, and are operated by gasoline or electricity.

 Naturally a quality water pump should be used. In addition, a one-way foot valve protects the prime on the pump by preventing the water from draining back into the supply when the pump shuts down.

 When drawing water from a source, always put the pump as close to the water as possible. Remember, it's easier for a pump to push water out than it is to suck water up. You'll ensure better pressure this way.

Hoses

A suction hose used on a water pump is a hard noncollapsible hose. If a fire hose were used as a suction hose, the minute the pump was primed the hose would collapse and prevent water from entering the pump.

 Output hoses are attached to the manifold. A regular fire hose is used in most cases, usually 2½ inches in diameter. When pumping from a water supply, there are three potential problems. You could lose water pressure because you've lost the prime, or suction, on your hose. You could lose revolutions on the pump. Your hose could pick up something that will block it.

 Always put a wire basket on your suction hose to prevent sediment or loose debris from being sucked into the pump and damaging it or blocking the hose (Figure 1–17).

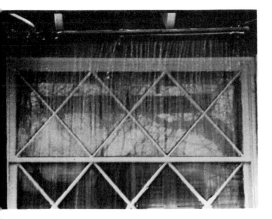

Figure 1–18 Window rain setup

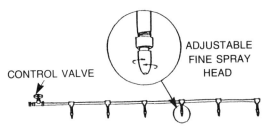

Figure 1–19 Fine spray bar

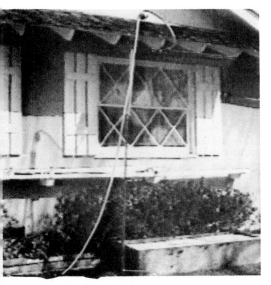

Figure 1–20 Window rain catch basin

When using fire hoses, especially on mains, make sure you use a good quality double-wall hose. A ruptured line can flood the equipment, or if it has enough pressure, cause it to whip around, possibly injuring your co-workers. Remember, water and electricity don't mix.

Valve Control

It's important to always turn valves on slowly when charging lines for the first time. A surge in pressure can easily break a hose or snap off a rainhead or a rain tower. Exercise extreme caution in turning on water supplies, especially when drawing from heavy-duty pumps such as fire trucks, water trucks, hydrants, and similar devices. Most pumps produce 150 pounds of pressure, ready and waiting when you start; some water trucks actually pump up to 600 pounds of pressure! So turn the main valves on slowly. After you have set all the individual rainstand valves to their required settings and all the lines have been charged with water pressure, an instant-on ball valve can be used to provide rain on cue.

Water Supplies

Many locations have no fire hydrants, so imagination, common sense, and originality are required to create alternative sources of water pressure for rain and water effects. Alternatives can be a nearby lake or river where a pump can be used to supply the water. Water trucks, fire trucks, and portable tanks are frequently used. You can also create a water reservoir with a portable pool, or even more basic, a hole in the ground filled with water.

Rain Effects on a Sound Stage

First and most importantly, waterproof the stage floor area with hot tar and tar paper. A sprayed liquid envelope or plastic sheets can be substituted. The most elaborate setup is a complete tank built to enclose the set and rimmed on its circumference with a wall approximately 18 inches high and sealed with fiberglass.

Rain Outside a Window

To achieve a rain effect on a window that is to be viewed from inside, there are several things you must do:

1. Seal the window with silicon or caulking to prevent water from leaking in from the window onto the set.
2. Use a drip pipe or spray nozzle overhead (Figure 1–18).
3. Use a small spray nozzle on the window itself (Figure 1–19).
4. If heavier rain is required, employ an overhead rain device such as a ¾-inch rain tower or a water wand.
5. Have a catch basin to collect water from the window.
6. Lay a rain mat in the catch basin to act as a silencer, dampening water noise and minimizing interference with the sound recording. Another way to quiet raindrops is with liquid soap. Suds on the water surface provide a cushion that stops the sound of rain dripping.
7. Use a siphon pump to recirculate the water from the catch basin back to the rain device and down again.
8. Install a hose to fill and later drain the water from the catch basin (Figure 1–20).

Rain on a Moving Car

Sooner or later you'll be asked to rig an automobile for traveling in th[e] rain. Try the following procedure.

Install a water pressure tank or a Hudson sprayer in the trunk of the ca[r.] Run a hose from the trunk to the top of the car and then to a spray nozz[le] and small pipe manifold mounted on the roof above the windshield or win[-] dows. The manifold adjusts the water flow. Suction cups, clamps, or gut[-] ter mounts hold these setups on the roof. A pressure gauge and a regulato[r] allow adjustments for the proper water pressure. The biggest problem wi[ll] be not having a long time to execute the shot because of the limited suppl[y] of water in the trunk. A larger tank can be made to fit the job and pressure[d] with air or inert gas (Figure 1–21). Another method is to use two or mor[e] Hudson sprayers in tandem.

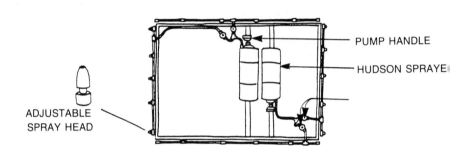

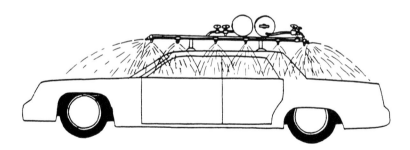

Figure 1–21 Rain on a moving car

Heavy Rain on Moving Car In most cases, the car will be on a trailer o[r] being pushed or pulled with a bar mounted on a camera car that's eithe[r] in front, behind, or alongside. The F/X vehicle is separate and equippe[d] with a large supply of water and a rainbar. The rainbar will be extende[d] on an arm over the front of the car or wherever necessary as directed.

Heavy Rain on Long Shots of a Moving Car This shot is predominantl[y] (but not exclusively) done from the interior of the car, shooting out. If th[e] scene is of a car moving along a road through a torrential downpour, yo[u] have a lot of work to do. Rainstands must be set up on the roadside opposit[e] the camera.

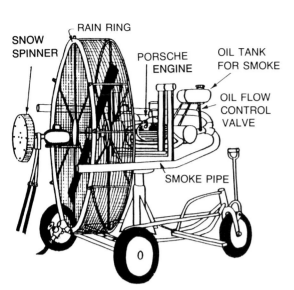

SNOW SPINNER
RAIN RING
PORSCHE ENGINE
OIL TANK FOR SMOKE
OIL FLOW CONTROL VALVE
SMOKE PIPE

Figure 1-22 Wizard super fan. A Porsche engine powers this machine, which features a rain ring, smoke attachments, and a snow foam spinner (also can be used on Red Bird fan).

We did this successfully in *The Return of the Living Dead* for a 1500-foot long shot. It took an entire day to set up and required four 4000-gallon water trucks plus three fire hydrants in order to get an adequate water supply. The script called for a very high shot of 50 feet, so we used a 60-foot crane (with 1½-inch rainheads) to put us above the camera crane. Seeing raindrops falling on actors from such a great height was tremendously effective.

Heavy Rain

Many film rain scenes require rain to turn into a hurricane or heavy storm. In this case, use a wind machine, such as a Ritter or a Red Bird with a rain ring on it (Figure 1-22). A lightning machine can also be added. The placement of heavy duty rain and snow machines is determined by weather conditions and, of course, the desires of the director.

Box 1-1 Water Weight

Water is very heavy, weighing about 7.5 pounds per gallon. A 2½-inch hose that is 1½ feet long contains about 1 gallon of water. If you have 200 feet of fire hose, you are attempting to control 1500 pounds of water, requiring a lot of labor to move or position these hoses when full. If you have the time, shut the water off and drain the hoses before moving them.

Also a cubic foot of water weighs 62.5 pounds. So if you have a water containment device, such as a box, remember how much water weighs before considering moving it. Always make sure the containment device is well built and waterproofed.

2

Snow Effects

Although there are many ways of creating snow, indoors and out, a popular method is to use a *Ritter fan*, a large, almost silent, wooden-bladed fan (also used for rain effects, see Figure 1–9b). Snow is dropped in front of it by hand, a shaker, or snow delivery machine. It can be fed from either the top or left side, facing into the airstream. It is never fed through the back, however, as flakes would get into both the blades and cage and foul up the mechanism.

One of the oldest methods, still used occasionally, is a snow bag attached to an overhead pipe. A line is pulled to control the volume of snow. The faster it is pulled, the faster the snow falls (Figure 2–1). Other delivery systems are automatic. These systems are all used for plastic snow. Plastic snowflakes come in various sizes from number 5 (the smallest) to number 20 (the largest). Extended polystyrene granules poured into a Ritter airstream create a blizzard effect. Providing you've used them on a clean surface, these snowflakes can be used over again.

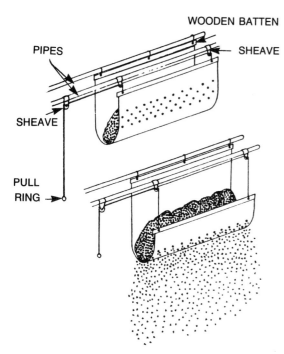

Figure 2–1 Old-fashioned snow bag

Outdoor Snow Effects

There are many ways to create snow effects outdoors.

1. **plastic flakes:** These come in large cartons containing sufficient material to cover an area about 2 inches thick by 49 square feet, or 7 feet by 7 feet, loosely spread.
2. **shaved ice:** Obtain from any local icehouse.
3. **snow blankets:** Synthetic cotton matting can be found at any upholstery house.
4. **Jetex foam machine:** This device attaches to a 1½-inch water line affixed with a pickup tube. The pickup tube syphons out the Jetex fluid and mixes it with water to create a fluffy white foam, like soapsuds. On a long shot it looks just like snow. It covers a large area, lies close to the ground, and is probably the easiest to clean up, as well as the least expensive of all the methods of delivering snow to a set. To clean up, just hose down the area (Figure 2–2).
5. **gypsum:** Gypsum comes in 50-pound bags, each bag producing half a cubic foot. Among gypsum's other names are dolomite, lime rock, 640, and marble white. To cover an area 50 feet by 20 feet by 3 inches deep, you'd need about 500 bags.
6. **salt:** Salt in the corners of windows and windowsills looks very good. To prevent it from falling off, wet down the surface before laying down the salt. Never use salt if animals are on the set or if you are working near trees, grass, or shrubs.
7. **aerosol shaving cream:** Use shaving cream on hard-to-stick-to surfaces like wire and chain-link fences. A few plastic flakes may also be dropped on the foam with mica chips blown on the surrounding area to give a slight reflection and glare and create more realism.

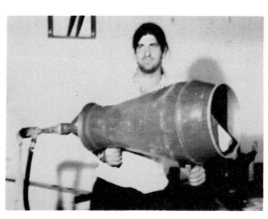

Figure 2–2 Jetex foam machine

Snow Scene Checklist

Here's a checklist to refer to when you're doing snow effects on a roof.

1. white cotton and muslin
2. flocking
3. icicles
4. wood frame with chicken wire covered with muslin for buildup
5. number 5 plastic snow

On a lawn, use the following for snow effects:

1. white cotton and muslin
2. number 5 plastic snow
3. shaved ice
4. Jetex foam

For flocking trees, cotton batting is best. However, flocking presents a cleanup problem. When possible, use shaving cream and mica chips to achieve the same effect.

For *ground effects*, you can use gypsum, or any white sandlike materials such as lime rock, marble rock, and dolomite. Remember, mica flakes and other snow dressings give you highlights for a better-looking effect.

Snow Sets

A *snow set*, either indoors or outdoors on location, requires a spread of white muslin over the area. White muslin has several advantages. First, it's a faster, easier cleanup. Second, you won't have to use as much fake snow to conceal grass, cement, rocks, dirt, and so on. Under the muslin, place sacks of sawdust to create mounds and additional wood and wire curves to give you the shape of things you require.

Unbleached muslin is much less expensive than the bleached variety and equally as good for long shots. Bleached muslin is superior for closeups and foreground shots. Unbleached muslin shrinks when wet and on most snow sets it will get wet. Remember that muslin makes everything much easier to clean up. Never use plastic sheeting under snow for cleanup because it is too slippery and can present a safety hazard.

Flocking

Before flocking, wet down the trees and shrubs lightly. Flocking has an added adhesive in it, so you needn't worry about it sticking. Blow on the flocking, adding a fine mist of water while applying, and it will adhere to tress and bushes.

Snow flocking is packed in 25-pound bags and referred to as snow-bond Christmas tree flock. It is flame retardant and lightweight, though very bulky.

Snow Blankets

Synthetic snow blankets look identical to snow and provide a good appearance on the ground, windowsills, greenery, and roofs. Cotton can also be used.

Figure 2–3a Foam spinners on a Ritter fan

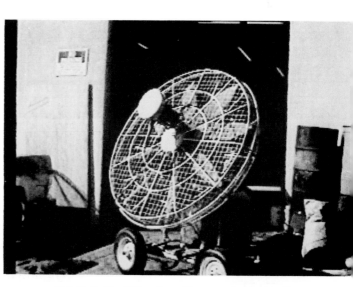

Figure 2–3b Ritter fan with snow foam attachment

Figure 2–4a Drum-type auto snow machine

Figure 2–4b Automatic snow shaker

Foam Spinners

Foam machines make ground cover much easier and faster. When put through a spinner attachment on a Ritter, Red Bird, or Super Wizard fan, it makes good-looking falling snow (Figure 2–3a and b).

Cleanup is simple and in addition is biodegradable.

Foam or snow spinners use a combination of air pressure, water, and a foaming agent such as Jetex foam, all mixed in the right amounts and forced through the foam spinner in front of a wind machine to create the desired effect. Two other automatic snow machines, the drum type and shaker, use plastic snow (Figure 2–4a and b).

Chopped Ice or Snow Ice

You can usually get a commercial ice company to come in and blow chopped ice on the set for you. It's the easiest method and is actually cheaper than trying to do it yourself.

Snow ice is available from icehouses in 50-pound bags.

White Sawdust as Snow

On occasion white sawdust has been used for snow and ground cover, and works well as long as it hasn't been contaminated with other types of sawdust. You need sawdust from a very soft white wood. The texture is likewise important and should be as fine as possible. Usually it can be obtained from a mill that deals with only one type of wood. If the color isn't just right, give it a light coat of white powder, either plasta or talcum powder, or any white substance. Gently blow over it until you've gotten the effect you're looking for. For glitter and sparkle, sprinkle some mica chips or vermiculite on the surface. **Caution:** Sawdust is not fireproof. Always have several water fire extinguishers on the set at all times.

Special Snow-Related Effects

Dripping Icicles

The effect of dripping icicles on the corners of eaves, roofs, and buildings can be achieved by using a Hudson sprayer with a small tube and a needle

valve for adjustment. This will make it appear as though the icicle is dripping. The icicles themselves are made from plastic molds.

Another method of making icicles without moldings is to drip Pycotex or Pycolastic, paraffin, or resin on a fine fiberglass cloth or on plastic wrap.

For molding icicles meant to be hit and to break away, breakaway glass material of Pycolastic or Pycotex is used. See Chapter 9, Nonpyrotechnic Projectiles, for other uses of Pycolastic and Pycotex.

Floating Ice or Floating Snow

To make floating ice or snow on a stream, lake, or other bodies of water, use finely ground Styrofoam flakes and/or chunks of Styrofoam shaped like chunks of ice. Wet them down well to give them realism and to stop them from shifting too much. By blowing mica chips on the ice, you get beautiful sparkling reflections.

Three Ways to Frost Windows

1. *prismatic lacquer:* When frosting a window to look like it's frozen with ice, use a fine brush and apply prismatic lacquer in the direction you want. When it dries, it looks like frost on a window.
2. *Epsom salts and stale beer:* Although an old method, using epsom salts and stale beer has many applications and the advantage of simplicity. The formula is truly basic: one part of flat beer mixed with two parts Epsom salts. Let it stand for a few minutes and then apply evenly to a clean glass with a cotton ball.
3. *Freon:* To frost or steam the window, or any glass, simply spray it quickly with Freon. Liquid nitrogen can also be used. **Caution:** Liquid nitrogen is very cold, about 310°F below zero. Use gloves, protective clothing, and safety glasses.

Footprints in the Snow

There are many ways of creating footprints, hoofprints, or tire tracks.

1. *shaved ice:* Unfortunately, footprints made of shaved ice melt quickly.
2. *Pyrocel:* This is the identical white material dentists use to take molds of impressions of teeth. It's similar to plaster of paris and can be used for molds of footprints, hoofprints, tire tracks, and so on.
3. *tiny beads of Styrofoam:* These are very small, almost the size of sand. When stepped on, they make good long-lasting footprints. Footprints can also be made by cutting Styrofoam into blocks, carving them into shapes, and coating them with hot paraffin.
4. *number 5:* plastic snow is often used.

Smoke in Snow Scenes

An unusual and creative effect can be achieved by putting a little smoke into a high-speed fan airstream, giving the look of a very fine driven snow while heavier granules of snow appear more dense than they are.

When actors are speaking during a blizzard scene and are facing into the snow stream, avoid blowing the plastic or styrene directly into their faces. It can lodge in their mouths and eyes, causing injury. Simply cut down the "snow" and increase the output of smoke. This way, actors can safely speak their lines.

Snow Machines

Ritter Machines

Sometimes it's necessary to use more than one wind or smoke machine to get the effect. For a blizzard scene, for instance, wind machines to blow smoke and snow can be used between the camera and the actors. By adding a second Ritter to blow the simulated snow between the camera and the actors, and possibly a third, larger fan to blow Styrofoam, polyurethane, or plastic flakes in the background (Figure 2–5) it's possible to create a dynamic blizzard.

New York Snow Machine

In New York, we used a snow machine that consisted of a deep hopper with a slotted opening at the top. Two bearings, a shaft, and a propeller-type device drove the mechanism, and regulated the flow rate of the snow material. As the motors turned, an elevator pushed the snow up the blowers, where a fan blew the snow out creating a snowfall. A regulator determined the speed and thus the density of the snowstorm. I have only seen these machines used in New York, thus the name New York snow machine (Figure 2–6).

Frost and Ice on Vehicles

Hypo is used in film processing, and its crystals dissolve easily in warm water. For best results, add the crystals to the water (not vice versa) and stir gently. Be sure that the crystals are thoroughly saturated. Spray this mixture on lightly. When it dries, it will look like the car (or whatever object was sprayed) has a coating of ice. This mixture is easily removed with water.

Hailstones

Rock salt is often used to simulate ice chips and chunks of snow. It can also serve as hailstones when used with a drop bag. As a substitute for rock salt, you can drop tiny white beans or white plastic beads.

Ice on Water Puddles

To achieve the look of ice on small puddles of water, pour melted wax or paraffin on the water's surface. It spreads out, hardens instantly, and floats. When stepped on, it cracks like ice.

Snow Commercial for Sprite

Recently I was called in to complete production on a commercial that was presenting considerable difficulties. The producers had already spent seven weeks shooting in Australia, two weeks alone on the most important effect, and still were unable to get the shot. Simply, the script called for a girl to ski down a slope, plow through a snow mound, and exit the other side with a smile and flashing eyes.

The problems were straightforward enough, although the solutions were not.

1. There is no snow in Southern California, thus we had to shoot in a studio.
2. There had to be ambient snow in the foreground and background caused by the actress hitting the snow.
3. There had to be the illusion of speed when she hit the snow mound.
4. All body movements had to appear as if she were actually skiing.

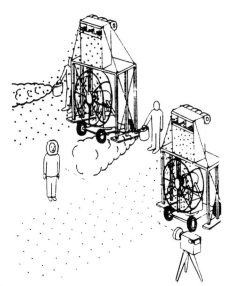

Figure 2–5 Blizzard scene using smoke and two Ritter fans

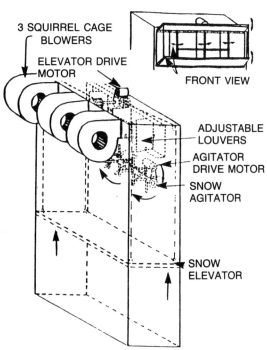

3 SQUIRREL CAGE BLOWERS

ELEVATOR DRIVE MOTOR

FRONT VIEW

ADJUSTABLE LOUVERS

AGITATOR DRIVE MOTOR

SNOW AGITATOR

SNOW ELEVATOR

Figure 2–6 New York snow machine

To create this effect, I mounted a 12 × 8-foot platform on top of a 75-foot track. Attached to the platform were seven air cannons and a frontmounted trip box, all containing various consistencies of snow. The trip box was activated by a shock cord and trip release to give the impression a skier had plowed through a mound of snow. Three Ritter fans blew the snow, and two E fans blew the actress's hair and clothing to simulate wind. The camera was set up at a 45° angle to give the impression of greater speed.

To duplicate the body, arm, and leg motions of a skier, her boots were attached to a lazy Susan; her ski poles were shock cord mounted to duplicate the effect of up-and-down, and back-and-forth movement. For safety, we provided her with a locking position for the ski poles to help her regain her balance in the event she lost control.

Trees were placed in the background and the stage floor was covered and dressed with snow. When the shot began, the actress moved down the rails and we cued the first cannons. Other cannons were activated as she passed through the snow and out the other side, whereupon we released the trip box. The consistency or texture of the snow in the cannons and box was determined by whether we wanted large flying chunks, a spray, or particles "exploding" from the "mound."

The background received its own dose of snow to correspond visually with the foreground.

All in all, we completed the entire shot in only 40 takes including rehearsal, finishing it in just two days. Figure 2–7a–d shows the setup and execution of the shot.

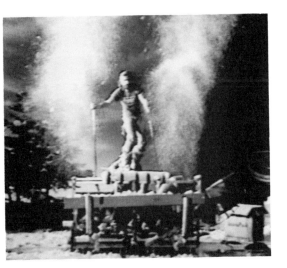

Figure 2-7a Side air cannons firing snow. Courtesy The Coca-Cola Company.

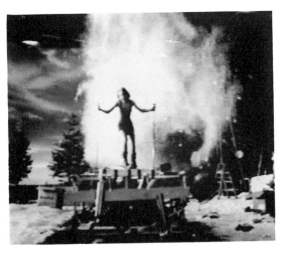

Figure 2–7b Rear air cannons firing snow. Courtesy The Coca-Cola Company.

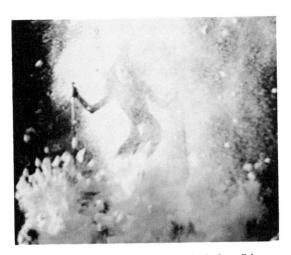

Figure 2–7c Front air cannons and trip box firing snow and chunks. Courtesy The Coca-Cola Company.

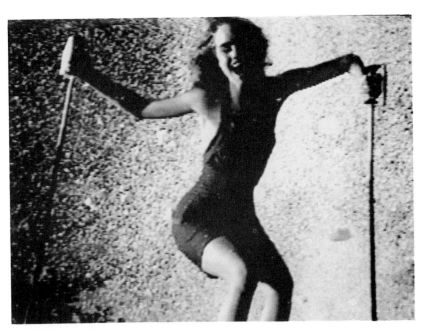

Figure 2–7d Actress breaking through the snow smiling. Courtesy The Coca-Cola Company.

13

3

Steam Effects

Figure 3-1 Peanut boiler

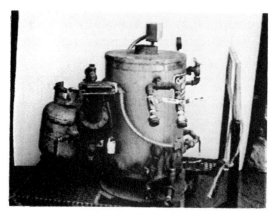

Figure 3-2 2½-Horsepower propane boiler

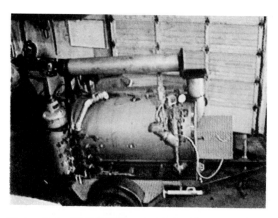

Figure 3-3 25-Horsepower propane boiler

Steam and pressure devices should not be on-stage when you're using them. They're noisy, and dangerous because they run on either gas or electricity, and are constantly under pressure and high temperatures from the boiler. The safest location for these machines is outside the studio.

Hoses are run into the studio, hooked to manifolds, and distributed by coupled extension hoses to the specific areas where the steam is needed. Items you'll be using in addition to the steam are steam hoses, steam traps, manifolds, fittings, and a chill box to keep the smoke or the steam floating close to the stage floor. A *chill box* is simply a box filled with dry ice with fittings and lines to the steam machine.

Steam Equipment

Steam Hoses

When working with steam, never use air hoses or regular outdoor garden hoses as a substitute for steam hoses, which are bonded, reinforced steel. They are temperature rated from 350° to 450°F. Steam hoses vary in size from ½ to roughly 3 inches in diameter and are pressure rated from 150 to 250 pounds per square inch. We cannot overemphasize the importance of using these specialized hoses.

Always install a bleed-off line to the boiler outlet in order to drain accumulated water and condensation from the lines. This prevents it from backing up into the system.

When using steam or fog on stage, it obviously must be controlled and contained. This is most easily done by keeping the stage floor cool and wet down. In addition, construct a barrier around the periphery to contain the fog. Make sure no air conditioners or fans that could possibly cause an air disturbance are running. If a great deal of moisture is present, apply water-resistant sealer to the stage floor or cover it with a tarpaulin. But remember, a tarp can prove slippery when wet.

Steam Traps

Steam traps have several purposes: they collect condensation from steam hoses, serve as a manifold, and function as a silencer and reservoir for the moisture drawn off from the unit.

Steam Boilers

The function of a water boiler is obvious and needs no further explanation. Its proper and safe use, however, should be detailed.

Steam boilers are rated by horsepower, starting at ¼ and moving up to ½, ¾, 1, 2, 5, 10, and 25 horsepower and larger. Your choice, of course, is determined by your particular needs (Figures 3-1 through 3-3).

Boilers are constructed in two sections: an upper and a lower float chamber. The upper chamber controls the water intake into the boiler; the lower controls the intake of fuel to the burner.

Most boilers has a series of floats, valves, and safety mechanisms to monitor its functioning. These, however, will only perform properly if the boiler itself is mounted absolutely level.

All steam boilers have pressure safety valves, also called pop-off valves. These valves are preset by the manufacturer to precise specifications. If the pressure within the boiler exceeds the design specifications, an explosion will occur. These valves are designed to release when too great a pressure is created, thus preventing the boiler from exploding. A second series of monitoring devices are the glass water gauges. These gauges monitor the water levels in the boiler and indicate if additional water should be added. If the level drops too low, excessive heat will again cause an explosion.

If you are working with a boiler and see no water in the glass gauge, shut it down immediately and allow it to cool. Adding water to a hot boiler can result in an explosion.

Since boilers should never have more than 75 pounds of pressure entering into the water line, a secondary regulator should be installed to prevent this. Likewise, a similar gauge indicating the amount of steam pressure in the boiler should be watched in order to monitor the flow rate.

At the end of each day, drain, or "blow down" the steam and water from the system. This technique rids the boiler of solid waste matter. Use caution because the water will remain hot enough to cause severe injury.

When operating a triple-cock steam boiler, take care because the upper cock releases steam, the middle releases steam and water, and the lower one releases hot water.

Commonsense precautions such as the use of gloves, protective glasses, and so on, should be used. Water at 212°F is live steam, and scalding is by no means a pleasant experience.

Steam acts differently than smoke. Steam vanishes, whereas smoke continues to rise and linger. There is a quality of difference in the feel and look of live steam over other types of smoke or fog effects. It requires some knowledge to operate steam machines or steam boilers, with some states even requiring licensing. Due to the many different models and methods of operation, it is advisable that steam devices be run only by qualified operators. Steam engines, whistles, and leaking steam pipes are created in this way, although there are other methods of achieving these effects.

Car Radiator Boiling Over

Freon is used to create the effect of a boiling radiator. Copper tubing is run from a Freon tank and properly positioned on the radiator. A 12-volt Freon valve is hooked to a driver-controlled switch that he or she activates on cue. Rycon 22 can also be used. Its major advantage is that it is safer for the environment.

Steam and Smoke Effects Outdoors

When you use steam and smoke effects outdoors, you may experience numerous problems. The weather is a major factor. Rain or continually shifting winds often force you to move your machines repeatedly so that the smoke or steam flows in the proper direction. Wide-ranging temperature variations, for example, hot or cold, can also wreak havoc on the effect, causing steam to rise or fall or dissipate too quickly or slowly. All these elements have to be considered when working outdoors.

Steam Curtains

A steam curtain is not what it sounds like, for it is not actually steam that is used but rather carbon dioxide (CO_2) and on occasion liquid nitrogen (LN_2). This can be rigged in two ways from either above or below.

The first time I ever saw this effect was at Radio City Music Hall where they had a built-in system that was rigged to release the gas from above. The carbon dioxide dropped down onto the stage floor, creating the illusion of a curtain of steam that masked the stage from the audience. During this interval a change of scenery took place, and when the carbon dioxide dissipated, the stage was totally reset.

I've used this technique often in rock and roll shows for groups such as Earth, Wind, and Fire, but from a slightly altered perspective. Rather than dropping the carbon dioxide from above (because of problems with rock and roll riggings), I designed and built a special system that ran across the apron of the stage. It consisted of a series of carbon dioxide mortars, about 12 inches high, attached to high-pressure flexible steel hoses. When fired, the carbon dioxide flew directly up creating the identical effect, but in reverse.

Remember, when using carbon dioxide you're working with a gas under 1000 pounds of pressure. If you use pipe instead of hose, always use schedule 80 piping.

4

Smoke Effects

Though this chapter deals with smoke and the machines that produce it, I think it important to note that visually there is very little difference between smoke and fog. The terms *smoke* and *fog* are virtually interchangeable in this context and depend only on the atmosphere you are trying to create. Simply, all these machines produce a white misty, gaseous visual of varying density and intensity. Depending upon the technique, you create either a "smoky" or a "foggy" look, though some of these devices are more readily applicable to one or the other effect.

Smoke effects allow a great deal of creativity for the effects person. Smoke patterns and ignition systems, once properly learned, enable a variety of simulations from bombs to magic wands to volcanoes to billows from a dragon's mouth.

There are many types of smoke-producing devices on the market, and they have several characteristics in common. They all use either oil- or water-based smoke fluid. This fluid is heated in a chamber by electric or gas flame above its boiling point and vaporizes into tiny liquid droplets, actually turning the liquid into a gas and creating what looks like smoke.

Caution: All vaporized smoke is toxic to some degree, so be careful to use it only in well-ventilated areas.

Box 4–1 Flashpoints

Flashpoints are defined as the lowest temperature at which vapors ignite when exposed to flame. Knowing the individual flashpoints of the products you are using is imperative when attempting to create a smoke effect.

When making smoke, always inform the proper authorities such as the fire department, police department, and local residents. To most people, smoke means fire, which can engender panic and chaos, the last thing you need on a shoot.

Smoke Producing Devices

The following is a list of some of the most common smoke-producing devices used in the United States.

1. Mole Richardson fogger
2. Ijeba Smoke Machine and Dinafogger
3. Super Fogger
4. New Mee Fog system
5. New Heavy Fog machine
6. Oil Cracker
7. New Liquid Nitrogen (LN$_2$) Fogger

8. dry ice fogger
9. Roscoe 1500 fog machine
10. Blitz fogger
11. bee smoker

Figure 4-1 Mole Richardson smoke gun

Figure 4-2 Mole fogger with dry ice basket

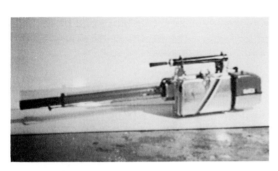

Figure 4-3a Ijeba TF-30 smoke machine

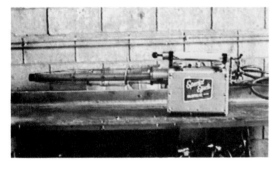

Figure 4-3b Dinafogger

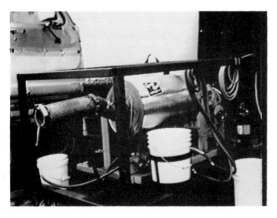

Figure 4-4 Super fogger

Mole Richardson Fogger

This system can be used with or without the dry ice basket mounted on the front. Smoke is forced through the basket and the cooling effect of the dry ice keeps the smoke or the steam close to the ground (Figures 4-1 and 4-2).

Ijeba Smoke Machine and the Dinafogger

The Ijeba is one of the better machines used for these effects; the Dinafogger (Figure 4-3b) is older and a bit more difficult and delicate to operate, but both function similarly.

Ijebas are essentially small, gasoline-powered jet engines which pressurize oil, spraying it into the chamber, changing it into a gas (Figure 4-3a and b). **Caution:** Never shut down an Ijeba until first turning off the oil supply. If this is not done, the escaping oil will ignite and the machine will become something akin to a flamethrower.

The Super Fogger

This is a propane-driven fog machine that condenses oil by running it through heated coils (Figure 4-4). It is only used when fog or smoke is needed to cover very large outdoor areas. It is similar to the World War II smoke machines used to obscure ships from an enemy.

New Mee Fog System

This is by far the safest of all fog or smoke producing devices. It uses water and air under high pressure instead of chemicals.

New Heavy Fog Machine

It uses an oil base fluid that is run through a heating coil and condensed into fog and/or smoke. The condensed smoke is then forced through a super cooling system that keeps the fog or smoke close to the ground. It can be used to blanket large areas up to 200 by 200 square feet. It has the added advantage of being a very quiet running machine.

Figure 4–5 Oil cracker

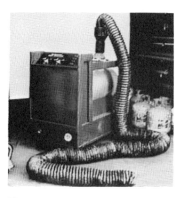

Figure 4–6 Liquid nitrogen fogger

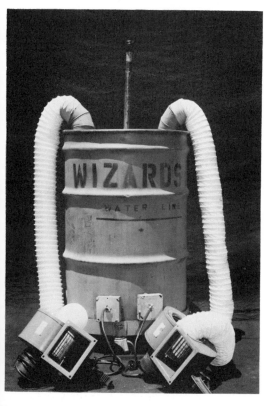

Figure 4–7a Dry ice fog machine

Oil Cracker

This machine employs oil under high pressure air to create a very fine over-all mist (Figure 4–5). It specifically accentuates light rays so that they are highly visible and precisely defined. Oil cracker machines are mostly used in rock and roll stage and video performances and in many commercials for atmosphere. **Caution:** These machines *must* be cleaned after each use and residual oil disposed of because bacteria tends to build up and cause health problems. Oil cracker machines do not provide a particularly pleasant atmosphere to breathe over an extended period and in addition discomfort for those who wear contact lenses or have sensitive eyes often results.

New Liquid Nitrogen (LN₂) Fogger

This is used for ground fog only. It must never be used where actors may be engulfed in it as liquid nitrogen completely displaces oxygen, with predictable results. Liquid nitrogen is pumped into a chamber in liquid form, converted into gas by heated blowers, and run on-stage via plastic tubes (Figure 4–6). **Caution:** Liquid nitrogen causes severe burns and frostbite if it contacts skin. It can penetrate clothing; therefore, special gloves, clothing, and enclosed safety glasses are mandatory. Liquid nitrogen is 310°F below zero. If, for example, your finger were immersed in it for as brief a time period as two seconds, it would be totally frozen and so brittle that it would shatter like glass.

Dry Ice Fog Machine

A most common effect seen in many movies (from *Dracula* to *The Hound of the Baskervilles* to *Wuthering Heights*) is the dense, grayish white, ground fog that lingers and hovers just above the earth. This effect is created by the dry ice fog machine. It is about the size of a 55-gallon drum with built-in water heaters that raise the temperature to 160°F (Figure 4–7a).

A wire basket holding dry ice chopped into sizes approximately 3 inches in diameter is held by a pipe above the barrel (Figure 4–7b). When the barrel is approximately half filled with hot water the basket is slowly lowered into it (Figure 4–7c). It must not be dumped quickly because it will give off a tremendous volume of fog that will hover above the ground and will not dissipate or rise unless it is blown off by a fan. Remember, you are using frozen carbon dioxide and no one should enter the fog or breathe it. It can be lethal. Never put this carbon dioxide fog over someone's head or engulf them in it because it displaces all oxygen. It is a good-looking effect and safe if properly used.

Figure 4–7b Dry ice basket

Figure 4–7c Dry ice basket and depth-adjusting handle

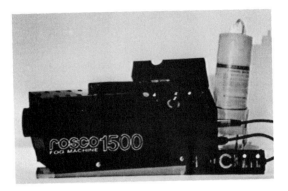

Figure 4–8 Rosco 1500 fog and smoke machine. Courtesy Rosco.

When breaking up dry ice, always wear protective gloves and goggles, as it is extremely cold (110°F below zero). Flying splinters, chunks, or ice dust that naturally occur when you smash the blocks can be frightfully caustic, burning eyes and hands. Do not use ice dust in the basket or machine because it will activate the machine ahead of time.

Rosco 1500 Fog and Smoke Machine
This is a new remotely controlled smoke/fog machine and works on similar principles to most smoke machines. A propylene glycol-based fluid is heated by a coil and pumped through an attached basket of dry ice. It has the best fine-tuning characteristics of any and all fog machines, with one reservation. Once it has been disconnected from electrical power, it shuts down, unlike the mole fogger, which can be manually pumped (Figure 4–8).

Blitz Fogger
Inside a blitz fogger is a heating coil fired by either electricity or propane. Fog is created when the oil flows through the heated coil, condenses, and is forced out the front nozzle. Blitz foggers can only be used outdoors (Figure 4–9a and b).

Be aware that oil dripping from the nozzle can be ignited by the open burner flame. Always keep the tip of the machine tilted down to prevent oil from flowing back into the heater. Once the coil is heated, the best and safest way to fog an area is to extinguish the fire before laying down the fog or smoke. Use a paddle when spreading the smoke to assure an even distribution on the set.

A major difference between the mole fogger and the blitz fogger is the pressure source that drives them. The blitz fogger relies on a pressurized container controlled by a device that adjusts the volume of fog.

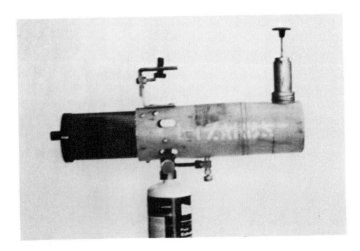

Figure 4–9a Blitz fogger

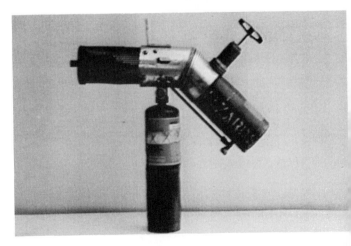

Figure 4–9b Angled Blitz fogger

Bee Smoker

An old-fashioned method of making smoke is with a bee smoker, a simple metal container with bellows mounted in the back. A combination of charcoal and olabanum fired with hot coals (approximately a teaspoonful) creates the smoke, which is then pumped out with the bellows. The bee smoker provides effective chimney smoke, smoke for barrooms, smoke emanating from under a door, or similar light smoke effects (Figure 4–10).

Figure 4–10　Bee smoker

Spectrasmoke

One of the best types of smoke is a product called Spectrasmoke, which can be used with most of the following devices. It comes in powder or coarse granule form of approximately 3 or 4 mesh size. There are several methods of igniting it. One is to use a safety fuse, which is about $^3/_{32}$ of an inch thick and burns at approximately 1 foot per 30 seconds. It can also be ignited with a simple electric match or nichrome wire. An electric match of 1 volt at 10 ml amps to 12 volts or 24 volts of DC can also be used. Never use an electrical power such as 110 or 220 volts.

Smoke powder is a fine substance that can be put into a pile and ignited. One inch of it burns in approximately 10 seconds. The powder comes in various colors: white, red, yellow, green, blue, gray, violet, off-white, orange, and pink (Figure 4–11).

The solid granules give more volume of smoke per ounce and burn a bit longer. They are available in the same colors as the powder (Figure 4–12).

Figure 4–11　Spectrasmoke powder

Figure 4–12　Spectrasmoke granules

Hand-Held Smoke Devices

Hand-held smoke devices are most often used by magicians in stage productions. They are 3 inches long, totally self-contained, and ignited elec-

21

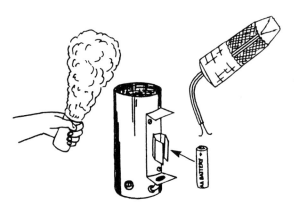

Figure 4–13 Hand-held firing unit for Spectrasmoke

trically by a small internally located battery unit. Almost any color can be employed (Figure 4–13).

Firing Boxes for Smoke Devices

Figure 4–14 illustrates some of the many firing boxes that can be constructed. All of them, including multiple firing boxes, use ignition systems from 1½- to 12-volt DC batteries. Be aware that attaching more devices to the firing boxes requires more power to detonate them. A 1½-volt battery will fire one unit, but it will not fire three simultaneously. Gauge your required amperage and use enough batteries to ensure ignition for as many devices as you need.

Smoke Stacks

When you need a large volume of smoke in any given area, attach smoke stacks to trees, in ground holes, behind pillars, or in virtually any place of concealment. They do leave a color residue around the stack itself, so it is important to protect the object to which the stack is mounted. A metal can or large wooden base often helps protect the mountings from being damaged.

Stacks come in three sizes: 1½ by 12 inches, which has a 100-second burn time, 1½ by 6 inches giving a 75-second burn, and 1½ by 4 inches, which burns for 50 seconds (Figure 4–15).

Long-Burning Smoke Cartridges

Smoke cartridges are ignited by an electric match or 12-volt battery, are slow burning, and put out a large volume of smoke. The burn time is approximately 75 seconds and, of course, they are available in standard colors. Three-quarter inch in diameter and 6 inches in length, smoke cartridges will operate in either a vertical or horizontal position and are useful in pipes, poles, crevices, or whenever there is a concealment problem. They are also available in short 30-second burns (Figure 4–16).

Maxi- and Mini-Smoke Pots and Mini-Cups

Maxi-smoke pots put out approximately 500 cubic feet of smoke. They are 1½ by 3½ inches in diameter and burn for 12 seconds (Figure 4–17). They are available in colors.

SIMPLE SINGLE SHOT

6-SHOT FIRING BOX

SELECTOR FIRING BOX

10-SHOT DELUXE FIRING BOX

Figure 4–14 Firing boxes

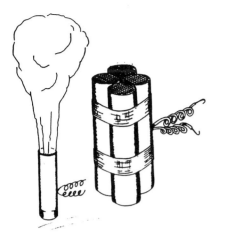

Figure 4–15 Spectrasmoke stacks, single and multiple stacks tied together

Figure 4–16 Spectrasmoke cartridge

Figure 4–17 Spectrasmoke maxi-pots

Figure 4–18 Spectrasmoke mini-pot

Mini-smoke pots provide a fairly large amount of smoke roughly 40 cubic feet about 10 feet high (Figure 4–18). Because of their small size (1 inch by 2 inches in diameter), they are easily concealable and therefore valuable when masking is required. They come in the standard colors and are ignited with an electric match requiring a 12-volt battery. The burn time is approximately 16 seconds.

A mini-cup is a self-contained unit shaped like a little metal cup with electrical wires (positive and negative) provided for battery ignition (Figure 4–19). It's an immediate on-cue effect so if you have split-second timing for a specific color of smoke lasting for a short time (say for a 30-second burn) mini-cups are most appropriate. The cups are approximately 1 inch across and $3/8$ of an inch deep and produce a slightly larger volume of smoke than smoke puffs (see below).

Smoke Puffs

For a fast 5 seconds of smoke in a small confined area, smoke puffs are most efficient. They require electrical ignition (the standard two-wire setup) to ignite them. A battery from 1½ to 12 volts can be used. Upon ignition they emit little bursts of smoke and a little noise and provide approximately a 5-second burn.

Smoke Cookies

Smoke cookies get their name from their round cookielike shape (Figure 4–20). To use them, simply break a section off, ignite it, blow out the flame, and place it into a metal canister, can, or cup.

By walking through a room with the burning canister you can, with practice, achieve the effect of a light, misty, or heavily smoked room (to simulate cigarette smoke, for example). Smoke cookies come in all standard colors.

Smoke cookies are quite costly, so it is not a good idea to burn one full-size cookie just to gain a lot of smoke.

Magnetic Cartridges

Magnetic cartridges are designed for use on vehicles, vertical surfaces, and any situation where loose powders or mini-pots are not feasible. They stick to any iron surface and can be relatively inconspicuous. Units can be ganged to create an unusual effect of progressive color changes over a long period of time (Figure 4–21).

Smoke Pellets

Smoke pellets, or cigar smokers, are quite similar to incense and are used primarily on sets. When placed in ashtrays, they simulate smoking ciga-

Figure 4-19 Spectrasmoke mini-cups

Figure 4–20 Spectrasmoke cookies

Figure 4–21 Magnetic cartridge

Figure 4–22 Smoke pellets or cigar smokers

Figure 4–23a Military smoke grenade

Figure 4–23b Simulated military-type smoke grenade

rettes, in guns, a smoking barrel, and can be used for barbecue pits, campfires, or atmospheric smoke. They vary from ¼ to 2 inches in diameter by 4 inches in length (Figure 4–22).

Body Smoke Pots

There are times when a scene requires actors' bodies to be smoking and smoldering as if from an explosion or fire; smoke comes from their pockets, from under their necks, their jackets, and so on.

This effect is accomplished with small metal smoke pots that have a mounting pin attached.

Prior to the scene, tiny slow-burning smoke pellets, very similar to incense (¾ of an inch across by 3 inches long), are lit and allowed to burn until the tip glows, whereupon they are placed in the pots. They are then pinned to the actor's specific body part. These are very safe to use and smoke while producing very little heat.

Military and Simulated Smoke Grenades

Smoke grenades are readily available all over the country from military surplus stores. Most have a pull-pin igniting device. Once the pin is pulled and the grenade thrown or dropped, it puts out tremendous volumes of smoke continuously (Figure 4–23a and b).

As with all smoke devices, make sure you are cleared with the local authorities and conform to the regulations of your area.

Other Smoke Producing Substances

Smoke Oils

Most oils used in making smoke create a white smoke when heated, but if that same oil is ignited or burned, it results in a black smoke in most circumstances.

If no other fogging oil is available, or if you've run out, mineral baby oil, vegetable, hydraulic, or motor oil can be used as a substitute. It is wise when using these substitutes to clean your machine thoroughly.

A-B Smoke Solutions

This product employs an A solution that can be used, for instance, to rim the edge of a cup, and a B solution that is sprayed with an atomizer at the cup. This results in a chemical reaction that causes steam or smoke to rise from the cup. As in any chemical effect, it is potentially dangerous and can have negative effects, so take standard safety precautions such as wearing goggles and proper covering for your hands and clothing.

Calcium Chips

You may be asked to create a boiling water effect with steam, yet there are no facilities at the location to actually boil water. A viable substitute are calcium chips, which are quite small and requires only a few teaspoons-ful and a cup of water to cause a violently boiling liquid. However, the chips leave a whitish-gray sludge residue that is quite unusable for any other purpose.

Fast-Burning Gray Smoke

Fast-burning smoke powder produces dense clouds of gray white smoke and a colored visible flame and is ignited electrically with a hot wire, fuse, or electric match. Fast-burning black smoke is identical and emits a col-

umn of smoke with a visible flame. It simulates oil or gas burning and explosions. Do not use any of these products near people or animals because they are quite caustic and toxic.

Black Smoke

Diesel fuel, fire in a can, tap paper, or old tires can all be used to create voluminous clouds of black smoke. Or try the simple act of dripping oil on hot charcoil.

Naphthalene

Another product often used for black smoke is Naphthalene. It creates a thick black substance when burned. Avoid an open flame around this substance because it has a low flashpoint and gives off ether gas.

Liquid Nitrogen Fog and Steam

Liquid nitrogen, or LN_2 is not only good for ground fog but also for frosting objects. It can be sprayed on any object to achieve this coating. It can also be used for cloud and steam effects.

Although liquid nitrogen emits large volumes of dense white smoke, it is a hazard primarily because it displaces oxygen. It also may cause frostbite if it contacts the skin. Besides these dangers, liquid nitrogen creates a wet and slippery floor that may cause injurious falls.

Fog Juices

Fog or smoke juices are made from mineral oil or water-based substites such as propylene glycol. Fog oil has a very high flashpoint, so the room must be well ventilated to avoid a buildup. In addition the vapors are toxic and can cause lung damage with prolonged exposure. Remember too that fog oil makes floors slippery.

Titanium Tetrachloride

Of the several types of liquid chemical smoke that are used, titanium tetrachloride is the most effective, though highly toxic. It can only be used outdoors, a fact that has caused it to be outlawed in some states.

Since it is air activated and a corrosive acid, extreme caution must be used when handling it. It should only be employed on smoldering campfires or when a continuous smoldering effect is needed. Don't use it at all if you can avoid it.

Black Smoke Liquid

Black smoke liquid burns with a dense black smoke when lit in a container. It's great for smokestacks on trains and ships, although it has some fallout and therefore should only be employed outdoors.

Kerosene

Burning kerosene provides smoke that can easily be lightened or darkened in color. A touch of alcohol lightens it; adding diesel fuel darkens it.

Smoke Rings

Years ago on "The Garry Moore Show," I did a takeoff on the old Times Square Camel sign that used to rise high above Broadway in New York. It was a famous billboard picturing a man smoking a cigarette and periodically puffing out huge, perfectly formed smoke rings from his mouth.

As in most effects, the simplest and easiest solutions give the most effec-

tive results, and this case was no different, although it required extensive experimentation to achieve it.

I began with a round drum 24 inches long by 24 inches in diameter and designed to produce a 6-inch round smoke ring capped at one end with sheet metal. A hole was then cut through this cap in the dimensions of the smoke ring.

Rubber sheeting was installed to seal to open end of the drum. In the center of the rubber sheeting we cut a small hole and into it glued a round ring to which we attached a piece of cable. Another ring was mounted onto the inside of the sealing metal cap. By pulling back on the rubber sheet and releasing it we would, in effect, create a bellows.

In the side of this cylinder we inserted a 1-inch hose through which we pumped smoke filling the drum (steam could also have been used). As the rubber was pulled back and released, it forced the smoke out through the small 6-inch hole giving us the perfect smoke ring (Figure 4–24).

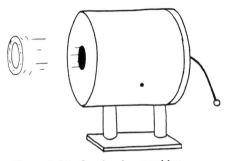

SMOKE FILL HOLE

RUBBER DIAPHRAGM

PULL RING

MOLE FOGGER

Figure 4–24 Smoke ring machine

Box 4–2 Kerodex

Skin creams are available that can protect your skin. A product called Kerodex is extremely helpful. It is a barrier cream used in the industry to protect the hands. It is invisible and resists a wide variety of irritants.

Another product, Kerodex 51, is primarily for dry or oily work and is designed for caustic products that are insoluble in water, such as grease or solvents, thinners, fiberglass, dyes, and the like. It washes off in soap and water and comes in 4-ounce tubes.

For wet work, Kerodex protects the skin against water, water-soluble irritants such as epoxy resins, plating solutions, bleach, photo chemicals, irritants, and soaps. It can be used with confidence against a broader range of irritants.

But nothing substitutes for caution. As the saying goes, "There are old special effects people and bold special effects people, but there are no old, bold special effects people."

Figure 5–1 Dry chemical extinguisher

Figure 5–2 Carbon dioxide extinguishers

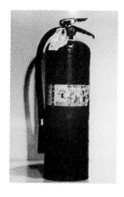 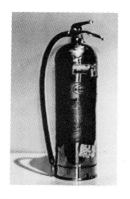

Figure 5–3 Haylon
extinguisher

Figure 5–4 Water-charged
extinguisher

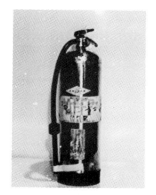

Figure 5–5 AFFF extinguisher

5

Fire Effects

Some of the most dramatic moments in films are created during a fire scene. Think of the burning of Atlanta during *Gone with the Wind*. In recent films, fire effects can be a main drawing card of the film, such as in *The Towering Inferno* or *Firestarter*. Fire may be a main scene in a film or a small effect, but it always needs to be handled by the effects person with the greatest care and planning. Fire is difficult to film and the director may get only one chance to film the scene. So set up your fire with special attention to detail and, even more importantly, plan how you're going to extinguish it.

Fire Extinguishers

There are three classes of fires:

1. Class A fires burn common, solid combustibles such as cloth, rubber, wood, paper, and many plastics.
2. Class B fires are fueled by flammable liquids and gases.
3. Class C fires involve electrical or electronic equipment.

There are also various types of extinguishing agents. Certain fire extinguishers are designed for specific types of fires. Know the type of fire you are creating and know what extinguisher you need to put it out.

- *Dry chemical:* A multi-purpose A, B, C dry chemical extinguisher, for instance, effectively extinguishes A, B, and C fires and has an ammonium phosphate agent base (Figure 5–1).
 Another dry chemical extinguisher works on class B and class C fires. This has a sodium bicarbonate agent base.
- *Carbon dioxide* is effective in extinguishing class B and class C fires and is preferred for electrical fires. It does not contaminate or leave residue on the materials that it extinguishes (Figure 5–2).
- *Haylon* extinguishes class A, B, and C fires and is a good choice on highly delicate equipment, such as computers. It is a vaporizing liquid, leaves no residue, and is especially effective in confined environments. Extinguishment can be accomplished with lower concentrations of Haylon than carbon dioxide. The agent base is bromochlorodifluoromethane (BCF) (Figure 5–3).
- *Water*-charged extinguishers effectively extinguish class A fires (Figure 5–4).
- *AFFF* extinguishers are used strictly for gasoline fires (Figure 5–5).

Torches

Burlap Torches

There are relatively few materials needed to make torches: a wooden pole, silicate of soda, wire, nails, and burlap. You may find oakum (a loosely

twisted hemp or jute fiber impregnated with tar) much easier to handle than burlap. Spray silicate of soda to fireproof the wooden handle so it does not burn along with the torch. In addition, it gives the torch a longer burn life. (See Box 5–1). When making torches, always use a wooden rather than a metal handle. Metal transfers heat and will become too hot to handle. The actual construction procedure is quite simple. Wrap burlap around the wooden pole, wire it in place, and use nails to secure it. Once the torch is completed, dip the firing end into a bucket of the particular fuel mixture you're using. After the torch is soaked, the excess fuel should be allowed to stand and drain off. Make sure no excess fuel is on the torch because when lit it could run down the handle and become a fire hazard for the person using it.

Timing the burn life of a torch is essential in order to assure that a scene will not be lost due to a premature burnout. The simplest procedure is to construct several identical torches, light one, and time it.

If torches have to be constantly extinguished and relit on a set, put several chunks of dry ice into a 5-gallon bucket and spray the dry ice with warm water, which will release the carbon dioxide. By dipping the burning end of the torch into the bucket, the flame will be extinguished immediately from lack of oxygen.

Box 5–1 Silicate of Soda

Silicate of soda (also known as waterglass) is basically a fireproofing material. When it is dry, it becomes a glasslike, fire-resistant substance. Because of its chemical structure, it should never come into contact with glass, as it causes deep etching and permanent damage. More often than not, silicate of soda requires thinning as it is a thick substance. This is easily accomplished by mixing it with water. This substance can be used to flameproof almost anything from wood to cloth.

Propane Torches

Propane torches may be used as a substitute for standard burlap torches (Figure 5–6). They are not difficult to construct and have definite advantages.

Along the side of the handle of a wooden pole, mount a copper tube down its length. Wrap it five or six times around the tip, being careful not to crush the tubing. After drilling holes every few inches in the wrapped section of the tubing, apply several layers of oakum and bind it with wire or mesh to hold it in place. Attach a propane hose to the base of the torch, run it through the actor's sleeve, and fit it to a small propane tank that the performer carries. Use a small regulator valve to adjust the fuel flow. Be careful when lighting this prop as it has a tendency to flare.

Propane torches are versatile and can be mounted on walls, on vehicles such as boats or cars, and positioned in places where oil torches are dangerous or impractical. Like any prop using gas, an element of danger exists, so as part of standard procedure, always check hoses, valves, and connections for leaks. This is done most easily with a brush and soapy water. If soap bubbles appear around the hose or connections, it indicates a leak. Always keep several carbon dioxide fire extinguishers on the set.

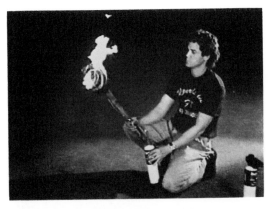

Figure 5–6 Hand-held propane torch

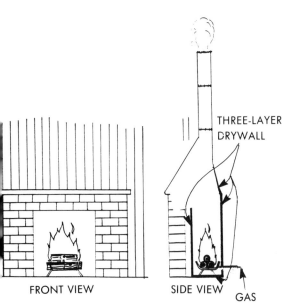

Figure 5-7 Firebox with hood and stack

Figure 5-8 Gas burner

Figure 5-9 Silencer used to soften hiss of gas through tubing

Fireplaces

There are set procedures to the construction of a fireplace. Begin with a firebox made of steel, surrounded by several layers of gypsum drywall to prevent heat transfer and thus inadvertent fire. The firebox must be separated from the floor and adjacent wall framing to permit a 2-inch airflow around the unit. Fireplace stacks rise up from this box and serve to dissipate the fumes and keep smoke and heat away from the set (Figure 5-7).

Next, place a gas burner in the fireplace 2 inches above the floor. The feeding gas line extending from the fireplace to the back of the firebox should be at approximately the same level as the burner. When lighting the fireplace, never open the gas cock until you are ready for ignition. A delay could cause a buildup of gas, resulting in an explosion. Installing a pilot light is ideal, but if impractical, use a piece of lit sterno on top of your burner or have someone with a torch ignite the gas when turned on (Figure 5-8).

If you can avoid it, never put a piece of paper into a burning fireplace. The heated air rises and sends the paper up through the stack, resulting in burning paper flying through the air. If you have to put a piece of paper in the fireplace, make sure you have wire mesh on top of your stack.

Using silencers for gas fireplaces is useful because, as you may be aware, there is always an unavoidable hissing sound of escaping gas. The silencer consists of a pipe approximately 1½ to 2 inches in diameter by 12 inches long, capped at either end and reduced down to the size of the copper tubing or pipe gas line. It is filled with steel wool that eliminates the noise, thus preventing ugly arguments between you and the sound person (Figure 5-9).

An adjustable needle valve and cutoff valve positioned between the tank valve and the fireplace is the best way to control the height of the flame. It also assures that the flame will remain constant from shot to shot, regardless of the intervening time span or cast and crew breaks. Just turn the tank valve off, leaving the settings as is on the needle valve. Naturally, as in all effects, take the standard safety precautions, such as gloves, glasses, and of course, the ever-present fire extinguisher.

Campfires

Campfire logs are usually made from materials such as metal lath or log-shaped wire mesh filled with a high-fiber filler such as fire clay or plasta mix and with dry colors (to achieve the proper hues of the log) and coated with silicate of soda for fireproofing. In some instances, you may need ashes for the scene. A high-fiber filler and some lampblack are often used for this. Products such as crushed pyrosilicate also give the effect. To complete the prop, you need a burner ring. This is made by punching small holes at half-inch intervals into a piece of coiled copper tubing through black iron pipe and attaching it to a propane line.

Slots are cut in the pipe at one-inch intervals to provide exit ports for the gas. The iron pipe can then be formed into various shapes, such as a ring, an H, or an X, depending on your requirements (Figure 5-10a-d).

Stage Campfire

When building a campfire on stage, use a firepad raised approximately 2 inches above the stage floor to allow an air space beneath. This setup pre-

Figure 5-10a Burner ring

Figure 5-10b Slots in burner cut at a diagonal maximizes flame

Figure 5-10c Campfire logs

Figure 5-10d X burner

Figure 5-11 Stage campfire burning

Figure 5-12 Propane tank safety cap

vents heat transfer to the wood and avoids scorching or burning. Materials most often used as firepads are drywall asbestos or corrugated steel plus steel pipe.

Construction of the campfire is the essence of simplicity. Place pieces of drywall on steel pipe, again leaving 2 inches of separation between it and the floor (the same applies to the use of corrugated steel and the asbestos substitute as long as it remains raised 2 inches) (Figure 5-11).

To rig and control a stage campfire, you need a burner or slotted pipe (e.g., copper tubing or black iron pipe) and the proper fittings for LPG (liquid propane) pressure hose. Never use any hose for gas except the LPG hose. It will always be marked as such. A silencer (see section on fireplaces), a propane gas bottle, a needle valve, a pilot light or wick to fire the gas, and safety standby equipment of water hose and fire extinguisher complete the package.

There are tremendous advantages to using gas as opposed to flammable liquids. A great deal of time is saved when redressing the set, for example, when the flames must be turned on and off instantaneously, but more importantly, gas eliminates the worry of fire hazards that are inherent when using a liquid that may drip or run. All propane tanks should have a safety cap attached to the tank that prevents leaks when being stored. LPG gas is preferable to natural gas because it has been pressurized, liquified, and odorized (Figure 5-12).

Candles

Candles can be a problem for special effects because they remain indifferent to whether or not the cameras are rolling and insist on continuing to burn. The difficulty is obvious when a scene is shot over a period of several hours and then numerous reaction or covering shots are done. It suddenly becomes apparent that the scenes cannot be matched because the lengths of the candles differ from camera angle to camera angle. This can be maddening, and unless you keep using regular candles, cutting them to size and replacing them, you must find another solution.

That solution is lighter fluid candles. Once dressed with wax, they look like candles, and they always remain standard in size no matter the length of the scene. If the scene is written to occur over a considerable time progression, these cannot of course be used.

Creating Fire Effects

Fire Bars

Fire bars come in all shapes and sizes. The most commonly used is a ¾-inch black iron pipe 1 to 6 feet long with ⅛-inch holes drilled 1½ inches apart its entire length. Depending on the effect you are looking for, slots can be cut on a bias about 2 inches apart along the length of the pipe to give the flame a more solid look.

Fire bars can be used for many different effects: in windows, in front of the camera as foreground flame, or whenever a flame is needed on a set. A LPG gas hose is attached to one end of the pipe, the other end of the hose is attached to a cutoff valve, and is attached to a regulator valve and from there to the LPG gas tank and valve. Figure 5–13a–d shows the different types of fire bars.

Fire Pans

Fire pans are similar to fire bars except that the bar is inside a steel pan and facing down instead of up (Figure 5–14a and b). This spreads the flame

Figure 5–13a Fire bar with circular holes

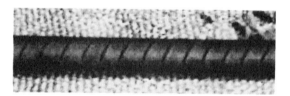

Figure 5–13b Fire bar with diagonal cuts

Figure 5–13c Fishtail gas burner

Figure 5–13d Burning fire bar

Figure 5–14a Fire pan

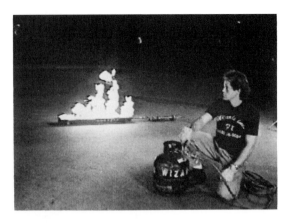

Figure 5–14b Burning fire pan

over a wider area, but it is used basically the same way. One advantage to the fire pan is when dumping the tank (turning the LPG tank upside down) to get the liquid out, the gas is contained in the pan, making it safer to handle. The best way to ignite a fire pan or bar is with a fire ribbon or sterno can on top. Light it, turn on the gas, and the bar or pan will ignite safely. A weed burner can also be used. Remember, liquid propane gas is heavier than air so it will always lie at the lowest point in a room if not ignited immediately after turning on the gas. **Be careful.**

Fire on Walls, Door Frames, Window Frames
When the script calls for a wall engulfed in flame, or just the frame of a window or door, the easiest way to accomplish this effect is to use rubber cement. The object to be burned is painted with two heavy coats of rubber cement and ignited with a propane torch. In the case of a wall that is burning end to end and floor to ceiling, it is advisable to put a fire bar at the base, which increases the volume of the flame greatly.

The fumes from rubber cement are very explosive, so be sure to use it in a confined area. Do not allow anyone to smoke on the set or even in the studio. Always keep several carbon dioxide fire extinguishers on the set while the person is painting the rubber cement. There have been many people burned doing this job.

Fire Ribbons
Fire ribbon comes in a tube not unlike toothpaste and is squeezed out in the same manner. It can start wood burning or be used as a trail to start or ignite powders or fluids and similar special effects devices. It is also quite useful as a pilot light for gas effects.

Fire Balls from an Air Cannon
Fireballs are somewhat dangerous, but they give great effects. (This is also discussed in Chapter 10, Pyrotechnics.) Air mortars are the primary delivery systems. The air mortar is filled with propane gas under approximately 150 pounds of pressure, all valves closed and sealed off. At the nozzle or outlet valve, place a bush burner flame thrower (simply a hot torch) for ignition.

Once the mortar and flame thrower are aimed, the gas is released by an electric solenoid valve all at once. It shoots a column of fire usually 30 to 50 feet long, even longer depending on the nozzle on the cannon.

This effect is perfect if you need a large flame shooting out a window or a doorway. It also works in any situation requiring a fireball to come shooting straight out at the camera. Remember to mount a heat shield to protect the camera when you use this effect. Obviously, no smoking should be permitted in the studio while performing this effect.

6

Chemical Effects

(See page 185 for basic safety rules for chemical effects)

This chapter is dedicated to a very close friend who passed away several years ago. I worked for and with him and enjoyed every minute of it. His name was Harry Raymond, professionally known as the Great Prince Hara.

Prince Hara was one of the world's best illusionists and by far the world's best pickpocket. He once said to me, "When you learn the pick-pocket routine, you'll never have to worry about having money. If you can't get the bookings, you can always work the subways."

Here's to you, Prince Hara. Without you, I'd never be where I am to-day. You taught me everything I know about magic. Thanks too for all these marvelous formulas you shared with me.

Black Foam

A black hard foam appears and overflows from a beaker. This is sometimes called *snake effect*.
- **chemicals needed:** powdered white sugar, sulfuric acid
- **equipment needed:** two 200 ml. beakers, glass stirring rod, large piece of cardboard underneath beakers to protect painted surfaces

How to Achieve the Effect
Fill one beaker one-third full of powdered white sugar. Fill the other beaker with 10 ml. of concentrated sulfuric acid. Pour the acid into the sugar. Stir with glass rod. The material will begin to darken and give off fumes. In a few moments, a black solid material will rise several inches above the beaker.

Safety Factors
Sulfuric acid is very dangerous. Wear proper clothes, gloves, and safety glasses. The fumes from this chemical effect are sulphur dioxide. Therefore, do not create this effect in a small unventilated room. Always do it outdoors or in a large ventilated room.

Bubbling, Smoking Test Tubes

- **chemicals needed:** warm water, dry ice, assorted food coloring
- **equipment needed:** assorted test tubes and beakers

How to Achieve the Effect
Fill test tubes or beakers with warm water, about three-quarters full. Add a few drops of food coloring to achieve desired color. Add a few small pieces of dry ice, about ½-inch squares. The substance will immediately start to bubble and form a white smoky vapor on top.

Safety Factors

Dry ice is very cold (110°F below zero), therefore it can actually burn the skin if you touch it with your bare hands. So either wear gloves or pick up dry ice with prongs. Also wear safety glasses. Very important: never enclose or seal dry ice in any type of capsule or container. When dry ice melts, it releases pressure that can be explosive.

A + B Blood

- **chemicals needed:** 25 grams potassium thiocyanate, 5 grams ferric chloride, salt
- **equipment needed:** two glass beakers

How to Achieve the Effect

Add a few milliliters of water to each beaker. Add the potassium thiocyanate (solution A) to one beaker and 5 grams of the ferric chloride (solution B) to the other beaker. Add a small pinch of salt to each beaker to make a saturated solution. Both A and B solutions are fairly clear and cannot be seen when placed on various objects.

Example Dip a knife blade into one of the solutions. Take a cotton swab and dip it into the other solution. Take the cotton swab solution and rub it into your hand or arm or any part of your body. Stay away from your eyes or mouth. Take the knife that has been dipped into the other solution and draw it across the part of the body you put the other solution on. It will turn bright red and look just like blood.

Other Uses for A + B Blood Take a white card or piece of cloth and saturate it with the A solution. Dip your finger into the B solution and you can write on the cloth. It will appear you are writing in blood!

Safety Factors

As with all chemical effects, take precautions. Keep chemicals away from eyes and mouth.

Cold Fire

- **chemicals needed:** carbon disulfide, carbon tetrachloride
- **equipment needed:** glass container or beaker, glass mixing rod, eye dropper

How to Achieve the Effect

Mix 60 ml. of carbon disulfide and 40 ml. of carbon tetrachloride in a glass beaker. Stir rapidly several times. Take an eye dropper and put about 10 drops in the center of the palm of your hand. Ignite with match. Cooling by rapid evaporation prevents hand burns. If you're afraid to burn the liquid in your hand, pour some fluid onto a piece of cloth. After it is ignited the cloth will show no signs of having been burned.

Safety Factors

The amount of liquid in the palm of your hand should be kept small because it could seep around to the back of your hand and possibly burn you. Never use this chemical in large quantities on any part of the body.

Take standard precautions such as wearing safety glasses. The chemicals used in this effect are toxic and should not be taken internally. Use common sense when creating cold fire. Before you ignite your flame, make sure the containers holding the chemicals are closed and far away from the flame. Have a fire extinguisher close by.

Fire Writing

- **chemicals needed:** potassium nitrate, water
- **equipment needed:** Fairly heavy paper or cardboard that is somewhat absorbent, glass beaker, paintbrush, match, torch, or cigarette

How to Achieve the Effect

Put 10 grams of potassium nitrate in a glass beaker and mix with 25 ml. of water. Then, write or print the words you want on the cardboard paper with a small paintbrush. Make sure all the letters are connected. Go over the printed letters several times, saturating them with the solution. Make sure the solution dries on the paper before you light it. It then can be ignited with a match, a torch, or a lit cigarette.

Safety Factors

As with all fire effects, you should have a fire extinguisher nearby and take the standard precautions when using chemicals, such as wearing safety glasses and so on. Chemicals should never be taken internally.

Invisible Ink 1: Making Letters Appear by Use of Flame

- **chemicals needed:** concentrated sulphuric acid
- **equipment needed:** glass beaker, candle or torch, glass rod, white cardboard

How to Achieve the Effect

Write your message on the white cardboard by dipping the rod into the sulphuric acid solution. After a few moments, take a lit candle or flame and move it back and forth across the card. Slowly, the letters will appear in black.

Safety Factors

Standard precautions should be taken using acids and chemicals, such as safety glasses, proper gloves, and protective clothing.

Invisible Ink 2: Making Letters Appear by Use of Heat

- **chemicals needed:** copper sulphate, ammonium chloride
- **equipment needed:** glass beaker, glass rod, white cardboard, light bulb

How to Achieve the Effect

Mix equal parts of both chemicals in a glass beaker. Then, write with the glass rod on the white cardboard. Once the chemicals have dried

thoroughly, place over a 100 to 150 watt light bulb. The heat created will make your words appear yellow in color.

Safety Factors
All the standard safety features are applicable.

Red Invisible Ink

- **chemicals needed:** 5 ml. cobalt nitrate
- **equipment needed:** glass beaker, glass rod, white cardboard, light bulb

How to Achieve the Effect
Dip glass rod into the cobalt nitrate and write your message on piece of white cardboard. Let dry thoroughly. Then pass it over a 100 to 150 watt light bulb. Your message will appear in rose-colored tint on the paper.

Safety Factors
Standard precautions should be taken (glasses, gloves, and clothes). Chemicals should never be taken internally.

Brown Invisible Ink

- **chemicals needed:** strong solution of ferric ammonium sulphate
- **equipment needed:** glass beaker, glass rod, white cardboard, light bulb

How to Achieve the Effect
Dip the rod into the solution and write your message on white cardboard. After it dries, pass the paper over a 100 to 150 watt light bulb. Message will appear in a brown color.

Safety Factors
Standard safety precautions apply.

Invisible Ink from Fruit

- **chemicals needed:** lemon or grapefruit juice
- **equipment needed:** clean ink-writing pen, beaker, white cardboard, light bulb

How to Achieve the Effect
Dip the clean pen into lemon or grapefruit juice (either one works well), and write your message on a piece of paper. Heat over a light bulb and letters will appear in light brownish color.

Safety Factors
None.

Nonchemical Form of Invisible Ink

- **chemicals needed:** vinegar
- **equipment needed:** clean ink-writing pen, beaker, white paper, light bulb

How to Achieve the Effect
Write message on piece of paper after dipping pen into vinegar. Pass paper across a 100 to 150 watt light bulb. Message will appear in light brown color.

Safety Factors
None.

Appearing and Disappearing Invisible Ink

- **chemicals needed:** solution of cobalt chloride
- **equipment needed:** piece of wood shaped like writing pen, white paper, iron or light bulb

How to Achieve the Effect
Fill the wooden pen with the cobalt solution just as you would fill any common fountain pen. Write your message on a piece of white paper. The writing will not be seen until a warm iron is passed over the paper or the paper is held over a heated surface such as a light bulb. The letters can be made to disappear simply by breathing on them!

Safety Factors
Standard safety precautions apply.

Different Colored Fireworks

- **chemicals needed:** different mixture of chemicals in powder form for each color of fire in the following ratios:
- **equipment needed:** mortar and pestle, asbestos mat, filter paper, matches

Blue fire: 8 ml. potassium chlorate, 2 ml. copper sulfide, 4 ml. sulfur, 2 ml. mercurous chloride, 1 ml. copper oxide, and 1 ml. charcoal

Green fire: 12 ml. barium nitrate, 3 ml. potassium chlorate, 2 ml. sulfur

White fire: 7 ml. potassium nitrate, 1 ml. antimony sulfide, 1 ml. sulfur

Red fire: 4 ml. strontium nitrate, 4 ml. potassium chlorate, 2 ml. charcoal, 1 ml. sulfur

Yellow fire: 6 ml. potassium chlorate, 2 ml. sodium oxalate, 2 ml. charcoal, 1 ml. sulfur

Purple fire: 1 ml. copper sulfate, 1 ml. sulfur, 1 ml. potassium chlorate

How to Achieve the Effect
Grind each substance into a powder separately in a mortar. After it is dry, place it on a large sheet of paper in the ratios indicated. As you rock the paper back and forth, the substances will become mixed. Place a small pile of mixed powder on the asbestos mat along with a thin piece of filter paper in the pile, and ignite it. (First soak the filter paper in a concentrated solution of potassium nitrate. Let it dry.)

Safety Factors
Standard safety precautions apply.

The Bottle of Many Colored Waters

In this effect, one bottle pours different colors of water into six different glasses.

- **chemicals needed:** in the jug, 5 grams of ferric ammonium sulfate and 500 ml. of water. In each of six glasses, put half a gram of the following chemicals, then dissolve with a few ml. of water: (1) potassium thiocyanate, (2) barium chloride, (3) potassium ferrocyanide, (4) tannic acid, (5) tartaric acid, and (6) sodium hydrogen sulfite.
- **equipment needed:** good lighting for magic trick, attractive jug for ferric ammonium sulfate solution

How to Achieve the Effect
See chemicals needed description.

Safety Factors
Standard safety precautions apply.

The Rod of Fire

- **chemicals needed:** powdered potassium chlorate, sugar, concentrated sulfuric acid
- **equipment needed:** glass rod, large candle with fluffy wick, mortar and pestle

How to Achieve the Effect
Mix equal quantities of powdered potassium chlorate and sugar and saturate the fluffy candle wick. Place the end of the glass rod into the concentrated sulfuric acid. Then touch it to the wick. It will flare immediately and continue to burn.

Safety Factors
Be sure to grind the potassium chlorate crystals and sugar separately in your mortar. You may create an explosion if you mix and then grind them together. Standard safety precautions apply.

Pitcher Changing Colored Waters

What looks like clear water is poured from an opaque jug or pitcher into seven glasses. Many strange color changes result!

- **chemicals needed:** 5 grams tannic acid, a few milliliters each of saturated solutions of ferric chloride and oxalic acid, concentrated ammonia, concentrated sulfuric acid, distilled water
- **equipment needed:** opaque attractive jug or pitcher, seven water glasses

How to Achieve the Effect
Put tannic acid into the jug. Fill it with distilled water and stir well. Line up the empty seven glasses. Proceed as follows:

Leave glasses 1 and 3 empty.

Put 5 drops of saturated ferric chloride solution into glasses 2 and 4.

Put 15 drops of oxalic acid into glass 5.

Put 10 drops of ammonia into glass 6.

Put 5 drops of sulfuric acid into glass 7.

When you are ready to perform, pour water from the jug into the first glass. It will look exactly like water.

When you pour water from your jug into your second glass, it looks like ink is being poured.

When you pour from your jug into the third glass, it will appear as though water is being poured.

When you pour into your fourth glass, it looks like ink is being poured.

Now, pour the liquid from all four glasses back into the jug.

Pour some of this liquid into glass 1. It looks like ink is being poured out.

When you pour this liquid into glass 2, it still looks like ink is being poured out.

But when you pour this liquid into glass 5, it looks like water!

When you pour this liquid into glass 6, it looks like wine!

When you pour all the glasses back into the jug, it looks like you have a jugful of wine.

When you pour this "wine" into glass 7, it looks like water.

Safety Factors
Standard safety precautions apply.

Exploding Shoes

When a person walks into a room and steps on small pieces of paper, they are shocked by sharp crackling sounds at their feet. This effect can also be created by touching the treated paper with a meter stick.

- **chemicals needed:** 5 grams iodine, 3 grams potassium iodide, 20 ml. concentrated ammonium hydroxide
- **equipment needed:** filter paper, funnel, beaker

How to Achieve the Effect
Stir the potassium iodide and iodine together in a beaker with 50 ml. of water. Add the ammonium hydroxide as you stir until the precipitate stops forming. First filter and then spread a thin layer of the wet solid on several filter papers. You should then break the filter papers into many small pieces and allow them to dry for several hours. When dry, the paper is extremely sensitive to touch and will explode violently with the lightest touch, even from a feather.

Safety Factors
Even though the nitrogen triiodide produced by the effect can be handled safely when wet, you can lessen the violence of the explosions by spreading a thin layer of the wet material on several pieces of the filter paper. *Never* let a sizable quantity of the dry material accumulate. Standard safety procedures apply.

Snakes from the Smoke

After you place some yellow powder and a few drops of liquid into a small evaporating dish and heat it slowly, a "snake" springs out of the dish in a cloud of smoke.

- **chemicals needed:** 3 grams paranitroacetanilide, 1 ml. concentrated sulfuric acid
- **equipment needed:** evaporating dish

How to Achieve the Effect

Put the paranitroacetanilide in the evaporating dish, then add the sulfuric acid. Heat for two or three minutes. A "snake" over a foot long and several inches in diameter will shoot upward.

Safety Factors

The smoke that rises at the moment of reaction is irritating to the eyes and lungs. Therefore, ask spectators to leave the room shortly after creating this effect if you are working in a place without high ceilings. Standard safety precautions apply.

Smoke from a Tube

Whenever you want, white smoke will shoot out of a tube.

- **chemicals needed:** concentrated hydrochloric acid, concentrated ammonium hydroxide
- **equipment needed:** two bottles with two-hole rubber stoppers, rubber bulb, rubber tubing

How to Achieve the Effect

Put a few milliliters of the hydrochloric acid in the first bottle. Then, place the same amount of ammonia in the second bottle. You should arrange the apparatus so that pressure on the bulb causes air to pass first to the bottle containing the acid. Make sure a glass tube extends from the acid bottle to the bottom of the ammonia bottle. Dense fumes generated in the second bottle will be conducted out of the ammonia bottle in a rubber tube. To create smoke, press on the rubber bulb. For a steady stream of smoke, take off the rubber bulb and blow into the first bottle.

Safety Factors

Standard safety precautions apply.

Smoke Rings

White smoke rings rise from an on-and-off flame that bursts above water in a transparent dish.

- **chemicals needed:** 200 ml. 40% potassium hydroxide solution, three or four small pieces of phosphorus
- **equipment needed:** 500 ml. distilling flask or ordinary flask with a two-hole rubber stopper, large beaker, ring stand, rubber tube, one-hole stopper

How to Achieve the Effect

Attach the flask to a ring stand. Add the phosphorus and the potassium hydroxide solution. Connect a rubber tube to the condensate tube of the flask. To the end of this attach glass tubing. This terminates under water in the beaker just below the surface. The open end extends upward. Fit a one-hole stopper in the flask. A glass tube extends through it into the solution; the other end of the tube is attached to a rubber hose connected to the gas supply. Allow the gas to bubble through the solution and then heat it to boiling. Smoke rings will then begin to form. To stop the flow of gas, remove the flame under the flask and pour water into the beaker. Water will be drawn into the flask as the steam cools. This prevents fire in the flask when disassembling the apparatus.

Safety Factors

Phosphorus is very flammable. It must be cut under water and handled with forceps. Standard safety procedures apply.

Violent Flames

Just a few drops of liquid on a mound of powder and bam, a raging fire!

- **chemicals needed:** granulated sugar, powdered potassium chlorate, concentrated sulfuric acid
- **equipment needed:** mortar and pestle, asbestos mat, medicine dropper

How to Achieve the Effect

Once you have ground the chemicals to a powder separately in your mortar, place equal volumes of the mixed materials in a mound on an asbestos mat. Then, when a few drops of sulfuric acid fall on the mixture, a fire is produced instantly.

Safety factors

Fire extinguisher and standard safety procedures.

Blinding Flash

- **chemicals needed:** powdered aluminum, sodium peroxide
- **equipment needed:** asbestos mat

How to Achieve the Effect

Place a ½-inch cone of aluminum on an asbestos mat. Then, place a small amount of sodium peroxide on top.

Safety Factors

The heat generated will cause the powdered aluminum to burn with such an intense flame that the flash is blinding. It will continue to glow for a long time. Care should be taken to guard against burns. The reaction happens very quickly, with intense heat.

Brilliant Sparks

- **chemicals needed:** 2 grams potassium nitrate, powdered charcoal

• **equipment needed:** evaporating dish, mortar and pestle

How to Achieve the Effect

Heat the potassium nitrate until molten in the evaporating dish. Then drop in the powdered charcoal carefully.

Safety Factors

Watch out for scattered burned carbon. Grind ordinary charcoal in a mortar when preparing material. Standard safety procedures apply.

Sprinkles of Fire

• **chemicals needed:** 5 grams ferrous oxalate, paraffin
• **equipment needed:** test tube with fitted cork, tongs, evaporating dish

How to Achieve the Effect

Heat ferrous oxalate in the test tube until fumes stop. While test tube is heating up, melt the paraffin in an evaporating dish. Put the cork in the melted paraffin while the test tube is heating, pick up the work with tongs and seal the tube. When cool, the melted paraffin makes an airtight seal. Then, stand on a chair with sealed test tube and remove the cork. As you sprinkle the contents in the air, they catch fire. The result is spectacular.

Safety Factors

Standard safety procedures apply.

Miniature Volcano

Red-hot particles erupt in a miniature volcano when a conical pile of red powder is lit.

• **chemicals needed:** 100 grams powdered ammonium dichromate, alcohol
• **equipment needed:** asbestos mat, filter paper

How to Achieve the Effect

Make a conical pile on the asbestos mat of the powdered chemical. Then, soak a roll of filter paper 2 inches long in the alcohol. Put the roll in the center of the cone. When you light it, the wick burns and ignites the powder, which shoots sparks several feet in the air.

Safety Factors

Though this piece of chemical magic is not dangerous, standard safety procedures still apply.

Bubbles That Burn

• **chemicals needed:** gasoline, soapsuds, glycerine
• **equipment needed:** clay pipe, cotton, wire screen for mouth of pipe bowl, candle, matches

How to Achieve the Effect

Fill a clay pipe with cotton, keeping the latter in place by inserting a wire screen at the mouth of the bowl. Saturate the cotton with gasoline, then

dip the pipe in strong soapsuds that contain a little glycerine. Blow easily in the stem as you hold the bowl down, as if you were just blowing bubbles. Sail the bubble into the air and touch it off with a lighted candle or match; the bubble will explode and disappear in a brilliant flash.

Safety Factors
Standard safety precautions apply.

Exploding Bubbles

- **chemicals needed:** gasoline, glycerine
- **equipment needed:** cotton, clay pipe, matches

How to Achieve the Effect
Soak a small piece of absorbent cotton in gasoline and place it in the mouth of the pipe before blowing the bubbles. Proceed in the regular manner by dipping the pipe in soapsuds containing a little glycerine and blowing. When the bubble sails into the air, light it with a match and it will disappear with a report and flash.

Safety Factors
Standard safety precautions apply.

Spontaneous Combustion

- **chemicals needed:** perchlorate of potash, granulated sugar, sulfuric acid

How to Achieve the Effect
A mixture of perchlorate of potash and ordinary granulated sugar will take fire at once when touched with a drop of sulfuric acid.

Safety Factors
Fire extinguisher and standard safety precautions apply.

Silver Fire

- **chemicals needed:** silver nitrate, charcoal

How to Achieve the Effect
When you sprinkle a few grains of silver nitrate on a piece of glowing charcoal, beautiful stars will be thrown off and the surface of the charcoal will be coated with silver.

Safety Factors
Standard safety precautions apply.

Blue Stars

- **chemicals needed:** potassium chlorate, copper sulphide, copper oxide, sulphur, mercurous chloride, charcoal

How to Achieve the Effect

Mix together these chemicals in powder form in the following amounts for the best results: potassium chlorate, 8 parts; copper sulphide, 2 parts; copper oxide, 1 part; sulphur, 4 parts; mercurous chloride, 2 parts; and charcoal, 1 part.

Safety Factors

Standard safety precautions apply.

Red Fire

- **chemicals needed:** strontium nitrate, potassium chlorate, mercurous chloride, sulphur, powdered shellac, charcoal

How to Achieve the Effect

Mix together the following chemicals: strontium nitrate, 4 parts; potassium chlorate, 12 parts; mercurous chloride, 4 parts; sulphur, 3 parts; powdered shellac, 1 part; and charcoal, 1 part.

Safety Factors

Standard safety precautions apply.

Green Fire

- **chemicals needed:** barium salt, potassium chlorate, sulphur, powdered shellac, mercurous chloride, charcoal

How to Achieve the Effect

If the barium salt used in the following experiment is pure and the ingredients well mixed, the resulting color will be a beautiful emerald green. Mix barium nitrate, 12 parts; potassium chlorate, 6 parts; sulphur, 3 parts; powdered shellac, 1 part; mercurous chloride, 2 parts; and charcoal, 1 part.

Safety Factors

Standard safety precautions apply.

Yellow Fire

- **chemicals needed:** potassium chlorate, sodium oxalate, sulphur, powdered shellac

How to Achieve the Effect

No list of colored fires is complete without this magical color flame. Yellow fire can be produced by mixing the following: potassium chlorate, 6 parts; sodium oxalate, 2 parts; sulphur, 2 parts; and powdered shellac, 1 part. When lit this fire burns with a beautiful yellow flame.

Safety Factors

Fire extinguisher and standard safety procedures apply.

Purple Vapor

- **chemicals needed:** iodine flakes or iodine powder
- **equipment needed:** hot glass flask or jar

How to Achieve the Effect

If a few flakes of iodine are dropped into a hot glass flask or jar, the container instantly becomes filled with a magnificent purple vapor.

Safety Factors

Standard safety precautions apply.

Chinese Fire Eating

No work on chemical magic would be complete without some reference to the age-old trick that startled our ancestors and set their minds guessing as to how it was done, namely fire eating.

Caution: The following trick is dangerous, therefore take care in preparing, selecting the necessary chemicals and equipment, and in general carrying out the experiments. Amateurs or inexperienced performers should not attempt it.

- **chemicals needed:** potassium nitrate, tow (small ball of string, similar to clothesline)
- **equipment needed:** soft cord, scissors or knife, matches

How to Achieve the Effect

Take a length of soft cord about as thick as an ordinary clothesline and soak it for 10 or 12 hours in a very strong (3 to 1) solution of potassium nitrate. Remove the cord from the solution, dry thoroughly, and then cut into 1-inch lengths. Light one of the pieces and place it in a ball of tow, taking care that the tow covers the smoking cord. This can safely be placed in your mouth, and clouds of smoke and even sparks may come out. Once the cord within the tow is in your mouth it is only necessary to blow to do this. If the heat becomes uncomfortable, simply close your mouth and breathe through your nose. Never inhale the breath through the mouth in any fire eating experiment or you will swallow smoke and have a fit of coughing that will spoil the experiment.

Safety Factors

Extreme caution is recommended as well as standard safety precautions.

Fireproofing

- **chemicals needed:** alum
- **equipment needed:** cloth (any kind), match

How to Achieve the Effect

Materials soaked in alum will not burn, consequently a very effective trick can be performed by soaking a handkerchief in hypo and, after drying it thoroughly, holding it in a flame. It will not burn.

Safety Factors

Standard safety precautions apply.

Demon Fire (Fire Breath)

- **chemicals needed:** white phosporous, bisulphide of carbon
- **equipment needed:** wide-mouthed bottle with stopper, small piece of paper

How to Achieve the Effect

Dissolve 1 part white phosporous in 6 parts of bisulphide of carbon, and keep in a tightly covered wide-mouthed bottle. Always keep the bottle well stoppered, as the carbon disulfide evaporates very easily. To perform the trick, gently dip a small piece of paper in the mixture, take out, and replace the stopper. Hold the paper away from your face and blow on it. When the carbon has evaporated, the paper will burn.

Safety Factors

Standard safety precautions apply.

The Mystery of Malabar

- **chemicals needed:** sodium salicylate, ferric ammonium sulphate
- **equipment needed:** piece of muslin, 12-inch-square wooden frame, clear glass pitcher

How to Achieve the Effect

Prepare a piece of muslin by soaking it in a solution of sodium salicylate. Remove from the solution, and when thoroughly dry stretch it over the wooden frame. Then prepare a solution of ferric ammonium sulphate and put it in the clear glass pitcher. After you have moistened the muslin on the frame, you are ready for the trick. Before doing it, address the spectators with the following patter: "You all have heard of the fakirs of India, who can perform wonderful feats of magic; some of them can walk on hot coals with their bare feet, others can make blood appear on certain parts of their body. I am going to reproduce for you a feat that was recently shown in the Malabar district. Here I have a piece of wet cloth stretched over a wooden frame." (Exhibit the frame, front and rear.) "Here I have a pitcher of clear water." (Dip your hand into the water and let the water drip back into the pitcher. Repeat this procedure several times, so as to get your hand thoroughly wet.) Then continue: "I am going to place my hand on the wet muslin." Place your hand on the wet muslin and keep it there a few seconds; when raised an impression of the hand in red will be left on the cloth. Wind up by saying, "Lo and behold! I have produced for you the hand of blood as performed by the fakirs of India."

Safety Factors

Standard safety precautions apply.

The Magic Wound

- **chemicals needed:** iron chloride, sodium sulphocyanate
- **equipment needed:** small rubber dagger (can be purchased at toy store)

How to Achieve the Effect

Apply a solution of iron chloride to the back of your hand. Dip the dagger in a solution of sodium sulphocyanate, and pass is over the surface to

which the iron chloride has been applied. It will seem as if you were cutting yourself; a crimson streak will appear in the path of the dagger. This is a very effective trick. The effect can be heightened with an appropriate story told as the trick is in progress.

Safety Factors
Standard safety precautions apply.

Anarchist Bombs

- **chemicals needed:** ammonium sulphide
- **equipment needed:** glass tube, Bunsen burner

How to Achieve the Effect
Anarchist, or stink bombs are familiar to nearly every child. Form a glass bulb by inserting the end of a glass tube in a Bunsen burner, rotating it until the end closes, and then keeping it in the flame, constantly turning until the end thickens; a bulb is then formed by quickly, but not forcefully, blowing into the open end. Draw out the stem so that the end contains a hole about the size of a pencil point. Allow to cool and fill with a solution of ammonium sulphide, leaving an air bubble at the tip. Do not fill too full. Seal the tip in the Bunsen burner. The "bomb" is then ready for action.

Safety Factors
Standard safety precautions apply.

Telltale Cigarette

- **chemicals needed:** sulfuric acid
- **equipment needed:** cigarettes, gold-ink pen

How to Achieve the Effect
Using the gold-ink pen, write a funny saying on each cigarette with sulfuric acid in water. Allow them to dry thoroughly. Give one to a friend; when she lights it and starts smoking, the letters will appear black, one by one, as the heat reaches them while the cigarette is being consumed.

Safety Factors
Standard safety precautions apply.

Permanent Bubbles

- **chemicals needed:** resin
- **equipment needed:** metal tube, scissors or knife

How to Achieve the Effect
Melt a quantity of resin over a low temperature flame. Dip a metal tube in it; blow quickly, and a bubble will form. Cut off the bubble before it hardens. Close the opening with resin. These bubbles are very brittle when dry and should be handled carefully.

Safety Factors

Standard safety precautions apply.

Rainbow Bubbles

- **chemicals needed:** Castile soap, glycerine
- **equipment needed:** bubble pipe, container for bubble solution

How to Achieve the Effect

When making a solution to blow bubbles, use a good grade of Castile soap; add a few drops of glycerine to the mixture when completed. Blow bubbles with this mixture. They will appear in all the colors of the rainbow.

Safety Factors

Standard safety precautions apply.

Bouncing Bubbles

- **chemicals needed:** Castile soap, glycerine
- **equipment needed:** bubble pipe, container for bubble solution

How to Achieve the Effect

Make a strong solution of Castile soap and add about a teaspoon of glycerine to a pint of the solution. Blow bubbles with this solution and you will be able to bounce them on a stiff felt hat or on a piece of felt over your head.

Safety Factors

Standard safety precautions apply.

Rubber Bones

- **chemicals needed:** vinegar
- **equipment needed:** chicken bones

How to Achieve the Effect

Clean several small chicken bones thoroughly, and place them in vinegar for about 24 hours. They will become quite elastic, similar to rubber.

Safety Factors

Don't ingest chicken bones.

The Dry Hand

- **chemicals needed:** lycopodium powder
- **equipment needed:** clear glass dish, ring or key

How to Achieve the Effect

This is a very old trick, used many years ago by the old-time magicians. Place any bright object, such as a ring or key, in a clear glass dish filled

with water. Then rub lycopodium powder thoroughly all over your hand and arm. The powder cannot be seen. Plunge your hand into the bowl of water and take the object from the bottom. When your hand is removed from the water, it will be quite dry.

Safety Factors
Standard safety precautions apply.

Liquid to Solid

- **chemicals needed:** Glauber's salts (sulphate of soda), sweet oil (available at drug stores, similar to eardrop oil)

How to Achieve the Effect
Dissolve about half a pound of Glauber's salts in a pint of boiling water; allow it to stand for a minute, so that any impurities may settle, then pour off the clear liquor while still boiling hot into a clear glass vessel or jar. Now put a few drops of sweet oil on the surface of the solution, and place it where it can cool and remain undisturbed. When cold it will appear like water, but if a stick or any solid substance is put into it, so as to form a nucleus, it will immediately become opaque and change into a solid mass of crystals. The oil is used to prevent dust from settling on the surface, which would cause it to crystallize without apparent reason.

Safety Factors
Standard safety precautions apply.

Smoke Mystery 1

- **chemicals needed:** muriatic acid, ammonia water
- **equipment needed:** two water glasses, piece of cloth or handkerchief, piece of newspaper, matches, fan

How to Achieve the Effect
Two ordinary water glasses are shown to the spectators as empty. Place the glasses mouth to mouth and cover them with a piece of cloth or handkerchief. Light a piece of newspaper, or anything that will make a lot of smoke, stand a few feet away from the covered glasses, and with a fan waft the smoke toward them. After a minute or so, remove the cloth from the glasses, where they will be seen to be full of smoke; when taken apart, a great volume of smoke will rise. In one of the glasses place a few drops of muriatic acid and in the other a few drops of strong ammonia water. Do not bring them together until you wish to produce the smoke effect.

Safety Factors
Standard safety precautions apply

Smoke Mystery 2

- **chemicals needed:** muriatic acid, liquid ammonia
- **equipment needed:** see Smoke Mystery 1

How to Achieve the Effect

Take two ordinary clean water glasses or, if possible, glass bowls. Put a few drops of muriatic acid into one of them, and rotate the glass so the liquid covers the bottom. Put a few drops of very strong liquid ammonia into the other glass and rotate so that the liquid covers the bottom. Keep the glasses far apart until you are ready to perform the trick. Then, place them mouth to mouth and cover from the front. They will begin to smoke immediately. Burning the paper is only to add to the mystery and heighten the illusion of the smoke penetrating into the glasses. Be sure to show the glasses one at a time, but do not let them come together until quite ready for the presentation of the trick.

Safety Factors

Standard safety precautions apply.

Luminous Paint

How to Achieve the Effect

Since only a small amount of the material is required at any time, buy it from a theatrical supply house. Supply houses manufacture the dry ingredients in different colors and will give you directions for mixing them. This is put up in many colors and information is given as to the best and most economical way of using it. It comes ready mixed and is easily applied. When these paints are brushed or sprayed on any article, object, or material, it should be exposed to sunlight or a strong electric lamp after which it will glow for some time in the dark.

Safety Factors

Standard safety precautions apply.

A Man Who Walks Away from His Shadow: An Illusion

- **chemicals needed:** luminous green paint
- **equipment needed:** a screen that looks like a white window shade, strip of gelatin on a wheel painted red, green, and blue, a light, one assistant

How to Achieve the Illusion

This illusion is one of the best ones based on chemical preparation. A screen that looks like an ordinary white window shade is shown. Stand behind the screen while the stage or room lights are shut off; a strong light to your rear causes your shadow to appear on the screen; while you move freely about, the shadow moves accordingly. No matter what position you take, the shadow still appears on the screen; if you walk away from the screen, the shadow remains fixed, visible to the audience. When the stage lights are turned on, the shadow vanishes. This can be repeated several times, with you assuming a different position each time. The explanation is this: The screen is coated or sprayed on the side away from the spectators with luminous green paint. The light used has a color attachment consisting of a film or strip of gelatin, preferably on a wheel, painted red, green, and blue; it can be purchased from any theatrical or lighting supply house. The screen and light are placed down stage. You the performer should be behind the screen. Your assistant turns the wheel, so as

to bring, first, the red portion of the gelatin strip before the light, which will make the latter show red. You can move freely about, as the red light does not affect the luminous material on the screen. Next have your assistant turn the wheel for the green color, and assume the position the shadow of which you wish to appear on the screen. Then have the wheel turned so that the light will show blue and, after you have kept your position in the blue light for a few seconds, walk away from your shadow, coming in front of the screen. The best method of carrying out the trick is to first station your assistant at the light; then tell the assemblage that you have the power to separate yourself from your shadow. Simply step behind the screen, between the light and the screen, and call out, "Red!" The assistant immediately turns the wheel to bring the red part of the gelatin strip before the light. After a few seconds, call out, "Green!" The assistant then turns on the green light. Stand a few seconds in the position you wish to cast on the screen, the green light having little effect on the luminous material. Still holding the same position call out, "Blue!" The assistant immediately turns the wheel to bring the blue portion of the strip on the light. Lastly, call out, "Green!" This time the assistant turns the wheel to bring before the light a part of the gelatin strip that has been rendered opaque; this shuts off the light. Then walk away from the screen. The onlookers will get the impression that there is a green light on, because the screen itself was sprayed luminous green before the exhibition. A good piece to recite when performing this illusion before children is Robert Louis Stevenson's poem "My Shadow," beginning "I have a little shadow that goes in and out with me. What can be the use of him is more than I can see."

Safety Factors
None.

Mud

I've been asked many times to make a mud pit or pile for an actor to fall into, such as in the film *The Return of the Living Dead.* In this film we had about 160 scenes of rain and mud. I had to create everything from little drizzly rains to torrential rain and mud. I also had to make rain that smoked and fried when it hit the ground.

In making mud, you can't just take ordinary earth and add water. It's not sanitary. It may have animal droppings or chemicals in it, impurities that could cause all sorts of problems for the actors.

I was working on a show down in Mexico, for instance, where an actor jumped into a pond for a shot and a day later had a rash that prevented him from working for a week. You have to make sure everything is sanitary and disease free. So when we make mud in this business, we use a chemical called methocellulose, which is a food stiffening device, and fuller's earth, which is pure ground clay that comes in different colors and grades. Sometimes we put peat moss on the surface. All these materials are very pure and clean.

- **materials needed:** fuller's earth, vermiculite, methocellulose, peat moss, sand
- **equipment needed:** large steel drums

How to Achieve the Effect

The methocellulose has to be cooked. On the set of *The Return of the Living Dead* we made about 100 gallons of this mud and poured it over the actors just before they went onto the set, and then they crawled up through the graves along the slimy rain-soaked roads. You have to cook it first until it's a very thick and slimy substance. It's clear when you're cooking it. Add the powder very, very slowly to the water as you're cooking it, stirring continuously. Naturally when we're making 55-gallon drums of it, we use big steel steam jennies to heat the water. Slowly add the material and keep spinning, until the consistency is nice and smooth, but thick enough to pick up by hand. It should slowly drip down like a heavy gummy substance. After it is cooked, while still warm, add fuller's earth to get the color and consistency of mud. If you want a light slimy mud you add more or less to it. Add vermiculite to lend it some substance, which gives you little lumps and chunks resembling the consistency of mud. Last, add the peat moss, which provides bigger lumps and stringy substances. Mix it very well and then seal it. Material is safe from bacteria and biodegradable for 10 days of storage. After that it decays and starts to smell because of the food stiffener.

Safety Factors

Stage mud is actually safe enough to eat. I knew the actors were leery about going into the mud at first because it looked so slimy and dirty, which it was supposed to be, so to prove to them that it was safe I just took a handful and ate it.

Quicksand

- **chemicals needed:** fuller's earth, vermiculite, peat moss

How to Achieve the Effect

The hole the actor is going to fall into should be about waist deep and big enough so that he can slowly allow himself, under his own power, to slowly sink under the mud until his head is completely under. How well the effect looks depends on the actor and how brave he is. Simply mix water, fuller's earth, vermiculite, and peat moss. On the surface put a lot of heavy vermiculite so that it looks solid and add enough peat moss so it resembles ordinary ground. When the actor steps on it, he will go down. The consistency has to be thick to look good, so be sure to add enough fuller's earth and mix well. You can get a good effect this way.

Safety Factors

Remember once again, the most important thing is the safety of the actor. If the actor goes down below the surface and you need bubbles to appear on the surface, use an air line. Simply take a ¼-inch rubber air line, attach a lead weight to it, and put it at the bottom of the pit. The special effects person turns on the air, adjusts it to what the director wants, and then on cue uses a button on the air to release only the desired amount of bubbles.

Wire Flying and Levitation

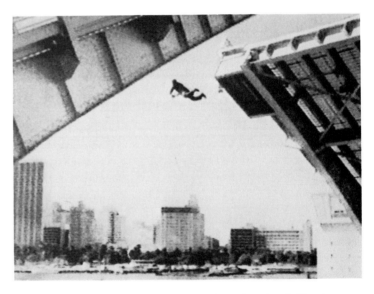

Figure 7-1a A scene from the opera *Hansel and Gretel* at Wolftrap, Virginia, using the Peter Pan flying rig

Wire flying is my favorite effect and one I've specialized in most of my life. It is one of the oldest forms of mechanical illusions, dating back to the ancient Greek theatre when mythic gods descended to the stage to decide the final outcome of the drama on clouds, wooden horses, and elaborate chariots operated by cranes in a theatrical convention called *deus ex machina*, or "a god from a machine." The goal then, as now, was to create the illusion of flying, and it has not changed in some two thousand years, though obviously the effect is more sophisticated today.

Audiences have seen it a thousand times in every form of the entertainment media, but they continue to be enthralled by Peter Pan floating gracefully across the stage, Superman winging his way into outer space, a live elephant floating in midair, or even a simple coffee cup hovering, swooping, or careening through an otherwise normal kitchen.

Figure 7-1b Stunt professional flying through a drawbridge in Miami. A 250-foot mechanical crane was used for this effect.

The Wire

Wire flying is based totally on the concept of suspension. Simply put, the object to be flown must be attached to the mechanism moving it. This is accomplished by the use of wire.

I use the term *wire* in a highly specific and narrow context. I am definitely not referring to piano wire, though it has been used by F/X people since the silent screen era and continues to be used in Hollywood to this day. Piano wire is the single greatest cause of injury to flyers. The number

Figure 7-1c Setup for flying bikes in E.T. commercial

of accidents directly related to a wire that has snapped in mid stunt is appalling. I would never risk a person's safety by using a material that I consider dangerous in any way.

In my experience, airplane cable is the only material that should *ever* be used on a flying rig. It is a multistrand wire designed for optimum strength and durability. The various alloys and specifications (tensile strengths, etc.) used in its manufacture are detailed in Tables 7–3 through 7–10 at the end of this chapter.

To increase the safety factor (which cannot be overemphasized), I strongly recommend a two-wire system at all times. This system must, of course, be sized based on the requirements of the gag to the weight of the flyer. Each gag, of course, requires a harness determined by the action required of the actor. It is important to note that there are no hard and fast rules (other than safety) that apply, except two:

1. The harness must be properly and comfortably fitted to the performer and designed to provide maximum support while executing the gag.
2. The hardware mounted on the harness mounting points must be positioned at the perfect balance point (based on the weight, height, and physical axis, or pivot point) of the performer and that the hardware is of the type designed for the maneuvers.

Shock Cord

Shock cord is a rubberized cord that comes in different sizes from $1/8$ to 2 inches thick. It stretches like a rubber band and gives the actor a floating motion.

Shock cord is not intended as a substitute for cable. Its purpose is to provide a floating or springing effect. The rigging of shock cord is used with cable and a spreader bar.

Invisible Cable

A flight gag is totally ineffective if the audience is aware of the cable. Various means have to be devised to make it invisible.

Blue Screen Process This is basically a traveling matte preparation where the foreground action is photographed against an evenly lit blue background using color negative film. The background light exposes through a specific narrow spectrum (cobalt blue) eliminating it from the film's blue spectrum while the foreground photographs normally. In printing from the negative through color filters and combining the images in silhouette (through a duplicate negative), mattes, or masks, are prepared. In post-production the foreground action is overlaid on any desired background. In this particular process, blue is "lost" as are the blue-painted cables. If a particular blue spectral band is necessary in the scene, "green" can be substituted. In television, this is achieved electronically rather than chemically.

To use the blue screen process to hide the cable, take the blue paint (cobalt blue) and paint the cable and hardware. Allow them to dry and the cables become invisible. This way you can use a much stronger, heavier cable and it won't show. You fly the person in all directions, under the supervision of your director, and the technicians take that particular segment of film and matte any background they want—sky, mountains, water, and so on. So it looks like the actor is flying through all sorts of dangerous situations. It's one of the oldest tricks in the book. In film this is called blue screen process; in videotape it's called *chroma key*.

Figure 7-2 Leonard Nimoy suspended over escalator. Cables are hidden by background.

Chemicals Spray paints, anodized plating, hair spray, Nestle's "Streak 'n Tips" (used for hair streaking), magic markers, shoe polish, black oxide, copper sulphate with vinegar, and gun bluers are all effective in eliminating reflections and light bounce on flying cables.

Background Set backgrounds are invaluable for masking the cables if the actor is in motion. When stationary, however, the cables are readily discernible. Backgrounds that are dark or have trees or vertical lines make effective masking as does lighting, provided it is flat lighting, thus reducing depth perception (Figure 7-2). Never backlight cable. Try to "flag," that is, mask off the lights so they do not directly illuminate the cables. This is done to prevent highlighting or flare from being picked up by the camera lens. Areas to avoid are shots against the sky and wires crossing in front of the actor's body or costume.

Harnesses

There are possibly as many types of harnesses as there are special effects people, but all have three things in common:

1. The harness must safely secure the performer to the flying apparatus.
2. It must fit the job requirements. The design for a ballerina is much different in size, weight, and overall appearance than for a fully costumed Santa Claus.
3. The comfort of the rig for the actor is essential, particularly if the harness must be worn for a considerable time. In such instances, customized fitting, although costly, is preferable to a standard harness.

The materials used in the manufacture of a harness vary from belt webbing to leather, which is my personal preference. Leather is strong, durable, stands up to abuse, and when padded with sheep's wool, is quite comfortable. Webbing, however, is a virtual necessity for formfitting costumes. Figures 7-3 through 7-17 show fifteen basic harness designs. A sixteenth harness not illustrated is the lap belt, similar to seat belts found in older cars.

Figure 7-3 Webbing harness: front view (left), side view (right). Used for flying dancers so harness doesn't show under leotards.

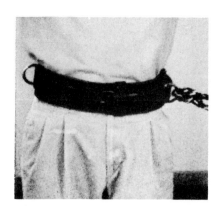

Figure 7-4 Belt harness fits around the waist so actor is suspended from that point. Used mostly as a safety belt in dangerous situations but is hidden beneath the costume.

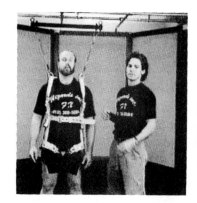

Figure 7-5 Safety belt harness, a two-piece top and bottom, belt primarily used as a safety precaution with high rigging.

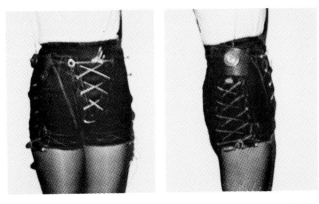

Figure 7–6 Jeans harness: front view (left), side view (right). Made of ordinary jeans fitted two sizes too large, padded and equipped with hardware that bears the weight.

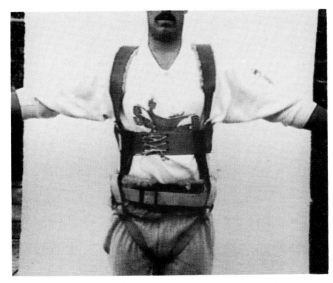

Figure 7–7 Two piece top and bottom harness. A full body rig that is most adaptable and necessary when a variety of flying angles are required.

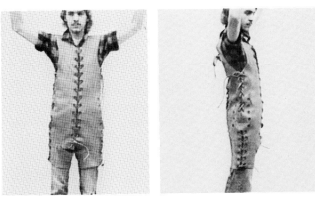

Figure 7–8 One-piece custom body suit: front view (left), side view (right). Cable connectors of all kinds can be placed where needed.

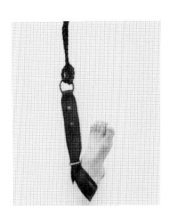

Figure 7–9 Ankle harness

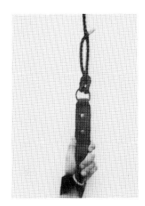

Figure 7–10 Wrist harness

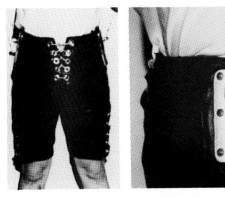

Figure 7–11 Adjustable spinning harness: front view (left), side view (right). A torso rig that enables the actor to be spun vertically.

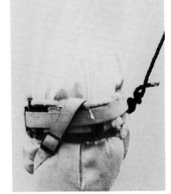

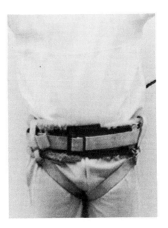

Figure 7–12 Training harness: front view (left), side view (right). Used almost exclusively as a safety/training rig.

Figure 7–13a Actor on hanging rig. Seen in practically every western, a two-piece rig designed to keep the actor's body straight when hanging, preventing injury to neck and back.

A. 1/8-inch main lifting cable
B. Sliding hangman's noose
C. Cable guide
D. Hanging harness
E. 1/8-inch cable through center of rope
F. Cable guide
G. O ring
H. Buckles
I. Two 1/8-inch cable attached to harness D ring and main lifting cables O ring
J. D ring
K. Leg straps

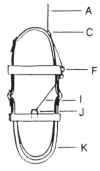

Figure 13b Schematic of hangman's rig

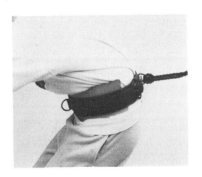

Figure 7–14 Pull-and-jerk harness. Like a belt harness in design but heavily padded and considerably wider, extends from just under the ribs down to lower belly. When an actor is hurled back by the impact of a shotgun blast, this harness is used.

Figure 7–15 Five-point safety harness. Used solely for protection in gags of rolling cars, crashes, and similar situations to prevent serious injury.

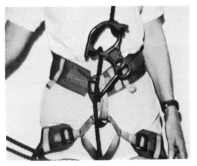

Figure 7–16 Rappeling harness: front view (left), side view (right). Used in stunts and by F/X people to quickly descend a mountain face or to reach areas otherwise inaccessible.

a

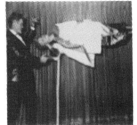

b

c

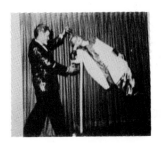

d

Figure 7–17a–d Mechanical harness (attached to mechanical device as opposed to wire) used in magician's levitation stunts: first position (a) and demonstrated by magician and assistant (b). Second position (c) and demonstrated by magician and assistant (d).

Figure 7–18 Cable loop with Nicos

Figure 7–19 Snap shackle: open (left), closed (right) used for quick release of cable

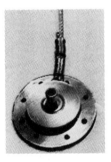
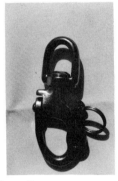

**Figure 7–20
Nonadjustable bearing
spinner**

**Figure 7–21
Adjustable spinner**

**Figure 7–22
Gimballed swivel
spinner**

**Figure 7–23
Adjustable gimballed
spinner**

Cable Connections

Both ends of the aircraft cable must, of course, be connected: one end to the harness and the other to the machinery flying the person.

Harness Preparation

Built into the harness are relatively simple attachments or hooks to which the cable can be linked. These hooks are usually secured by steel plate, copper rivets, bolts, webbing, and a heavy leather backing. The specific method used to secure the hardware is determined by weight, design, and safety requirements of the harness.

Cable Preparation

Before the cable can be attached to the harness hooks, considerable preparation must be done on the cable end itself. The cable is formed into a loop. This loop is then secured with two Nicos, oval pieces of metal that are tightly compressed or crimped with a Nico press. The loop is thus prevented from separating (Figure 7–18). The attachment of the harness to the Nico'd loop is made (essentially) with seven pieces of hardware.

1. *Shackle:* This is a U bolt/threaded pin-type unit. The shackle is fitted to both the cable loop and harness, then the pin is slipped through the holes at the end of the U and securely tightened.
2. *Nonadjustable bearing Gimballed spinner:* This has the appearance of a shackle mounted on an axle to allow it to swivel 360 degrees. The cable is mounted directly to the spinner (Figure 7–20).
3. *Adjustable spinner:* The same as the nonadjustable gimballed spinner except it is mounted on a shaft that is adjustable on a metal plate mounted to the side of the harness (Figure 7–21).
4. *Gimballed swivel spinner:* See Figure 7–22.
5. *Adjustable Gimballed spinner:* Its purpose is virtually identical to the nonadjustable gimballed spinner in that they both provide 360-degree mobility but here the cable is Nico-pressed to the swivel rather than the spinner. The choice of either of these devices is at the F/X person's discretion (Figure 7–23).
6. *Pop-in swivel:* This is used when quick release or attachment to the harness is required (Figure 7–24).
7. *Back plates:* These are used to pick up the flying actor from the back only (Figure 7–25).

Figure 7–24 Pop-in swivel

Figure 7–25 Back plates

Figure 7–26a–d Spreader bars

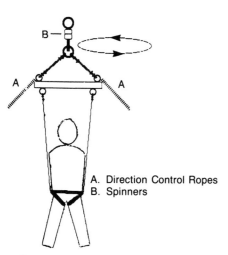

a Straight spreader

A. Direction Control Ropes
B. Spinners

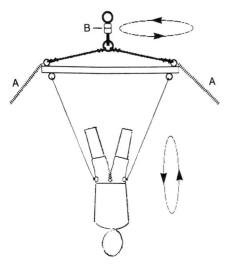

b Spinning spreader bar

Spreader Bars

A spreader bar is a square section of heavy steel tubing with welded eyebolts attached to it. The cables leading from the flying harness are then attached to these eyebolts using the Nico-press system or, if the Nicos are unavailable, cable clamps.

The spreader bar serves three functions:

1. It keeps the several cables attached to the actor's harness from becoming entangled (or entangling the actor) as he or she executes the required movements.
2. It provides a balance point for the actor. In order to fly properly, the actor's body must be stabilized, much like neutral buoyancy. Without these balance points he or she would be out of control and unable to perform the directed action.
3. It controls the vertical, horizontal, and spinning movements of the performer.

Balance points are maintained by two cables attached to either side of the performer at anywhere from belt level to approximately 7 inches down the hip. Once these points are established on the individual, the pins can be adjusted on the harness for the greatest balance. The spreader bar is then attached to a spinner, the main flying cable, or directly to the flight mechanism itself.

It is imperative that the closest attention be paid to all phases of planning, rigging, and safety when using these devices, as the actors have virtually no control over their maneuvers. The responsibility lies in the hands of the offstage F/X people who manipulate the spreader bar by rope.

If you have two people on one spreader bar, they must either be the same weight or weights must be added to balance their weights. How many individuals that can be flown on one spreader bar is determined by the size and strength of the bar itself and of the flying crane. I've flown as many as six people at one time from a single bar on a 40-foot flying crane, although this is not common. A ½-inch rope is attached to the I bolts at either end of the spreader bar in order to maintain direction and control of the person flying (Figure 7–26a–d).

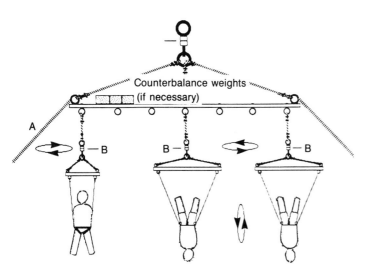

Counterbalance weights
(if necessary)

c Two-or three-person spreader bar

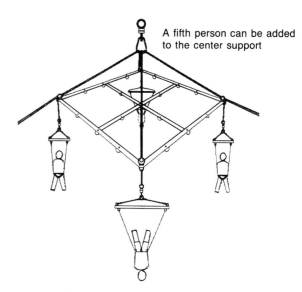

A fifth person can be added to the center support

d Four- or five-person spreader bar

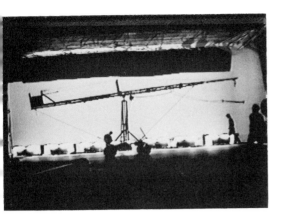

Figure 7–27 35-foot crane used in flying

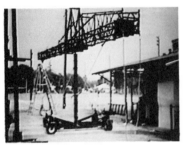

Figure 7–28a 40-foot crane flies four people at one time

Figure 7–28b Pivoting mechanism for 65-foot crane

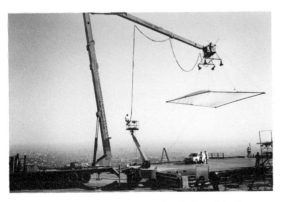

Figure 7–28e 150-foot crane for flying objects or people

Flying Rigs

There are several basic systems used to create flying effects plus innumerable variations on these designs. For the most part, special effects people are limited only by the requirements of the job and their own imaginations.

Be that as it may, flying rigs are controlled either by cranes or overhead track systems, except in the case of the pendulum or Peter Pan rig (see page 65 for discussion). One type is suspended and works off an I beam. The other, regardless of what it hangs from, works from a traveler track. More important than how the flying rigs are hung are the rig's different directional capabilities, different methods of operation, different methods of lifting (using sand bags, steel, or lead weights), and the different techniques of setting up the rig itself (using sheaves, hemp rope, pulleys, etc.).

Overhead track systems, whether I-beam mounted or on traveler tracks, have similar design characteristics in that they:

1. both use similar rigging on main support beams
2. both are counterweighted by steel, lead, or sand bag weights
3. both have traveler stops
4. both use essentially the same hardware
5. both have adjustable floor sheaves and braking systems
6. both use some form of traveling carriage
7. both use wheels to move the carriage or to move the rig along the lower inner lip of the I beam
8. both use a pipe as a connector between the main supporting member and the flying rig

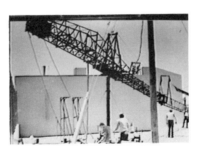

Figure 7–28c 65-foot flying crane with 1000-pound capacity

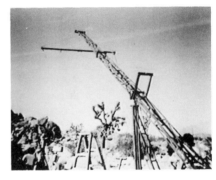

Figure 7–28d 35-foot crane rigged with rain bar

Flying Cranes

Cranes are large, heavy, metal support systems consisting of a moveable arm extension, or boom, to which a spreader bar is mounted. The boom is fixed on a vertical pivoting axis and mounted on a wheeled base for mobility (Figure 7–27). The boom can be raised or lowered, spun 360 degrees on its axis, and rolled free wheel or on tracks across sound stages, around corners, and through streets. All these maneuvers can be performed individually, sequentially, or simultaneously.

Boom lengths vary from 35 to 250 feet or more as the shot (camera angles, flying height, etc.) requires. In my experience, I've found 35- and 65-foot booms to be fully versatile allowing me to execute complex flight with two actors on the 35 footer, and with as many as six on the 65 footer. Although these machines are quite mobile, their size and weight require crews of three or more (Figure 7–28 a–e).

END VIEW

A. Pipe
B. Welded connectors
C. Track
D. Wheel
E. Axle

F. Bolts
G. Traveler rod
H. D ring
I. Shackle
J. Nico-pressed cable

Figure 7–29 Heavy duty curtain traveler track

END VIEW

A. Pipe
B. Welded connectors
C. I beam
D. Wheel (rubber)
E. Axle
F. Bearing
G. Wheel supports

H. Tie-in support bar
I. Tie-in support bar
J. Main support bar
K. D ring
L. Nico-pressed cable
M. D ring
N. D ring

Figure 7–30 I-beam extra heavy-duty traveler track

Cranes fall into categories defined by their methods of operation. For simplicity, I've titled them counterbalance and mechanical.

The *counterbalance crane* is used for silent operation (as on a sound stage). The crane is operated manually. Smooth, fluid, and precise control of the boom is achieved by metal weights (lead or steel) mounted on the boom behind the pivot axis. These weights equal the combined weight of the boom and the flying load suspended from the end of the boom. This method of counterbalancing provides a load-lifting ratio of 2 to 1; for example: 100 pounds to be lifted requires 200 pounds on counterweight to equal a balance.

The *mechanical crane* is identical in most aspects to the counterbalance crane except that winches, drawn by electric, gas, diesel, hydraulics, pneumatic, or hand power, control its movement. Its noisy operation makes it unsuitable where sound is a consideration.

Two Types of Flying Track

In the simplest terms, a flying track is an overhead, mounted I-beam that guides the movement of a flying rig from one point to another.

The Heavy-Duty Curtain Traveler Track This is illustrated in Figure 7–29. It is used only for flying one person at a time. It is used mainly in theatre.

The I-Beam Extra Heavy Duty Flying Track This is illustrated in Figure 7–30 and is used for both people and heavy objects. Its primary use is in film and television.

The two- and four-directional stationary flying traveler track can be rigged identically and made as long as needed. All the figures shown in this section are rigged with the I-beam track.

Overhead Directional Flying Track Systems

There are two standard variations on one design, each having a specialized function. They are similar in that the units are maneuvered by hand-pulled ropes or cables, assisted by a series of block counterbalance weights. The system is attached to I beams or traveler tracks.

The major difference in the two designs is in the rigging of the track. The tracks can be raised or lowered, remain stationary, or be rigged directly to an overhead grid. From there, the carriage, which does the traveling, is attached to the track.

Two-Directional Stationary Track This is exclusively a two-rope, two-movement system. By pulling the onstage rope, the actor moves on stage; by pulling the offstage rope, the actor does the reverse (Figure 7–31).

Four-Directional Stationary Track This is a system that uses a carriage that moves the actor. It has a four-way capability: on- and offstage and higher or lower. What differentiates the stationary track is that the carriage moves while the track remains fixed (Figure 7–32). It is used mainly in theatre, TV studios, and film studios.

Drawings not to scale

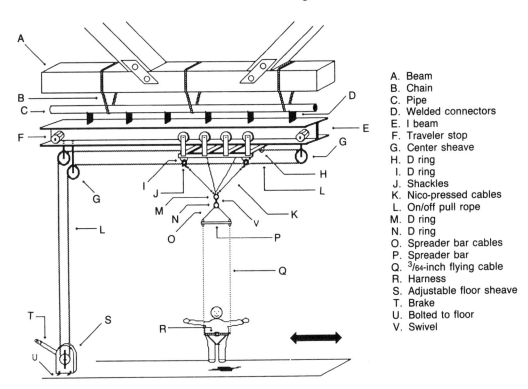

Figure 7–31 Two-directional stationary flying traveler track

A. Beam
B. Chain
C. Pipe
D. Welded connectors
E. I beam
F. Traveler stop
G. Center sheave
H. D ring
I. D ring
J. Shackles
K. Nico-pressed cables
L. On/off pull rope
M. D ring
N. D ring
O. Spreader bar cables
P. Spreader bar
Q. $3/64$-inch flying cable
R. Harness
S. Adjustable floor sheave
T. Brake
U. Bolted to floor
V. Swivel

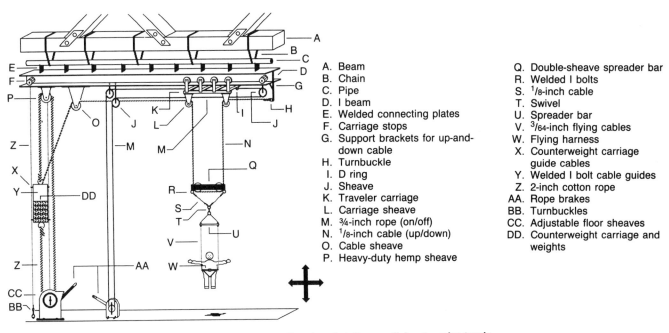

Figure 7–32 Four-directional stationary flying traveler track

A. Beam
B. Chain
C. Pipe
D. I beam
E. Welded connecting plates
F. Carriage stops
G. Support brackets for up-and-down cable
H. Turnbuckle
I. D ring
J. Sheave
K. Traveler carriage
L. Carriage sheave
M. ¾-inch rope (on/off)
N. ⅛-inch cable (up/down)
O. Cable sheave
P. Heavy-duty hemp sheave
Q. Double-sheave spreader bar
R. Welded I bolts
S. ⅛-inch cable
T. Swivel
U. Spreader bar
V. $3/64$-inch flying cables
W. Flying harness
X. Counterweight carriage guide cables
Y. Welded I bolt cable guides
Z. 2-inch cotton rope
AA. Rope brakes
BB. Turnbuckles
CC. Adjustable floor sheaves
DD. Counterweight carriage and weights

63

Four-Directional Flying Traveler Track This again uses a carriage. Two sets of two ropes each are employed in this rig. In this instance, the track moves up and down while the carriage moves right or left (Figure 7–33). This is used mainly in the theatre.

Four-Way Flying Traveler Cable Rig This is used primarily outdoors for flying extended lengths. This rig can be stretched between two mountains for 1000 feet or more as long as both ends are in solid anchors. The on-off-up-down capabilities are inherent in the rig. It is similar to a track system but without the track, and necessitates a cable carriage (Figure 7–34). It is used in film, outdoors, and at rock and roll concerts.

Drawings not to scale

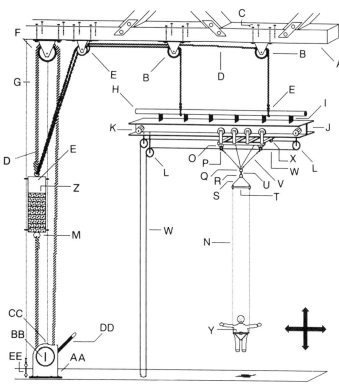

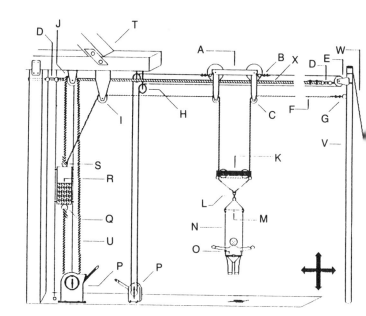

A. Beam
B. Heavy-duty sheave
C. Sheave bolted through beam
D. ¼-inch cable
E. Heavy-duty double sheave
F. Heavy-duty hemp sheave
G. 2 inch hemp rope
H. Pipe
I. Welded connectors
J. I beam
K. Carriage stop
L. Center sheave
M. Heavy-duty D. ring
N. ³/₆₄-inch flying cable
O. D ring
P. Shackle
Q. D ring
R. D ring
S. Spreader bar cable
T. Spreader bar
U. Swivel
V. Nico-pressed cable
W. On/off rope
X. D ring
Y. Flying Harness
Z. Counterweights
AA. Bolted to floor
BB. Adjustable sheave
CC Adjustable floor sheave
DD. Hemp brake
EE. Turnbuckle

Figure 7–33 Four-directional flying traveler track

A. Cable traveler carriage
B. D ring
C. Sheaves
D. Turnbuckle
E. Sheave
F. ½-inch rope
G. D ring
H. Sheave
I. Heavy duty sheave
J. Main sheave (heavy duty)
K. Double sheave spreader bar
M. Spreader bar
N. ³/₆₄-inch flying cables
O. Harness
P. Adjustable floor sheave
Q. Welded D ring
R. Counterweights
S. Welded D rings
T. Beam
U. 1-inch cotton rope
V. Pole
X. ½ inch main cable

Figure 7–34 Four-directional flying traveler cable. As long as both ends are in solid anchors, this rig can be stretched between two mountains for 1000 feet or more.

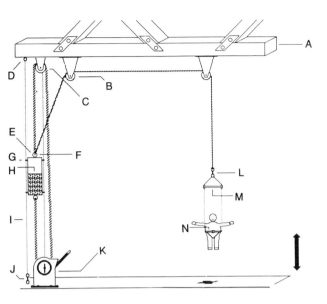

A. Beam
B. Center sheave
C. Heavy-duty sheave
D. Ring
E. Heavy-duty ring
F. Welded D ring
G. Counterweight guides

H. Counterweight
I. Guide rope
J. Swivel
K. Adjustable floor sheave
M. Spreader bar
N. Harness

Figure 7–35 Two-directional flying counterweight rig

A. Gridiron
B. Center sheave
C. 1/8-inch flying cable
D. Main lifting sheave
E. Sandbags
F. Welded D ring
G. Heavy-duty swivel

H. Spreader bar
I. Hemp brake
J. Adjustable floor sheave
K. Bolted to floor
L. 2-inch cotton rope
M. Two 3/64-inch flying cables
N. Flying harness

Figure 7–36 Two-directional flying sandbag rig

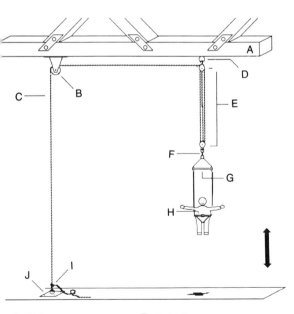

A. Pole
B. Center sheave
C. 3/4-inch hemp
D. Ring
E. 3 to 1 block and fall

F. Swivel
G. Spreader bar
H. Harness
I. D ring welded to plate
J. Plate bolted to floor

Figure 7–37 Two-directional flying block and fall rig

Two-Directional Flying Counterweight Rig This rig provides only up- and down-movement and is a single cable system (Figure 7–35). This is used mostly in film studios and for television.

Two-Directional Flying Sandbag Rig The sandbag rig is identical to the counterweight rig except for the use of sandbags in place of metal weights (Figure 7–36). This too is used mainly in film studios and for television.

Two-Directional Flying Block and Fall Rig It affords only up- and down-movement, but it has the mechanical advantage of a 5 to 1 energy-to-load lift ratio (Figure 7–37). This is used in film and television.

The Pendulum Rig (Peter Pan Rig) This rig is the most complicated of all flying devices and demands the most comprehensive rehearsal and coordination between the effects person and the performer (Figures 7–38, 7–39, and 7–40). This rig is used almost exclusively in the theatre.

The Peter Pan rig is controlled by a single continuous rope manipulated from offstage. From the effects person's position, the rope is run up to the fly gallery and through the Peter Pan mechanism. From there it is connected to a cable across the grid and over a sheave located directly above center stage. The cable continues down to a spreader bar from which two cables are strung down, connecting it to the flight harness. Center stage is defined as the lowest point of the pendulum swing.

Once begun, almost every aspect of the flying (height, radius, and speed) is done by the F/X person through rope manipulation. Pulling

A. Beam
B. Swivel
C. 1/8-inch cable
D. Pendulum drum mechanism
E. 1/8-inch cable
F. 1/8-inch cable
G. Heavy-duty O ring
H. 2-inch cotton rope
I. Heavy-duty O ring
J. Double floor sheave
K. Plate bolted to floor
L. Foot brake (apply pressure
 to stop
M. 3/64-inch flying cable

Drawings not to scale

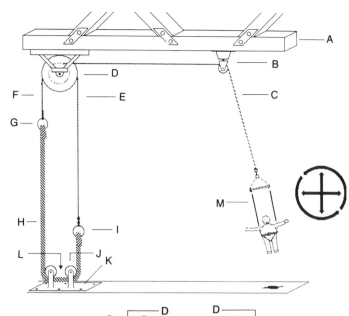

**Figure 7–38 Five-directional pendulum
(Peter Pan) rig**

A. 24-inch cable drum A
B. 8-inch cable drum B
C. 24-inch cable drum C
D. 150 feet 1/8-inch cable
E. Four locking rods
F. Locking nuts
G. Bearing locking collar
H. Sliding locking collar
I. Bearing
J. Bolts for bearing
K. 1½-inch case-hardened shaft
L. Steel frame
M. Steel base
N. Bolt-down brackets
O. Nut and bolt
P. Heavy-duty O rings

**Figure 7–39 Front view of
pendulum rig drum mechanism**

1. Drums A, B, and C revolve independently of each other on shaft (K)
 when all four locking rods (E) are removed.
2. Drum A and drum B cables are wound counterclockwise.
 Drum C cable is wound clockwise.
3. A and C drum cables are dropped from the gridiron to the floor.
4. 2-inch cotton rope (Figure 7–38 H) is connected to drum A's O ring (P) and
 fed through the double floor sheave (Figure 7–38 J) and attached to the O ring of drum C.
5. Drum C's cable is wound back up to the grid taking the rope within 2 feet of the drums.
6. Drum B's cable is fed through the swivel sheave (Figure 7–38 B) and dropped to the stage.
7. Spreader bar with cables is attached to the cable O ring of drum B.
8. Take up slack on all cables, align the three drums, replace the four locking rods, and lock
 into place.

A. 24-inch cable drum A
B. 150 feet 1/8-inch cable (for drum B)
C. Heavy-duty O ring
D. 24-inch cable drum C
E. 8-inch cable drum B
F. Holes for locking rod
G. Bolts for bearing
H. 1½-inch case-hardened shaft
I. Bearings
J. 150 feet 1/8-inch cable (for drum A)
K. Bolt-down brackets
L. Steel base
M. 150 feet 1/8-inch cable (for drum C)

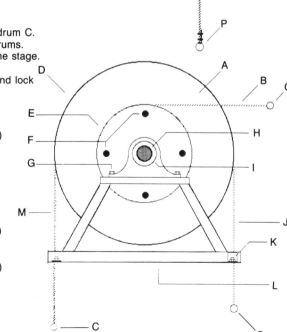

**Figure 7–40 Side view of
pendulum rig drum mechanism**

down on the rope raises the actor. Conversely, the actor is lowered by feeding rope out. It is a simple process of increasing or decreasing the rope length.

The three important elements of flight are height, radius, and particularly speed. An ordinary fishing weight on a string will clarify the physics involved. Tie the loose end of a string to one finger. Hold the weight in the other hand at shoulder height. When you release the weight, it will swing slowly like a pendulum in broad arcs until it gradually stops. By shortening the string, the weight will arc faster and stop sooner.

Repeat both experiments, but this time twirl the weight in a 360 degree circle and notice the relatively slow speed of the large radius of the long string versus the increased speed of the shorter radius. If you imagine the weight as the actor, strung with rope and cable instead of string, it is obvious that in order to fly from high to low, low to high, in tight circles, or in swooping glides over the heads of the audience, the flight must be controlled by the F/X person's manipulation of the rope.

The complexity is readily apparent, just as the exacting coordination between the flying team should be. It demands intense concentration and rehearsal to land someone on a light bulb or come to a smooth stop on the stage.

Slide for Life

The slide for life is basically a circus rig but is often used in movie stunts demanding a lengthy hand-held slide down a rope. Either hemp or cable may be used and the height, length, and angle of descent varies but is usually approximately 45 degrees.

A thick piece of leather or rubber covered with harness webbing is wrapped around the slide as a grip and is protection for the hands during the descent (see detail in Figure 7–41). Hand pressure is used to control speed. A safety catcher with a rope at the bottom of the run protects the person if he or she loses control. The slide is used in film, television, and the circus.

A sheave on the cable or rope is sometimes used as a variation of the slide (see top left of Figure 7–41). A safety hook is attached to the rope

Drawing not to scale

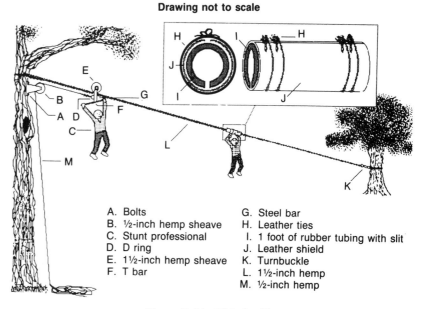

A. Bolts
B. ½-inch hemp sheave
C. Stunt professional
D. D ring
E. 1½-inch hemp sheave
F. T bar
G. Steel bar
H. Leather ties
I. 1 foot of rubber tubing with slit
J. Leather shield
K. Turnbuckle
L. 1½-inch hemp
M. ½-inch hemp

Figure 7–41 Slide for life

A. 2 x 12 clear hardwood board
B. Steel frame base
C. Two adjustable jack stands
D. 2-inch pipe, secured to board
 with U-bolt mounting brackets

E. Jack stand coupler
F. Four heavy-duty swivel casters
G. Sandbags
H. F/X person
I. Actor

Figure 7–42 Teeter board

and to the flyer in case the flyer loses his or her grip. It is used in film and for television.

Hanging Rig

The hanging rig is used with the previously described hanging harness (see page 58). A cable located in the center of a hemp rope is fitted behind the actor's neck where the cable is attached to the harness through the cable to the waist. A hangman's noose, designed to slide up and down, is knotted from a second piece of hemp and fitted around the actor's neck and fitted with false rope. It is not attached firmly, rather it's designed to slide with the actor when he or she drops.

Teeter Board (Teeter-Totter)

The teeter board is as elementary as a seesaw. The actor stands on one end while sandbags counterweight the opposite side. The crew pushes down on the bags, the actor rises, and vice versa to lower him or her. Turns of 360 degrees can be done by attaching a spinner to the teeter board. Care must be taken that the performer is balanced and able to adjust to changing angles and that the crew steadies the device as they move it to prevent sideways slippage (Figure 7–42). The scene is shot in three sequences. First, from the waist up as the actor rises, then a cut to the actor's feet showing no support as he or she is raised (off camera) from a bar-supported rope. Then we cut to a master shot of the actor floating, which uses a flying rig and harness. **Caution:** Advise the actor never to step off the teeter board until the weight at the other end has been removed. Rotating the teeter board with a camera mounted on it will give the appearance to the camera that the room is spinning.

Flying Safety

1. Use this and the following checklists and constantly update and revise them.
2. Double- and triple-check everything: harnesses, fastenings, webbing,

leather bindings, cables, bolts, nuts, rivets, lacing, buckles, grommets, thread, padding, and glued seams.

3. Never use a cable more than once. If it's been used all day, destroy it and replace it with a new cable.

4. Thoroughly rehearse both performers and crew in procedures.

5. For all effects, but most especially those dangerous or possibly dangerous effects such as flying or levitation, avoid distractions. When a person is harnessed and attached to a rig, *always* keep your total attention on him or her. *Never* leave your post at any time for any reason.

6. When working with counterweight systems, remember that the person being "lifted" has been balanced by counterweights. If you remove the person from the rig, you must first remove the counterbalance weight or override it.

7. Never use shock cord as the weight-bearing support. Always back it up with cable.

8. Hardware strengths are detailed in the appendices, and you should be thoroughly familiar with them. Note that *breaking strength* and *working load* are not interchangeable terms. This is true of both rope and cable. For example, in flying a 200-pound man on a cable rated at a breaking strength of 1000 pounds, the actual working load is only one-fifth of 1000 pounds or 200 pounds. Since the proper rigging is with two cables (not one) you have now created a more than acceptable 10 to 1 safety factor. Regarding hemp, the working load in most cases is 10 to 1 on a *single line.* Check your specification charts for exact statistics (see the end of this chapter, Table 7–12 for hemp specifications and Tables 7–13 through 7–20 for other rope specs).

9. Always use double Nicos on all cable attachments.

10. When flying an actor, you must not only be aware of him or her but also the position of other actors, crew, scenery, production equipment, and so on. This is why you rehearse.

11. When working in proximity to electrical equipment, the gaffer must ground the flying rig.

12. One of the most important things in flying is the chain of command. In films, it works like this: At the top is the director, then the first assistant director, special effects director or lead special effects person , and then the special effects crew. The special effects crew *never* takes orders from anyone except the special effects director or the lead special effects person. This hierarchy avoids any confusion and assures the safety of the person in the rig.

Flying Checklist

Of all the million things to remember about flying, the safety of the person you're flying is number one. Consequently, all your equipment must be in first-rate condition and weighted for the person or actor you're flying. The following safety checklist should be observed whenever you're flying anyone.

Condition of the Harness

What is the actual visual appearance and general condition of the harness? Check for stains. Chemical and paint stains can affect the material and therefore the safety of the harness.

1. *Rivets:* Check for wear, looseness, loose washers, or missing washers.
2. *Bolts:* Check for loose bolts, damaged threads on the bolts, loose washers, or any missing hardware of any type—bolts, washers, or nuts.
3. *Grommets:* Look for any loose, damaged, or missing grommets.
4. *Webbing:* Check for fraying, cuts, broken or loose threads, wear or damage of any kind, especially at buckles, clips, clamps, and straps.
5. *Leather:* Check for wear and for broken or frayed threads. Check for glue that is separating on the seams or from the padding. Check for brittleness, wear, or damage of any kind, especially at buckles, clips, clamps, straps, and mounting hardware.
6. *Padding:* Check to see that threads aren't broken or worn; check seams for separation.
7. *Seams:* Check all seams thoroughly. In leather harnesses most seams are glued. At this point, repeat this procedure once again!

Preparing the Flying Cables

1. Check with the cameraman or director to find out the headspace or distance between the spreader bar and the actor's head. On some shots it's a very short distance, just a couple of feet. On long shots you may need as much as 20 to 30 feet.
2. Cut cable 6 inches longer than the required length to make loops on either end of the cable. These loops provide the linkup to the harness and spreader bars.
3. Loop each end of the cable to the required size, pressing two Nicos on each loop. Leave ½ inch of cable free, above the top Nico. Make sure there is ½ to ¾ inch between the two Nicos.
4. Check the Nicos very closely to make sure they've been properly pressed. If you see any flat edges, replace the Nico and size it.
5. Attach one cable to each side of the spreader bar using a shackle.
6. Attach the spreader bar to your flying device by means of a shackle, sized to the length you need.
7. Raise the cables approximately 3 feet off the floor and have the art department paint them the color required for the scene, or have them chemically treated for masking. Allow the proper time for the cable to dry. In some cases, the cables will be treated chemically to blacken them. Also allow time for the chemicals to dry before using. Always keep flying cables suspended in the air. Never leave them on the floor where they can be stepped on or rolled over by scenery or props and be damaged.
8. Before each use of the cable, inspect the cable closely for wear, fraying, or damage. The slightest bit of damage means the cable should be replaced immediately.
9. The best way to inspect a cable for damage is to take your thumb and forefinger and, starting at the top of the cable, squeeze gently on the cable and run your fingers down it very slowly. This procedure will reveal any nicks and burrs, no matter how slight, which means it should be replaced immediately.

Fitting the Person to the Harness

1. At this stage, the most important thing is the comfort of the actor. Have the actor, wardrobe mistress, or whoever is dressing the person

put the harness on the actor, leaving all buckles, straps, and ties loose, so you can check for any padding that may be required.

2. Tighten all straps, buckles, webbing, and ties. At this time do not put in any extra padding.

3. Using the hooks on the side of the harness, raise the actor a few inches off the ground and check the fitting. If there are any spots in the harness that feel rough or tight or are creating a problem, put in sheep's wool padding until it is comfortable.

4. Most stock harnesses will not fit the person well, so you'll need padding. However, custom-fitted harnesses can be as comfortable as a pair of jeans.

5. On harnesses that have their lifting devices on either side, heavy-duty padding will keep the inward pressure off the person. This can be seen in the series of harness illustrations.

6. Gaffer's tape or black camera tape should be wrapped over and around the Nico presses. This way, the actor won't get nicked from the Nico presses or the cable sticking out of the end of the Nico press.

7. Hook the cable to the predetermined device on the harness.

8. Put the required amount of counterweight to balance the actor in the weight carriage and slowly lift the actor a few inches off the ground. Give the flyer all the time needed to feel comfortable and safe. Assure them of the safety of the rig. Most actors have never flown before and want to look natural while they're flying, so they need all the confidence you can give them regarding the safety of the procedure.

Actor's Instructions

For harnesses of the spinning type (Superman), the actor needs certain specialized instructions. Once the actor's balance point has been found by positioning the movable pins in the harness, he or she can control certain movements with the body. To lay over and fly like Superman, they can change the position of their arms to affect their balance point.

1. To go from flying to a vertical landing position, the arms are pulled close to the chest.

2. To dive, the arms are stretched out horizontally while the legs are pulled into the body.

3. To move from a dive into a spin, duplicate the previous movement until upside down, then straighten the legs keeping the arms out, which results in a 360-degree vertical circle.

4. If the person is on a spinner attached to a spreader bar, he or she will be able to execute 360-degree horizontal circles.

All other movements up and down, right or left, in and out, are controlled by the F/X person on the flying rig.

Levitation

Levitation, unlike flying that employs cable, uses steel lifting bars, strategically mounted extensions, or "fingers" projecting at 45-degree angles and a lifting mechanism. The person rests on padded fingers that are masked. Offstage the free end of the lifting bar is connected to a lifting machine that controls the speed, height, turns, and spins according to the choreography

Figure 7–43 Rhythm and blues, Gemini and the Planets

(Figure 7–43). The following are just a few of the effects that are possible using levitation.

Floating Piano

This rig is similar in theory to other such rigs except for the addition of counterbalancing weights. The lifting bar is attached to the piano and counterbalanced at its other end offstage (Figure 7–44). It has been used on television by Steve Allen, Roger Williams, Liberace, rock groups, E.L.P., and Earth, Wind & Fire.

As an example of how elaborate this can become, I once (and *only* once) levitated Steve Allen and his piano as he played. He floated on and off stage while the entire unit spun in circles. As a topper, the back curtains parted showing nothing supporting the rig, a difficult and expensive operation.

Floating Drums

The same rigging as just described except drums replace the piano. It has been used on television by Buddy Rich and Earth, Wind & Fire. In some instances tributary bars and fingers may be required on the central bar for more complex maneuvers (Figure 7–45).

Drawings not to scale

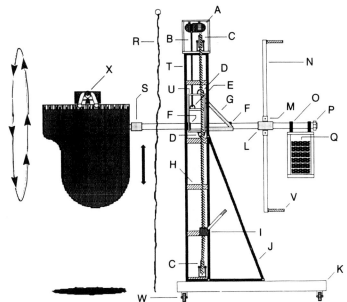

A. One-ton chain lift
B. Chain
C. 1-inch hemp sheave
D. Heavy-duty D rings
E. Shackle
F. Heavy-duty bearing
G. Steel bearing frame
H. Steel supports
I. Hemp brake
J. Steel braces
K. Steel and wood base
L. Coupler

M. Handle joints
N. Steel bars
O. Counterweight carriage bearings
P. End bolts
Q. Counterweights
R. Curtain
S. Piano coupler
T. Lifting frame
U. Carriage
V. Spinning handles
W. One-way casters
X Actor

Figure 7–44 Floating piano

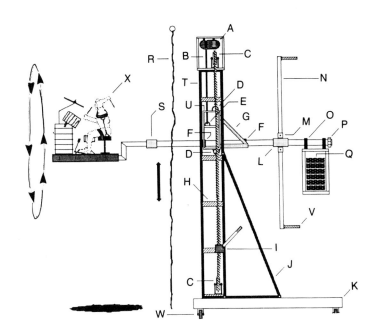

A. One-ton chain lift
B. Chain
C. 1-inch hemp sheave
D. Heavy-duty D rings
E. Shackle
F. Heavy-duty bearing
G. Steel bearing frame
H. Steel supports
I. Hemp brake
J. Steel braces
K. Steel and wood base
L. Coupler

M. Handle joints
N. Steel bars
O. Counterweight carriage
 bearings
P. End bolt
Q. Counterweights
R. Curtain
S. Piano coupler
T. Lifting frame
U. Carriage
v. Spinning handles
W. One-way casters
X. Magician's assistant

Figure 7–45 Floating drum set

Drawings not to scale

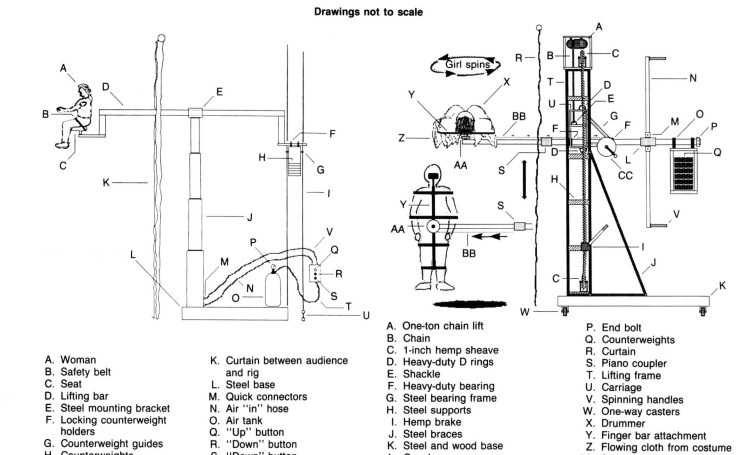

A. Woman
B. Safety belt
C. Seat
D. Lifting bar
E. Steel mounting bracket
F. Locking counterweight holders
G. Counterweight guides
H. Counterweights
I. Guide rope
J. Heavy-duty telescoping air cylinder
K. Curtain between audience and rig
L. Steel base
M. Quick connectors
N. Air "in" hose
O. Air tank
Q. "Up" button
R. "Down" button
S. "Down" button
T. Main air line
U. Turnbuckle
V. Air "out" hose

Figure 7–46 Air cylinder levitation

A. One-ton chain lift
B. Chain
C. 1-inch hemp sheave
D. Heavy-duty D rings
E. Shackle
F. Heavy-duty bearing
G. Steel bearing frame
H. Steel supports
I. Hemp brake
J. Steel braces
K. Steel and wood base
L. Coupler
M. Handle joints
N. Steel bars
O. Counterweight carriage bearings
P. End bolt
Q. Counterweights
R. Curtain
S. Piano coupler
T. Lifting frame
U. Carriage
V. Spinning handles
W. One-way casters
X. Drummer
Y. Finger bar attachment
Z. Flowing cloth from costume
AA. Spinning cable sheave
BB. Spinning cable
CC. Take-up

Figure 7–47 Four-finger levitation

Air Cylinder Levitation

This device is comprised of a cylinder of compressed air that drives a telescoping tube up and through a dump valve that releases the air to lower the telescope. It must be used in conjunction with counterweights, a lifting bar, and an air cylinder unit. Guide wires control swaying from side to side (Figure 7–46).

The air cylinder, or pneumatic, levitation machine has several advantages over other systems in specific situations. A few cases in which they come into their own are when electrical power is limited, if there are space constraints where large rigs cannot be used, and instances when flying sequences are limited to close-ups, making it unreasonable and unnecessary to set up large cranes.

Flying Inanimate Objects

Earlier I spoke of the dangers of using piano wire for flying. To clarify, I should state that I was referring specifically to the flying of people. Monofilament and piano wire are necessary to fly props or heavier objects, such as cups, dishes, candles, and so on, where invisibility takes precedence over strength.

Lead line

Slide wraps toward loop while pulling lead line

Figure 7–48 Ten-wrap Fisherman's tie using monofilament

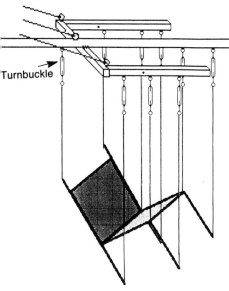

Turnbuckle

Figure 7–49 Rig for flying heavy objects. Note: Use turnbuckles to adjust even tension on each line. You may add as many lines as required to carry the weight.

Monofilament

Monofilament is fishing line, manufactured from plastic-based materials. It is lightweight, strong, and simple to work with. Unlike cable, monofilament connections are tied. A ten-wrap Fisherman's tie is the most suitable knot (Figure 7–48).

The major disadvantage of monofilament is its limited weight-bearing abilities and its intolerance to lacquer, acetone, thinners, paint sprays, and the like. These chemicals tend to quickly dissolve the bonding structure, making the monofilament useless. Specs for monofilament are commonly referred to as test strength, such as "10-pound test line." It's a guaranteed stress limit, which is always marked on the box or spool of line purchased.

One thing to remember about monofilament is that it is affected by heat. So be very careful that you don't put it near lamps or heaters of any type. When monofilament comes close to heat, it stretches and eventually breaks. By stretching, it throws everything off balance. Be sure to keep it away from the hot spots of lights.

Monofilament is easy to mask with black magic marker or Nestle's Streaks 'n Tips, making it ideal for projects requiring invisibility. In addition, a brown monofilament is manufactured that often solves the masking problem quite satisfactorily.

One- or 2-pound brown monofilament is virtually invisible, both to the eye and to the camera. So what can you do if you have a product that weighs 5 pounds and you need that invisible look that comes from 1- or 2-pound mono? Very simply, keep adding additional lines and balancing the item until you have enough lines to at least double the weight of the object. For example, if you have a 1-pound line and you have 5 pounds to lift, put eight or ten lines on the product. They'll never be seen.

The important thing when adding lines is to keep an even tension on each line when lifting. This can be accomplished by using small turnbuckles on each line (Figure 7–49). It's extremely important to keep identical tension between the rig that you're attached to and the object that's being flown. Lift it evenly to ensure even weight distribution. This will allow a very smooth, floating look.

The method by which you secure the line is also important. Use certain types of glue such as Krazy Glue or some of the two part (A-B) glues that are in spray bottles. If you cannot glue the product for some reason, drill a hole through the product and use a long sewing needle to thread the monofilament through these holes, out the other side, and back up to your rig, giving you one continuous line through the product. These holes should be drilled about three-quarters of the way up the height of the product.

Flying a Bottle When flying a bottle, drill holes about three-quarters up the side of the bottle. This keeps it in good balance. By making the line continuous, you can easily adjust the bottle or angle the bottle from side to side.

A third line enables you to tip the bottle and pour out a small amount of liquid. Run this line to the bottom center of the bottle and glue it. Then run the line up to the rig. By lifting on this line, the bottle will tip. Do not overtip the bottle, or the bottle will flip. The same method can be used on cups and glasses. A good example of flying small objects can be seen in the films *Zapped* and *Zapped Again.*

Piano Wire

When greater strength is important, piano wire can be employed. Piano wire is always made from metal, either steel or a tin alloy. It can withstand considerable chemical abuse and therefore is easy to conceal. Two choices for piano wire are high carbon metallic tinned wire and Wilstabrite, a stainless steel wire. Table 7–1, High Carbon Metallic Tinned Piano Wire, and Table 7–2, Wilstabrite Wire, show specs provided by the manufacturers that are estimates only and though not guaranteed are as close to accurate as possible. Of the two piano wires, Wilstabrite resists painting and therefore is used only in limited situations. Wilstabrite does have the following characteristics: full hard temper, bright polished finish, true to gauge, absolutely round and smooth, diameters from .003 to .102 inclusive, tobacco brown finish, nonglare and invisible in water, stainless steel with a small amount of silver to give it softness and still retain a high strength.

Connections with piano wire are also made with knots as follows:

1. The tight or close wrapped knot is best when the point of attachment must be concealed. The knot can quickly and easily be made with the help of a wrapping tool (Figure 7–50).

Figure 7–50 Tight-wrap tie using piano wire

TABLE 7–1 HIGH CARBON METALLIC TINNED PIANO WIRE

Number	Diameter	Estimated Breaking Stress (pounds)
2	.011	28
3	.012	34
4	.013	39
5	.014	46
6	.016	60
7	.018	76
8	.020	93
9	.022	114
10	.024	136
11	.026	159
12	.029	198
13	.031	226
14	.033	256
15	.035	288
16	.037	322
17	.039	358
18	.041	396
19	.043	435
20	.045	477
21	.047	520
22	.049	565
23	.051	612
24	.055	712
25	.059	820
26	.063	935
27	.071	1188

TABLE 7–2 WILSTABRITE WIRE AND LINES

Wilstabrite Hard Wire Leaders and Lures			Wilstabrite Soft Wire Monel-Trolling Lines, etc.		
Number	Diameter	Breaking Stress (pounds)	Number	Diameter	Breaking Stress (pounds)
2	.011	27	4/0	.006	3
3	.012	32	3/0	.007	4
4	.013	38	2/0	.008	5 1/2
5	.014	44	0	.009	6 1/2
6	.016	58	1	.010	8 1/2
7	.018	69	2	.011	10
8	.020	86	3	.012	12
9	.022	104	4	.013	14
10	.024	119	5	.014	16
11	.026	140	6	.016	20
12	.029	174	7	.018	25
13	.031	188	8	.020	31
14	.033	213	9	.022	38
15	.035	240	10	.024	45
16	.037	267	11	.026	53
17	.039	297	12	.029	65
18	.041	330	13	.031	74
19	.043	362	14	.033	84
20	.045	397	15	.035	95
21	.047	432			
22	.049	470			
23	.051	479			
24	.055	556			
25	.059	641			
26	.063	730			
27	.071	846			

ONLY USE THIS WIRE FOR FLYING OBJECTS, NEVER TO FLY PEOPLE

Figure 7–51 Butterfly wrap using piano wire

2. If masking the point of attachment is not a concern, a butterfly tie works ideally (Figure 7–51).

Whenever piano wire is tied, make a special effort to prevent it from kinking, which would cause the wire to break.

As we mentioned before in our discussion on monofilament, you can use more than one line to obtain an effect where you can only use a 1- or 2-pound monofilament. The same principle applies to piano wire. If you need that invisible look, use as many wires as needed to make up the weight specification of the object. You'll achieve the same results. Always use turnbuckles between your wire and your rig, which will allow for a perfect adjustment.

Object-Flying Crane

Since a 60-foot crane would be inappropriate to fly an 8-ounce glass of orange juice, the object-flying crane is a viable substitute. The boom from which the object is flown can be either fixed or telescoping as may the vertical pivotal axis on which it is mounted. Both the boom and the vertical axis ride on a dolly platform. The controlling (back) end of the boom must be counterbalanced to afford the greatest sense of maneuverability. A series of sheaves and pulleys on the side of the boom enhances the unit's versatility by allowing in- and out-movement. In appearance, the object-flying crane is similar to a mike boom (Figure 7–52).

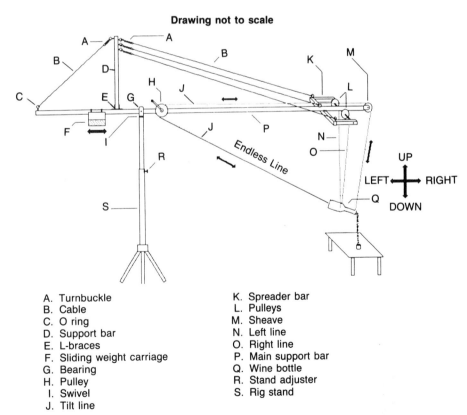

A. Turnbuckle
B. Cable
C. O ring
D. Support bar
E. L-braces
F. Sliding weight carriage
G. Bearing
H. Pulley
I. Swivel
J. Tilt line

K. Spreader bar
L. Pulleys
M. Sheave
N. Left line
O. Right line
P. Main support bar
Q. Wine bottle
R. Stand adjuster
S. Rig stand

Figure 7–52 Crane for flying a small object

Trip Releases

In big action scenes such as an earthquake, buildings are shown being blown up. There are images of ceilings and beams falling, walls collapsing, trees being hit by lightning and dropping to the ground, tons of dust and debris swirling onto the set and onto the actors.

All these effects use a device called a trip release. Figures 7–53 through 7–58 illustrate 12 different types of mechanical trip releases. Of course, there are many others. They come in different sizes and shapes, but all have one thing in common: Trip releases are mechanical devices that secure objects suspended or restrained until they are disengaged by a manual, electrical, or pyrotechnic trigger. Other types of trip releases that use a pyro device to trip them will be discussed in Chapter 10, Pyrotechnics.

Figure 7–53 Hand-operated trip release: open (left), closed (right)

Figure 7–54 Mechanical trip release: open (left), closed (right)

Figure 7–55 Mechanical trip release: open (left), closed (right)

Figure 7–56 Combination trip release: open (left), closed (right)

Figure 7–57 Pelican hook: open (left), closed (right)

Figure 7–58 Combination trip release: squib or hand operated

Drop Boxes and Drop Bags

Drop boxes have a release door that is also tripped by pulling a rope or cable. When the door opens, it releases all the debris inside the box onto the actor or scene all at one time (Figure 7-59).

Drop, or trip, bags are the same in principle as drop boxes, the difference being that instead of all the debris dropping at one time, it can be dropped at various intervals, depending on how fast or slow the bag is raised or lowered (Figure 7-60).

Drawings not to scale

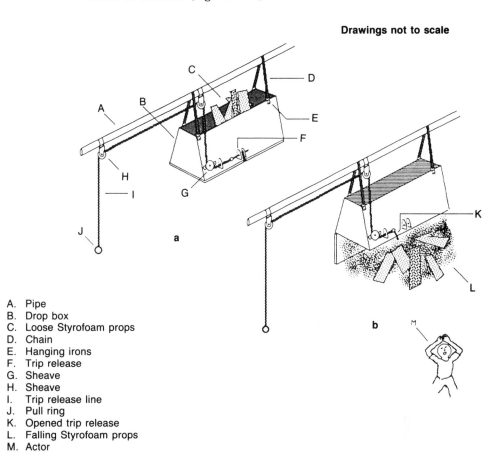

A. Pipe
B. Drop box
C. Loose Styrofoam props
D. Chain
E. Hanging irons
F. Trip release
G. Sheave
H. Sheave
I. Trip release line
J. Pull ring
K. Opened trip release
L. Falling Styrofoam props
M. Actor

Figure 7-59 Drop box: loaded (a) tripped (b)

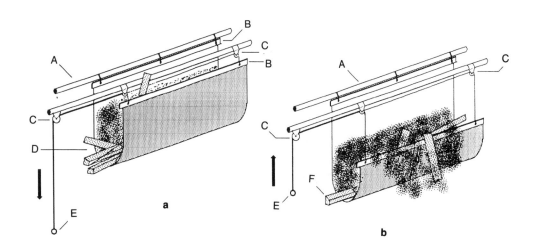

A. Pipe
B. Wooden battens
C. Sheaves
D. Styrofoam props
E. Pull rings
F. Falling Styrofoam props

Figure 7-60 Drop bag: loaded (a), tripped (b)

Cable Slings

Cable slings are often used as rigging tools. The various configurations of cable slings are designed to do one thing: lift. Whether doing stage, television, or motion picture rigging, it is absolutely imperative that you be familiar with all of the different cable slings in order to move materials of virtually any weight from one place to another (Figure 7–61). These slings have often been used in logging films, such as *Sometimes A Great Notion*, in the lifting and moving of logs but more often they are used behind the scenes to handle heavy, awkward, and bulky objects. In the television commercial that shows a car being lowered onto a high mesa in the desert, a cable sling was used to attach the car to the helicopter.

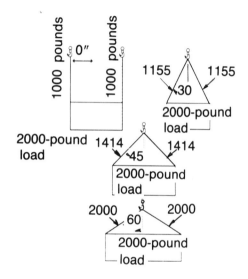

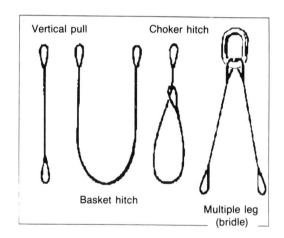

The rated capacity of any sling decreases as the leg angle from the vertical increases. Tension increases in each leg of a multiple-leg sling (or bride hitch) at the angles of 0, 30, 45, and 60 degrees.

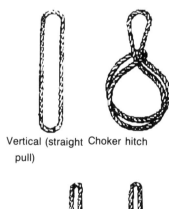

Vertical (straight pull) Choker hitch

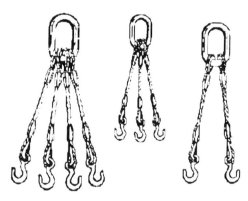

Multiple-leg cable slings

Basket hitch

Figure 7–61 Cable slings

The Dead Man Rig

The term *dead man rig*, like so many other names given to special effects riggings, tools, and hardware, is more an image than a definition of form or function. If you ask why the rig is called that, you will most likely get a strange look and the answer, "'Cause it's always been called that. Can't you see it's buried?" Well, sometimes it is and sometimes it's not, which is why there are below ground and above ground dead man rigs, identical in every respect—except when they're different, which they are! Special effects people see nothing contradictory or confusing in this, which probably explains how they came to be special effects people in the first place. If *you're* confused, that's because you're thinking logically and in F/X that's a big mistake—unless of course it works, which it won't, except when it does!

When you hear "dead man rig," think generic anchor. If you can do that, you'll have a head start in understanding the device and how, when, where, and why it's used. A dead man rig serves to restrain any heavy object through a combination of steel cable and a sheave. In special effects, a railroad tie (in some instances a length of telephone pole) becomes a dead man rig once a steel cable(s) is attached to it and the unit is buried below ground. This is the below ground dead man rig (Figure 7–62a).

Whenever possible, bury the rig because the weight of the earth serves to greatly increase its stability and enhances its ability to resist forces pulling against it. When you are prevented from digging because the shooting is being done on concrete or on asphalt, you will have to resort to the above ground dead man rig. The tie or pole is then secured to the ground with turnbuckles held in place by bullpricks driven directly into and through the artificial surface (Figure 7–62b).

A stunt that I've done dozens of times and which you've seen in hundreds of films is the slingshot car (*slingshot* here refers to a maneuver in auto racing in which a drafting car accelerates past the car in front by taking advantage of reserve power). Here the dead man rig comes into its own. In a movie called *Choke Canyon* I rigged two Ford Broncos and launched them simultaneously from a cliff. When they hit the canyon floor, they exploded in balls of flame. The stunt professionals were both excellent drivers and felt comfortable with the high speed run toward the cliff's edge. Nor did they feel any particular qualms about flying a vehicle off a mountain. They did, however, express some concern as to what would happen when they and the cars hit bottom and blew up. As this didn't seem unreasonable, we decided to launch the Fords without the drivers in them and instead rely on dual dead man rigs to get the cars up to speed. The details of how the cars were rigged is covered in Chapter 12, Special Effects and Stunts.

As a final note on dead man rigs, you should be aware that you can't buy bull pricks. You have to make them yourself from old car axles unless you find a store that sells them (in which case, they probably won't know what you're asking for anyway because they'll call them something else, so make them yourself).

Figure 7–62 Below-the-ground dead man (a); above-the-ground dead man (b)

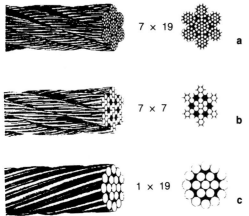

7×19 **a**

7×7 **b**

1×19 **c**

Figure 7–63 Bundle patterns for aircraft cable (galvanized or stainless): (a) 7 × 19, (b) 7 × 7, (c) 1 × 19

Cable (Preformed Aircraft Cables and Strands)

7 × 19 Class This is made of 6 strands of 19 wires each around a wire strand core. In larger sizes a 7 × 7 independent wire rope core is used.

7 × 7 Class This is similar to 6 × 7 except for its wire strand core in place of a fiber core, also comparable in flexibility and abrasion resistance. Working load is one-fifth of breaking strength when *flying people*, one-quarter of breaking strength when *flying objects*.

1 × 19 Class The 1 × 19 construction consists of a nonflexible strand of 19 wires. It is generally used for yacht rigging and other guying purposes.

TABLE 7–3 7 × 19 CLASS CABLE

	Galvanized		Stainless	
Diameter (inches)	Working Load (pounds)	Breaking Strength (pounds)	Working Load (pounds)	Breaking Strength (pounds)
1/16	—	—	—	—
3/32	210	1,050	210	1,050
1/8	400	2,000	380	1,900
5/32	560	2,800	520	2,600
3/16	840	4,200	780	3,900
7/32	1,120	5,600	1,000	5,000
1/4	1,400	7,000	1,320	6,600
5/16	1,960	9,800	1,920	9,600
3/8	2,960	14,800	2,600	13,000

TABLE 7–4 7 × 7 CLASS CABLE

	Galvanized		Stainless	
Diameter (inches)	Working Load (pounds)	Breaking Strength (pounds)	Working Load (pounds)	Breaking Strength (pounds)
1/16	96	480	96	480
3/32	184	920	184	920
1/8	340	1,700	340	1,700
5/32	520	2,600	520	2,600
3/16	740	3,700	740	3,700
1/4	1,220	6,100	1,220	6,100
5/16	1,840	9,200	1,820	9,100
3/8	2,660	13,300	2,520	12,600

TABLE 7–5 1 × 19 CLASS CABLE

	Galvanized		Stainless	
Diameter (inches)	Working Load (pounds)	Breaking Strength (pounds)	Working Load (pounds)	Breaking Strength (pounds)
1/16	100	500	100	500
3/32	240	1,200	240	1,200
1/8	420	2,100	420	2,100
5/32	660	3,300	660	3,300
3/16	940	4,700	940	4,700
1/4	1,640	8,200	1,640	8,200
5/16	2,500	12,500	2,500	12,500
3/8	3,600	18,000	3,500	17,500

Nonjacketed Cable

In Table 7–6, Composition A refers to carbon steel, zinc coated, and Composition B refers to corrosion-resistant steel (302/304SS). The working load is one-fifth of breaking strength when flying people. The working load is one-quarter of breaking strength when flying objects.

TABLE 7–6 MIL SPEC AIRCRAFT CABLE TO MIL-W-83420

Nominal Diameter of Wire Rope	Construction	Minimum Breaking Strength Composition A	Minimum Breaking Strength Composition B
1/32	3 × 7	110	110
3/64	7 × 7	270	270
1/16	7 × 7	480	480
1/16	7 × 19	480	480
3/32	7 × 7	920	920
3/32	7 × 19	1,000	920
1/8	7 × 19	2,000	1,760
5/32	7 × 19	2,800	2,400
3/16	7 × 19	4,200	3,700
7/32	7 × 19	5,600	5,000
1/4	7 × 19	7,000	6,400
9/32	7 × 19	8,000	7,800
5/16	7 × 19	9,800	9,800
3/8	7 × 19	14,400	12,000

Plastic-Jacketed Cable

Various types of material are available to extrude onto wire rope. The two most common are PVC (polyvinyl chloride) and nylon. PVC is the most common plastic coating because of its flexibility and low cost, but nylon is more durable and abrasion resistant for pulleys. A wide variety of custom colors as well as numerous diameters of coatings are available.

Working load is one-fifth of breaking strength when flying people. Working load is one-quarter of breaking strength when flying objects.

TABLE 7–7 1 × 19 CONSTRUCTION, PLASTIC—JACKETED CABLE

Cable Diameter (inches)	Cable Diameter (inches)	Stainless Steel Breaking Strength (pounds)	Galvanized Breaking Strength (pounds)
3/64	1/16 or 3/32	300	375
1/16	3/32 or 1/8	500	500
3/32	1/8 or 5/32	1,200	1,200
1/8	5/32 or 3/16	2,100	2,100
5/32	3/16 or 7/32	3,300	3,300
3/16	7/32, 1/4, or 5/16	4,700	4,700
1/4	5/16 or 3/8	8,200	8,200
5/16	3/8 or 7/16	12,500	12,500
3/8	7/16 or 1/2	18,000	18,000

SAFETY WARNING: When using PLASTIC COATED CABLE of any kind, the coating must be removed before using nicos or any type of cable clamp, or the cable can slip through the nicos or cable clamps. The coating only needs to be removed in the area that comes in contact with nicos or cable clamps.

TABLE 7–8 7 × 7 CONSTRUCTION, PLASTIC—JACKETED CABLE

Cable Diameter (inches)	Cable Diameter (inches)	Stainless Steel Breaking Strength (pounds)	Galvanized Breaking Strength (pounds)
3/64	1/16 or 3/32	270	270
1/16	3/32 or 1/8	480	480
3/32	1/8 or 5/32	920	920
1/8	5/32 or 3/16	1,700	1,700
5/32	3/16 or 7/32	2,600	2,600
3/16	7/32, 1/4, or 5/16	3,700	3,700
1/4	5/16 or 3/8	6,100	6,100
5/16	3/8 or 7/16	9,200	9,200
3/8	7/16 or 1/2	13,100	13,100

SAFETY WARNING: When using PLASTIC COATED CABLE of any kind, the coating must be removed before using nicos or any type of cable clamp, or the cable can slip through the nicos or cable clamps. The coating only needs to be removed in the area that comes in contact with nicos or cable clamps.

TABLE 7–9 7 × 19 CONSTRUCTION, PLASTIC—JACKETED CABLE

Cable Diameter (inches)	Cable Diameter (inches)	Stainless Steel Breaking Strength (pounds)	Galvanized Breaking Strength (pounds)
3/64	1/16 or 3/32	270	—
1/16	3/32 or 1/8	480	480
3/32	1/8 or 5/32	920	1,000
1/8	5/32 or 3/16	1,760	2,000
5/32	3/16 or 7/32	2,400	2,800
3/16	7/32, 1/4, or 5/16	3,700	4,200
1/4	5/16 or 3/8	6,400	7,000
5/16	3/8 or 7/16	9,000	9,800
3/8	7/16 or 1/2	12,000	14,000

SAFETY WARNING: When using PLASTIC COATED CABLE of any kind, the coating must be removed before using nicos or any type of cable clamp, or the cable can slip through the nicos or cable clamps. The coating only needs to be removed in the area that comes in contact with nicos or cable clamps.

TABLE 7–10 SEVEN-STRAND CABLE

Fabrication	Breaking Strength (pounds per square inch test)	Major Cable Diameter	Wire Size (inches)
1 × 3	8	.008	.004
1 × 3	12	.010	.006
1 × 7	18	.011	.004
1 × 7	27	.012	.0045
1 × 7	40	.015	.005
1 × 7	60	.018	.006
1 × 7	90	.024	.008
1 × 7	135	.027	.009
1 × 7	170	.033	.011
1 × 7	250	.039	.013
1 × 7	600	.062	.020

Seven-strand is made from stainless steel wire. When flying people, the working load is one-fifth of the breaking strength; when flying objects, the working load is one-quarter of the breaking strength.

Rope

Table 7–11 lists the characteristics of various fibers used in cordage.

TABLE 7–11 FIBER FACTS OF VARIOUS ROPES

	Nylon	Polyester	Polypropylene	Manila	Sisal	Cotton
Strength						
Tenacity of dry fiber (in grams/denier)	9.0	8.5	6.5	5–6.0	4–5.0	2–3.0
Wet strength compared to dry strength	85–90%	100%	100%	Up to 120%	Up to 120%	Up to 120%
Rope shock load absorption ability	Excellent	Good	Very good	Poor	Poor	Very poor
Weight						
Specific gravity of fibers or filaments	1.14	1.38	.91	1.38	1.38	1.54
Able to float	No	No	Yes	No	No	No
Rope strength/weight ratio (average)	3.0	2.25	2.5	1.0	.75	.50
Elongation						
Typical percentage of rope elongation at 20% of the breaking test	20–25%	16–18%	18–22%	10–12%	10–12%	—
Average percentage of rope elongation at 75% of the breaking test	42%	29%	37%	19%	19%	—
Creep (extention under sustained load)	Moderate	Low	High	Very low	Very low	—
Effects of moisture						
Water absorption of of individual fibers	8.0–12.0%	1.0%	None	Up to 100% of weight	Up to 100% of weight	Up to 100% of weight
Resistance to rot, mildew, and deterioration due to marine organisms	Excellent	Excellent	Excellent	Poor	Very poor	Very poor
Chemical resistance						
Effect of acids	Decomposed by strong mineral acids; resistant to weak acids	Resistant to most mineral acids; disintegrated by 95% sulphuric acid	Very resistant	Will disintegrate in hot dilute and cold concentrated acids	Same as manila	Same as manila
Effect of alkalis	Little or none	No effect cold; slowly disintegrated by strong alkalis at the boil	Very resistant	Poor resistance; will loose strength where exposed	Same as manila	May swell, but will not be damaged

(continued)

TABLE 7–11 Continued

	Nylon	Polyester	Polypropylene	Manila	Sisal	Cotton
Chemical resistance *continued*						
Effect of organic solvents	Resistant; soluble in some phenolic compounds in 90% formic acid	Generally unaffected; soluble in some phenolic compounds	Soluble in chlorinated hydrocarbons at 160°F	Fair resistance for fiber, but hydrocarbons will remove protective lubricants on rope	Good resistance	Good resistance
Degradation						
Resistance to ultraviolet in sunlight	Good	Excellent	Good; black is best	Good	Good	Good
Resistance to aging for stored rope	Excellent	Excellent	Excellent	Good	Good	Good
Rope abrasion resistance						
Surface	Very good	Best	Good	Good	Fair	Good
Internal	Excellent	Best	Good	Good	Good	Good
Effect of temperature on dry rope						
High temperature working limit	300°F	300°F	200°F	300°F	300°F	300°F
Low temperature working limit	−70°F	−70°F	−20°F	−100°F	−100°F	−100°F
Melting point	480°F	482°F	330°F			
Performance						
Ability of rope to render, or ease out smoothly over metal while under load	Poor	Good	Very poor	Excellent	Good	Good

Hemp Rope

New Rope Tensile Strengths New rope tensile strengths are based on tests of new and unused rope of standard construction in accordance with Cordage Institute standard test methods.

Working Loads Working loads are for rope in good condition with appropriate splices, in noncritical applications, and under normal service conditions. Working loads should be exceeded only with expert knowledge of conditions and professional estimates of risk. Working loads should be reduced where life, limb, or valuable property are involved or for exceptional service conditions such as shock loads, sustained loads, and so on. Working load is one-tenth of breaking strength when flying people. Working load is one-eighth of breaking strength when flying objects.

TABLE 7–12 MANILA TWISTED ROPE: THREE-STRAND MEDIUM LAY

Diameter (in inches)	Approximate Tensile (or Breaking) Strength	Working Load (pounds)
1/4	540	54
5/16	900	90
3/8	1,200	122
1/2	2,380	264
5/8	3,960	495
3/4	4,860	694
7/8	6,950	992
1	8,100	1157
1 1/8	10,800	1542
1 1/4	12,200	1742
1 1/2	16,700	2385
1 3/4	23,800	3400
2	28,000	4000

Synthetic Rope

Polypropylene Twisted Rope Lightweight, strong, and low stretch, polypropylene floats and will not mildew, decay, or rot. It has good resistance to acids, solvents, alkalies, and abrasion. Polypropylene is excellent for mooring lines, pulling lines, and general utility ropes. It is opaque yellow in color.

New Rope Tensile Strengths New rope tensile strengths are based on tests of new and unused rope of standard construction in accordance with Cordage Institute standard test methods.

Working Loads Working loads are for rope in good condition with appropriate splices, in noncritical applications, and under normal service conditions. Working loads should be exceeded only with expert knowledge of conditions and professional estimates of risk. Working loads should be reduced where life, limb, or valuable property are involved or for exceptional service conditions such as shock loads, sustained loads, and so on. Working load is one-tenth of breaking strength when flying people.

TABLE 7–13 POLYPROPYLENE TWISTED ROPE

Diameter (inches)	Approximate Tensile Strength	Working Load (pounds)
1/4	1,130	113
5/16	1,700	170
3/8	2,400	235
7/16	3,100	352
1/2	3,600	420
5/8	5,600	700
3/4	7,600	1000
7/8	10,000	1400
1	12,500	1760
1 1/4	18,000	2600
1 1/2	26,000	3770
1 3/4	38,000	5400
2	46,000	6600

Truck Rope Polypropylene Monofilament polypropylene, a black rope with orange tracer, is exceptionally popular for tie downs and load holding. It possesses high strength with low stretch.

New Rope Tensile Strengths New rope tensile strengths are based on tests of new and unused rope of standard construction in accordance with Cordage Institute standard test methods.

Working Loads Working loads are for rope in good condition with appropriate splices, in noncritical applications, and under normal service conditions. Working loads should be exceeded only with expert knowledge of conditions and professional estimates of risk. Working loads should be reduced where life, limb, or valuable property are involved or for exceptional service conditions such as shock loads, sustained loads, and so on. Working load is one-tenth of breaking strength when flying people, one-eighth of breaking strength when flying objects.

TABLE 7–14 TRUCK ROPE POLYPROPYLENE

Diameter (inches)	Length (feet)	Approximate Tensile Strength	Working Load (pounds)
3/8	600	2400	360
7/16	600	3100	465
1/2	600	3600	540
5/8	600	5600	840
3/4	600	7600	1140

Hollow-Braided Polypropylene This rope is highly versatile, economical, easy to splice, and very strong.

New Rope Tensile Strength New rope tensile strengths are based on tests of new and unused rope of standard construction in accordance with Cordage Institute standard test methods.

Working Loads Working loads are for rope in good condition with appropriate splices, in noncritical applications, and under normal service conditions. Working loads should be exceeded only with expert knowledge of conditions and professional estimates of risk. Working loads should be reduced where life, limb, or valuable property are involved or for exceptional service conditions such as shock loads, sustained loads, and so on. Working load is one-tenth of breaking strength with flying people. Working load is one-eighth of breaking strength when flying objects.

TABLE 7–15 HOLLOW-BRAIDED POLYPROPYLENE

Diameter (inches)	(millimeters)	Approximate New Rope Tensile Strength (pounds)	Maximum Recommended Working Load (pounds)
1/8	3.17	250	50
3/16	4.76	750	160
1/4	6.35	1150	250
5/16	7.94	1800	325
3/8	9.53	2100	440
1/2	12.70	3500	945

Double-Braid Polyester Stage Rope Both the jacket and core of this rope are 100% polyester. Polyester fiber combines very low stretch or elasticity with high strength. Its resistance to ultraviolet degradation is superior to that of any other synthetic fiber. It's specifications are: specific gravity is 1.38; critical temperature is 350°F, 176°C; water absorption is less than 1%; and dry wear is very good.

Compliance to strengths and weights in table is based on testing according to the Cordage Institute standard test methods for fiber rope and/or ASTM D-4268 standard methods of testing fiber ropes. Linear densities are average within maximum 5% more than listed. To estimate the minimum tensile strength of new rope, reduce the approximate average by 20%. The Cordage Institute defines minimum tensile strength as two standard deviations below the average tensile strength of the rope.

TABLE 7–16 DOUBLE-BRAID POLYESTER STAGE ROPE

Diameter (inches)	Circumference (inches)	Recommended Working Load (pounds)
1/4	3/4	390
5/16	1	585
3/8	1 1/8	780
7/16	1 1/4	1,241
1/2	1 1/2	1,598
9/16	1 3/4	2,232
5/8	2	2,754
3/4	2 1/4	3,438
7/8	2 3/4	5,560
1	3	7,260
1 1/8	3 1/2	8,940
1 1/4	3 3/4	10,600
1 5/16	4	11,720
1 1/2	4 1/2	13,840
1 5/8	5	16,800
1 3/4	5 1/2	20,200
2	6	23,600
2 1/8	6 1/2	28,000
2 1/4	7	32,200
2 1/2	7 1/2	36,400
2 5/8	8	40,600
2 3/4	8 1/2	44,800
3	9	53,200

TABLE 7–17 STA-SET/SOFT (POLYESTER BRAIDED STAGE ROPE)

Normal Size		
Diameter (inches)	Circumference (inches)	Average Tensile Strength (pounds)
1/4	3/4	2,000
5/16	1	2,900
3/8	1 1/8	4,400
7/16	1 1/4	6,200
1/2	1 1/2	8,000
5/8	2	12,300
3/4	2 1/4	15,000
7/8	2 3/4	21,400
1	3	24,600

TABLE 7–18 STA-SET X-SOFT

Normal Size		
Diameter (inches)	Circumference (inches)	Average Tensile Strength (pounds)
1/4	3/4	2,000
5/16	1	3,100
3/8	1 1/8	4,500
7/16	1 1/14	6,300
1/2	1 1/2	7,900
5/8	2	14,000
3/4	2 1/4	17,600
7/8	2 3/4	26,300
1	3	31,600

Double-Braided Nylon Rope This rope has both a nylon jacket and nylon core.

TABLE 7–19 DOUBLE-BRAIDED NYLON ROPE

Diameter (inches)	Circumference (inches)	Recommended Working Load (pounds)
1/4	3/4	345
5/16	1	510
3/8	1 1/8	735
7/16	1 1/4	1,122
1/2	1 1/2	1,445
9/16	1 3/4	2,106
5/8	2	2,736
3/4	2 1/4	3,438
7/8	2 3/4	5,660
1	3	6,720
1 1/8	3 1/2	9,000
1 1/4	3 3/4	10,400
1 5/16	4	11,800
1 1/2	4 1/2	14,800
1 5/8	5	18,200
1 3/4	5 1/2	22,000
2	6	26,200
2 1/8	6 1/2	30,600
2 1/4	7	35,400
2 1/2	7 1/2	40,400
2 5/8	8	46,000
2 3/4	8 1/2	51,400
3	9	57,000

Solid-Braided Nylon Rope Solid-braided nylon is the strongest fiber cord manufactured! It is widely used in marine, industrial, home, and farm applications. The superior performance of nylon more than offsets its higher initial cost. Nylon is characterized by its high tensile strength and light weight, even when wet. It has excellent resistance to abrasion, mold,

mildew, and most chemicals. It is rot proof and not damaged by oil or gasoline. Nylon is an elastic cord with excellent recovery, a quality that gives it a shock absorbing action and allows it to absorb shock loads that would break other cords of equal size. It is natural white in color.

New Rope Tensile Strengths New rope tensile strengths are based on tests of new and unused rope of standard construction in accordance with Cordage Institute standard test methods.

Working Loads Working loads are for rope in good condition with appropriate splices, in noncritical applications, and under normal service conditions. Working loads should be exceeded only with expert knowledge of conditions and professional estimates of risk. Working loads should be reduced where life, limb, or valuable property are involved or for exceptional service conditions such as shock loads, sustained loads, and so on.

TABLE 7–20 SOLID-BRAIDED NYLON ROPE

Diameter (inches)	(millimeters)	Approximate New Rope Tensile Strength (pounds)	Maximum Recommended Working Load (pounds)
1/8	3.17	475	110
3/16	4.76	860	175
1/4	6.35	1400	275
5/16	7.94	1800	550
3/8	9.53	2700	725
1/2	12.70	5200	1000

Knots

Figures 7–64 through 7–70 illustrate knots and some of their most common uses. Take time to practice each knot before you have to use it. As with everything in this business, safety and planning are the keys to a successful effect.

Figure 7–64 Two ways to lock a block and fall

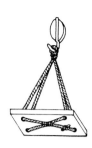
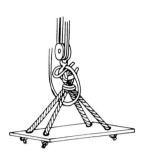

Figure 7-65 Three ways to rig a boatswain's chair

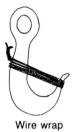
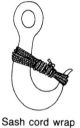

Wire wrap Sash cord wrap

Figure 7-66 Two ways to safety (mouse) a hook

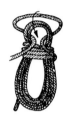
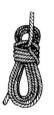

Figure 7-67 Tie-ups for coiled rope

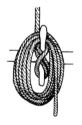
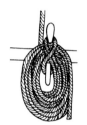
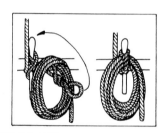

Figure 7-68 Pin rail coils

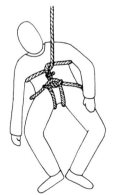

Two ways to lift
a drum or barrel

Lifting a ladder

Lifting long-handled tools

Lifting a pipe

Three ways to lift a hammer

Lifting or lowering
an injured person

Figure 7-69 Methods of lifting objects using rope or hemp

Assorted Hook Ties

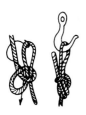

1. Bowline with bight

2. Rolling hitch

3. Single hook hitch

4. Ring hitch

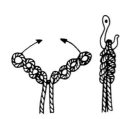

5. Cat's paw

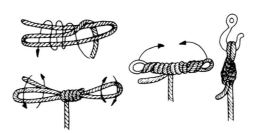

6. Single cat's paw

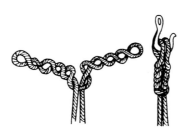

7. Racking hitch

Assorted D-Ring Ties

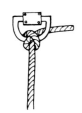

8. Half hitch

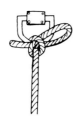

9. Slipped half hitch

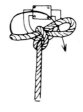

10. Slipped half hitch with tucked end

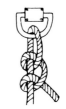

11. Double half hitch

Figure 7–70 Simple knots

Pipe Hitches

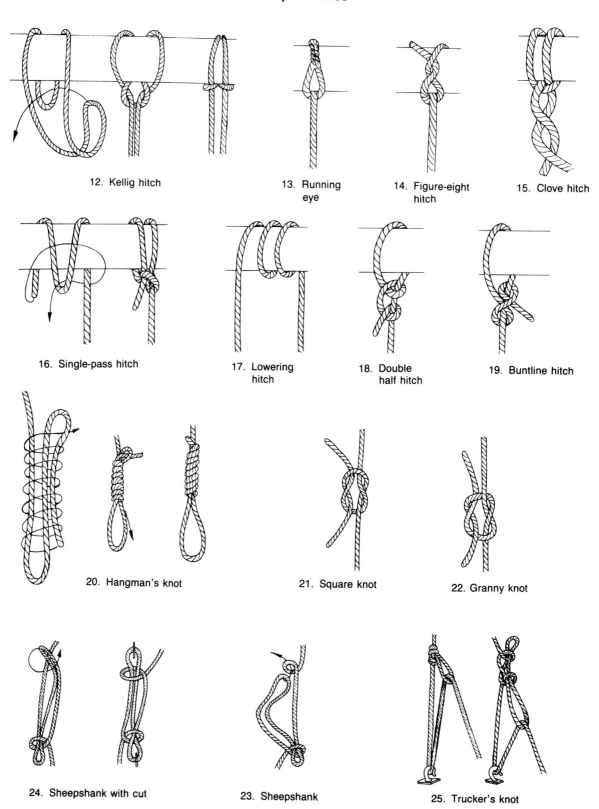

12. Kellig hitch

13. Running eye

14. Figure-eight hitch

15. Clove hitch

16. Single-pass hitch

17. Lowering hitch

18. Double half hitch

19. Buntline hitch

20. Hangman's knot

21. Square knot

22. Granny knot

24. Sheepshank with cut

23. Sheepshank

25. Trucker's knot

Figure 7–70 Simple knots (continued)

Chain

Grip Chain

We'll begin our discussion of chain with grip chain since it is used differently than all other chain in this business. Grip chain is not used for lifting or pulling as with other chains, but as a counterbalance chain for double-hung window sashes, arc lamp chain, animal chain, and for applications requiring a flat metal chain operating over pulleys. It is made of low carbon steel or bronze. It is also available in stainless steel, brass, and aluminum on special order. The links are flat and stamped. Standard finishes are bright, Blu-Krome (zinc plated), copper plated, and hot galvanized. Grip chain comes in 100-foot cartons (order unit is feet).

Grip chain is used extensively in film work. Never use this chain over its working load limit. Always use several bolt downs at each end of the chain for safety.

TABLE 7–21 GRIP CHAIN

Trade Size	Stock Thickness (inches)	Inside Length of Link (inches)	Working Load Limit (pounds)		Trade Size
			Steel	Bronze	
8	.035	.55	75	68	8
25	.042	.55	94	80	25
30	.028	.59	81	75	30
35	.035	.59	106	100	35
40	.042	.59	131	125	40
45	.050	.56	175	163	45
50	.060	.56	225	210	50

Chain Facts

Materials Grades

1. *Low-Carbon Steel:* Basic open hearth, 1005–1010 carbon steel grades, which meet the requirements for average nonheat-treated general-purpose chain products.
2. *High-Carbon Steels:* Basic open hearth, 1020–1030 carbon steel grades, which may be heat treated, thus providing higher impact strength, abrasion resistance, and tensile strengths than those afforded by low-carbon steel.
3. *High-Carbon Boron-Treated Modified Steel:* Basic open hearth carbon steel modified with boron that is heat treated to provide even higher impact strengths, abrasion resistance, and tensile strengths than high-carbon steels, which are necessary for transport chain applications.
4. *Alloy Steel:* Basic oxygen, electric furnace, or open hearth product that contains at least one of the following elements in an alloying amount: nickel, chromium, molybdenum, or their equivalents.

Boron, manganese, or silicon are not considered acceptable substitut elements in this context. The maximum percentage of impurities in th steel are phosphorus, .045% and sulphur, .045%.

These materials make it possible to produce the product in accordanc with the minimal requirements of the American Society for Testin Materials (ASTM), National Association of Chain Manufacture (NACM), and U.S. government specifications. Chain can be manufac tured from special materials upon request.

Material Sizes and Dimensions

The material sizes of the chain vary with the grade of product. Most com mercial welded chain, with the exception of systems 7μ and 8, is produce in wire diameters $1/32$ inch larger than nominal size. Consult the ap plicable product charts for these variances.

Chain is generally identified by the trade size and the system or grade Assemblies or cut lengths of chain are sometimes identified by *reach*. Thi is simply the measurement from the inside surfaces of the end components be it a link or a hook.

Nominal weights and dimensions are subject to plus or minute 4% toler ances. Where the product is manufactured to the metric system, the fol lowing conversion method may be used: millimeters to inches, divid millimeters by 25.4; inches to millimeters, multiply inches by 25.4; bas value: 25.4 mm = 1 inch.

Attachments

Be absolutely sure that any attachments you use with chain are of suitabl material and strength to provide adequate safety protection, that is, a minimum of matching the strengths. This is equally important for th devices or methods used to connect the attachments to the chain.

In addition to standard chain attachments such as hooks, rings, an swivels, Wizards, Inc., can furnish eyebolts, grab links, snaps, fastenin devices, and many types of special fittings. A sketch or print showin dimensions of any special chain attachments that may be required shoul accompany the inquiry or order along with the load rating that will be re quired of that component. **Warning:** Do not use weldless chain and attach ments made of low- and high-carbon steel for overhead lifting purposes

Proof Coil Chain

System 3 (Proof Coil Chain)

This is an excellent general-purpose chain of standard commercial quality for all ordinary applications not requiring high strength-to-weight ratios. It is frequently used for fabricating tow chains, binding or tie-down chain, and logging chains. *Do not use for overhead lifting.* Elongation minimum is 15% and it is proof tested. The chain is made of low-carbon steel and is electrically welded. Standard finishes are self-colored (SC) or hot galvanized (HG). It is also available in Blu-Krome (BK) $3/16$ inch through $3/8$ inch and polycoated ($1/2$-inch refill reel). Sizes 1 inch and above are hallmarked approximately 11 links apart (hallmark: C3). The chain comes in drums and half drums (order unit is feet); 100-pounds pails and refill reels are available to fit Campbell merchandisers (order unit is each). This chain is available in 1 inch and 1 $1/4$ inch on request. The last digit of the stock number changes to a 1 if a nonstandard quantity is ordered.

TABLE 7–22 PROOF COIL CHAIN

Inside Trade Size (inches)	Inside Length (inches)	Links Width (inches)	Per Foot (foot)	Working Load Limit (pounds)
1/8	.89	.29	13 1/2	375
3/16	.95	.40	12 1/2	750
1/4	1.00	.50	12	1,250
5/16	1.10	.50	11	1,900
3/8	1.23	.62	10	2,650
7/16	1.37	.75	8 3/4	3,500
1/2	1.54	.79	8	4,500
5/8	1.87	1.00	6 1/2	6,900
3/4	2.12	1.12	5 1/2	9,750
7/8	2.34	1.37	5	11,375

Trade Size (inches)	Working Load Limit (pounds)
3/16	750
1/4	1,250
5/16	1,900
3/8	2,650
1/2	4,500

High-Test Chain

System 4 (High-Test Chain)

High-test chain is designed for use in load binding, towing, logging, and other applications requiring higher strength-to-weight ratios than system 3. Do not use it for overhead lifting. Its elongation minimum is 15% (proof tested). The chain is made of high-carbon steel and may be heat treated. It is electrically welded. Standard finishes are shot peened (SP) and hot galvanized (HG). Blu-Krome (BK) is available in Cam-pails and reels only. Sizes ¼ inch through ½ inch are "Measure Mark" and "Hallmark" chains (hallmark: CH-C4). The chain comes in drums and half drums (order unit is feet). Pails and refill reels are available to fit Campbell merchandisers (order unit is each).

TABLE 7–23 HIGH-TEST CHAIN

Trade Size (inches)	Material Diameter	Inside Length (inches)	Inside Width (inches)	Links Per Foot	Working Load Limit (pounds)
1/4	.281	79	.40	15	2.600
5/16	.343	1.01	.48	12	3,900
3/8	.406	1.15	.58	10 1/2	5,400
7/16	.468	1.29	.67	9 1/4	7,200
1/2	.531	1.43	.76	8 1/2	9,200
5/8	.656	1.79	.90	6	11,500
3/4	.781	2.21	1.10	5 1/2	16,200

Alloy Chain

System 8 (Cam-Alloy Chain)

Alloy chain is specifically recommended for overhead lifting and applications that demand a combination of minimum weights and high working load limits. It elongates in excess of the 15% minimum requirement and

is proof tested. Alloy chain is made of heat-treated alloy steel and is electrically welded. It comes in shot peened and is packaged in continuous lengths in drums (order unit is feet). *Note:* Alloy chain is not to be used in the manufacture of chain slings. Campbell does not manufacture compatible attachments.

TABLE 7–24 CAM-ALLOY CHAIN

Trade Size (inches)	Material Diameter	Inside Length (inches)	Inside Width (inches)	Links Per Foot	Working Load Load Limit (pounds)
7/32	.218	.69	.30	17 1/2	2,500
9/32	.281	.86	.45	14	4,100
15/16+	.315	.94	.46	12 1/2	5,100
3/8	.394	1.10	.55	11	7,300
1/2	.512	1.55	.72	7 3/4	13,000
5/8	.630	1.84	.92	6 1/2	20,300
3/4	.787	2.20	1.09	5 1/2	29,300
7/8	.881	2.45	1.22	5	39,900
1	1.000	2.80	1.40	4 1/4	52,100
1 1/4	1.250	3.50	1.75	3 1/2	81,400

Passing Link Chain

Passing link chain has general utility and farming applications. Its link are electric welded and are sufficiently wide to pass each other easily, thereby minimizing tangling and kinking. It's made of mild steel in a bright finish and is also available in a Hi-Sheen alternate finish. Passing link chain is packaged 100 feet per carton.

TABLE 7–25 PASSING LINK CHAIN

Trade Size (inches)	Material Diameter	Inside Length (inches)	Inside Width (inches)	Links Per Foot	Working Load Load Limit (pounds)
2/0	192	.87	.46	14	450
4/0	218	.87	.50	14	600

Straight Link Machine Chain

This chain has general utility uses. It has electric welded, straight links, is made of low-carbon steel, and standard finish is bright. Alternate finishes available are Hi-Sheen and hot galvanized. It is packaged 100 feet per carton.

TABLE 7–26 STRAIGHT LINK MACHINE CHAIN

Trade Size	Approx. Material Size (inches)	Inside Link Dimensions (inches)		Links Per Foot	Working Load Limit (pounds)
		Length	Width		
4	.120	.53	.21	22.6	215
2	.148	.61	.26	19.6	325
1/0	.177	.74	.31	16.2	465
2/0	.192	.79	.34	15.2	545
4/0	.218	1.03	.42	11.6	700
5/0	.250	1.08	.45	11.1	925

Binder Chains

Wizards offers a complete line of tie-down chains. All chains listed here meet the new DOT regulations. System 3 (proof coil) has a self-colored finish and is used as a general utility chain. System 4 (high test) comes in a bright finish and is employed in heavy-duty trucking. System 7 (transport quality) is plated for higher strength and reliability. These chains are packed in bulk; order unit is each. **Warning:** Binder chains should *never* be used above the working load limit.

TABLE 7–27 BINDER CHAINS

System 3 (Proof Coil)

Size (inches by feet)	Pounds Each	Working Load Limit (pounds)
3/8 × 12	21	2,650
3/8 × 14	24	2,650
3/8 × 16	26	2,650
3/8 × 18	29	2,650
3/8 × 20	32	2,650
3/8 × 25	40	2,650

System 4 (High Test)

Size (inches by feet)	Pounds Each	Working Load Limit (pounds)
5/16 × 12	15	3,900
5/16 × 14	17	3,900
5/16 × 16	19	3,900
5/16 × 18	21	3,900
5/16 × 20	23	3,900
5/16 × 25	28	3,900
3/8 × 12	22	5,400
3/8 × 14	25	5,400
3/8 × 16	28	5,400
3/8 × 18	31	5,400
3/8 × 20	34	5,400
3/8 × 25	40	5,400

System 7 (Transport Quality)

Size (inches by feet)	Pounds Each	Working Load Limit (pounds)
5/16 × 12	15	4,700
5/16 × 14	17	4,700
5/16 × 16	19	4,700
5/16 × 18	21	4,700
5/16 × 20	23	4,700
5/16 × 25	28	4,700
3/8 × 12	22	6,600
3/8 × 14	25	6,600
3/8 × 16	28	6,600
3/8 × 18	31	6,600
3/8 × 20	34	6,600
3/8 × 25	41	6,600

Transport Chain

System 7 (Transport Chain)

Transport chain is designed for use in load binding, towing, logging, and many applications requiring higher strength-to-weight ratios than system

4. System 7 meets stringent DOT regulations with smaller chain that is lighter in weight and easier to handle. Do not use it for overhead lifting. Minimum elongation is 15% (proof tested). Transport chain is made of special high-hardenability boron-treated steel and is heat treated and electrically welded. It is plated with yellow chromate.

TABLE 7–28 TRANSPORT CHAIN

Trade Size (inches)	Material Diameter	Inside Length (inches)	Inside Width (inches)	Links Per Foot	Working Load Limit (pounds)
1/4	.281	.86	.45	14	3,150
5/16	.343	1.01	.46	11 1/2	4,700
3/8	.394	1.10	.55	11	6,600
7/16	.468	1.29	.67	9	8,750
1/2	.512	1.55	.72	7 3/4	11,300

Straight Link Coil Chain

This chain has general utility uses. It has electric welded, straight links, is made of low-carbon steel, and standard finish is bright. Alternate finishes available are Hi-Sheen and hot galvanized. It is packaged 100 foot per carton.

TABLE 7–29 STRAIGHT LINK COIL CHAIN

Trade Size	Approx. Material Size (inches)	Inside Link Dimensions (inches)		Links Per Foot	Working Load Limit (pounds)
		Length	Width		
4	.120	1.09	.21	11.0	205
2	.148	1.16	.26	10.3	310
1/0	.177	1.24	.32	9.7	440
2/0	.192	1.29	.33	9.3	520
4/0	.218	1.40	.39	8.6	670
5/0	.250	1.49	.45	8.0	880

Chain Connectors

The double clevis comes in self-colored or hot galvanized finish. It is packaged in bulk or individually as specified.

TABLE 7–30 CHAIN CONNECTORS

Chain Size (inches)	Max. Working Load Limit (pounds)	Pieces Per Carton	Approximate Weight (pounds)
1/4 or 5/16	4,700	10	.33
3/8	6,600	10	.46
7/16 or 1/2	11,300	5	1.1

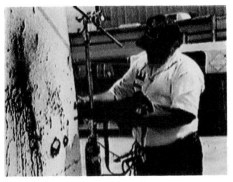

Figure 8-1 Example of hole made in a Celtex board at point-blank range by blank .45 caliber black powder shell

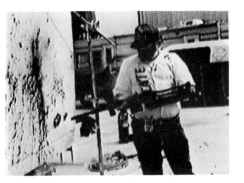

Figure 8-2 Example of hole made in a Celtex board at point-blank range by blank 12-gauge shotgun shell

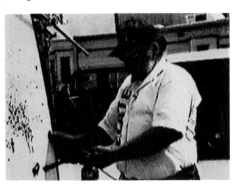

Figure 8-3 Example of hole made in a Celtex board at point-blank range by 9 millimeter shell

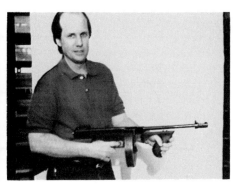

Figure 8-4 Thomson .45 caliber machne gun held by Sid Stembridge of Stembridge Rental

8

Weapons

Guns have been a part of motion pictures since *The Great Train Robbery* in 1903. It almost seems as though more guns have been shot in movies than film footage.

In most cases, prop masters handle these weapons, but in certain cases, the special effects people do. I usually take care of all weapons on any shoot that I'm working and for good reason. I'm a fully licensed dealer, licensed by federal, state, and local authorities to handle pistols, revolvers, machine guns, shotguns, heavy weapons, and assault rifles.

Most firearms used in film are standard operating weapons. The sole difference is that blanks are used instead of real bullets. Blanks range in power from one-quarter up to full charged loads. Regardless, all blanks are dangerous within 15 feet. Full-charge blanks create as much thrust as real bullets and the waxed cardboard wadding that seats the powder in place can penetrate the skin and injure or kill. Consider the tragic death of a young up-and-coming TV star who shot himself in the head while playing Russian roulette on the set between takes with a blank gun, and you will understand these are not toys.

You must be very careful of people's eyes and faces when firing blanks since injury can be caused by specks of paper and debris. Never leave blanks unattended and never leave a gun loaded. Always treat every prop weapon that you handle, even if you "know" it is unloaded, as if it were loaded. There is an old saying that unloaded guns have killed as many people as loaded ones (Figures 8-1, 8-2, and 8-3).

Semiautomatic and Automatic Weapons

With semiautomatic and automatic weapons, certain modifications are necessary in order to fire blanks. The muzzle of the weapon must be threaded so that you can insert a cylinder into it. Once it is locked in, drill it to a much smaller diameter than the cartridge for which it was designed. When fired, the blank causes the weapon to react in much the same way as if a real cartridge had been fired.

Basically, propellant gases are tapped off from a point along the barrel and diverted even while the bullet is being propelled through the barrel. This is safe because the diverted gases have to overcome the inertia of a gas piston, which eventually moves to the rear of the weapon, taking with it the breechblock from the fixed barrel. This gas pressure usually provides all the propulsion required until a point is reached where the breech is far enough to the rear for the gases to be vented through open ports in the receiver. Springs then return the piston and the breechblock to the start position, loading a new round in the process.

Needless to say there are several variations of this principle, but they all operate along the same general lines. The blank acts very similarly to the bullet, providing the gases and therefore the back pressure to move the breechblock (Figures 8-4 through 8-10).

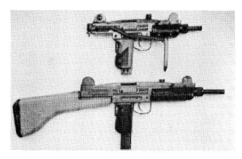

Figure 8–5 Uzi mini and Uzi 9 mm

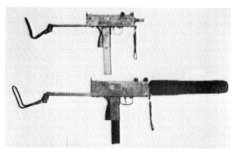

Figure 8–6 Mac 11 (top) and Mac 10 (bottom), .45 caliber or 9 mm with silencer

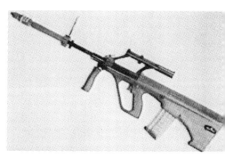

Figure 8–7 Steyr 5.56 mm-Aug

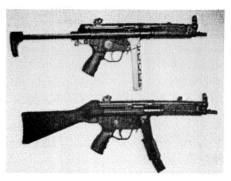

Figure 8–8 9 mm H&K MP 5A3 (top) and H&K MP5A2 (bottom)

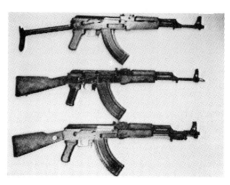

Figure 8–9 7.62 mm AKM-47

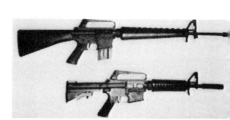

Figure 8–10 5.56 mm M-16 (top) and CAR-16 (bottom)

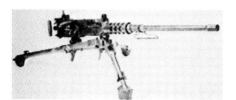

Figure 8–11 Browning .50 caliber machine gun

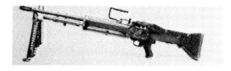

Figure 8–12 7.62-mm M-60 Machine gun

Machine Guns Using Belt-Fed Ammo

Weapons such as .50 caliber machine guns are very expensive to fire. Ammunition costs approximately $2 per round. In addition, you have to plug the muzzle of the weapon and install a "blank breech" in the gun to enable the shells to feed properly and fire correctly.

These weapons, especially the .30 caliber machine gun and the .50 caliber machine guns shown in Figure 8–11, should never be fired continuously because they will heat up and jam. Firing is done in short bursts, usually no more than four or five rounds at a time. The M-60 machine gun (a belt-fed .308 caliber weapon) should also be fired only in short bursts (Figure 8–12).

Mortars

Mortars (Figure 8–13) are a different breed altogether. Blanks of .44 caliber are mounted on the bottom of the shells. When dropped down the tube, the shell strikes a firing pin, exploding the blank and blowing smoke from the muzzle, making it appear that the mortar has fired.

Bazookas and Rocket Launchers

There are many different types of rocket guns such as the Soviet built rocket grenade and the American bazooka. These weapons require a different technique because they are essentially tubes open at both ends (Figures 8–14 and 8–15a and b).

102

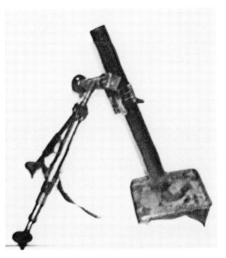

Figure 8-13　40 mm Mortar

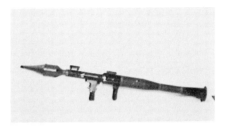

Figure 8-14　Soviet built RPG grenade launcher

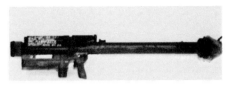

a

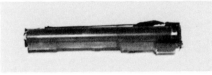
b

Figure 8-15　(a) 4.7 mm Bazooka (American); (b) Laws rocket launcher

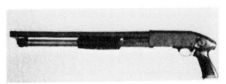

Figure 8-16　12-Gauge Ithaca Undercover pump shotgun

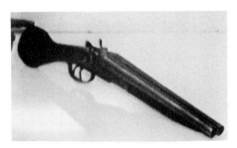

Figure 8-17　12-Gauge double-barrel sawed-off shotgun. Note: A Federal license is required to use this equipment.

Figure 8-18　Semiautomatic MM1 multiround projectile launcher fires tear gas and rockets. This equipment was used in *The Dogs of War*.

Figure 8-19　Street sweeper 12-gauge semiautomatic shotgun

Commonly one small black powder charge is placed in the muzzle of the bazooka and another in the rear. A flash charge can be added to give a more dramatic look to the back flash.

Esty rockets are wire guided. A wire is run through the barrel of the weapon and the shell, usually made of balsa wood or lightweight cardboard, is attached to it. The Esty is mounted on the tail of the rocket. When fired, the rocket runs down the wire to the target, which has been previously rigged with explosives. When it hits, the explosives are ignited, completing the effect.

Shotguns and Semiautomatic Shotguns

Shotguns are by far the most dangerous weapons to use in a scene (Figures 8-16 and 8-17). The 12-gauge shell comes in one-quarter loads, one-half loads, full loads, in black powder loads for day shots and flash powder loads for night shots. Because of the size of the shell, there is a great deal more powder than in most shells, creating a potentially dangerous situation when an actor must fire the weapon at another nearby actor. The weapon should never be fired at anyone closer than 20 feet. Semiautomatic shotguns hold up to 12 rounds of 12-gauge shells and can be fired as fast as the trigger can be pulled (Figures 8-18 and 8-19).

9

Nonpyrotechnic Projectiles

Projectile effects have been a staple of motion pictures since their earliest beginnings. In 1903, Edwin S. Porter of the Edison Company directed the first creative film drama ever made in America. Called *The Great Train Robbery*, it was based on the story of Butch Cassidy and the Sundance Kid. It ran barely ten minutes, but in that brief time established a blueprint for countless westerns to follow. Considering how primitive the industry was in that era, it was a truly remarkable film, employing innovative editing and cinematic techniques. By far the most startling and exciting moment contained in those few feet of film was that brief image at the end when the chief villain, played by George Barns, pointed his six-shooter out at the audience and fired.

In the nearly ten decades since those first silent gunshots, millions of bullets, spears, knives, and arrows have punctured thousands of actors in hundreds of films, unfortunately not always safely. As late as the 1930s, danger to the performer was still an everyday reality. In the 1930 film *Little Caesar* starring Edward G. Robinson, a scene takes place where Robinson as Little Rocco leans against a brick wall, his head inches away from where live rounds from a .45 caliber machine gun are being fired by an expert marksman. Needless to say, no one today would subject a performer to that kind of danger.

Bullet Hit Effects

Bullet hit effects fall into two categories: nonpyrotechnic and pyrotechnic. Pyrotechnic deals with projectiles launched or exploded by electrical or chemical charges. Our concern here is with nonpyro or "soft" bullet hits.

Skin Hits

There are four kinds of soft bullet hits used on the skin of an actor:

1. cotton wads soaked in stage blood
2. stearic acid skin hits
3. cooked canned peas (dyed red)
4. pop-off hits

The cotton wad, stearic acid, and pea hits share a certain commonality. Each is soaked in a red dye and then delivered by means of a blowtube not dissimilar in design and use from that used by aboriginal natives in the Amazon. Insert the projectile into the tube and blow a puff of air, thus launching it.

The pop-off, or snap-off effect is somewhat more difficult. A small piece of latex rubber designed to match the actor's skin tone is attached to a very fine (approximately 1-pound test) monofilament line. Next, the area of the actor's skin designated as the target point is made up to simulate a wound.

The latex is attached over the wound and covered with the appropriate makeup. On cue the operator pulls the monofilament, yanking off the latex covering and thus giving the appearance of a hit.

By far the best bullet effect is the stearic acid. First you must make the mold.

Constructing the Stearic Acid Blood Hit Mold Making the stearic acid hit is a wax-formed mold process. Construct the mold from a piece of 1½-inch round aluminum stock approximately 3 inches long. Drill a hole the size of the bullet you are using through the center of the round stock corresponding to the caliber of the simulated bullet. Form a rod on a lathe and turn it down to fit it snugly in the hole. The rod must slide freely (Figure 9–1a).

Next, drill a ¼-inch hole in the side of the block and thread it for a ¼-inch bolt that serves to hold the rod at any desired position. By sliding the rod up or down you can make the projectile any length you need (Figure 9–1b).

Once the rod is constructed, use it to extract the bullet from the mold. A bullet ¾ inch to 1¼ inches long is usually sufficient. Lubricate the inside of the mold with a drop or two of kerosene and then allow it to drain. This will ease the extraction of the finished bullet.

Constructing the mold is a delicate, tedious, and time-consuming process and thus a single bullet mold has little useful application. A six-bullet mold can be used if more than one hit is used at the same time (Figure 9–1c).

Making the Stearic Acid Mold Hit Stearic acid is basically a white, crystalline, fatty acide that can be obtained at any chemical supply com-

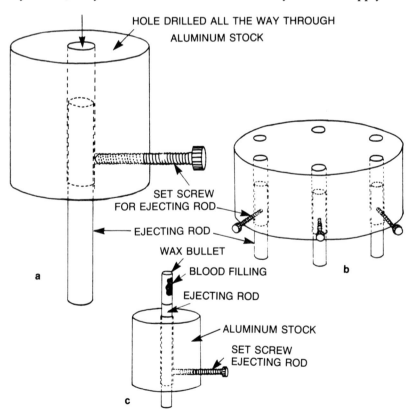

HOLE DRILLED ALL THE WAY THROUGH
ALUMINUM STOCK

SET SCREW
FOR EJECTING ROD

EJECTING ROD

WAX BULLET

BLOOD FILLING

EJECTING ROD

ALUMINUM STOCK

SET SCREW
EJECTING ROD

a

b

c

Figure 9–1 Stearic acid bullet hit molds: single bullet (a and c); six-bullet mold (b)

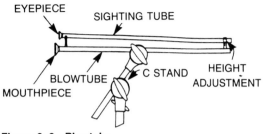

EYEPIECE SIGHTING TUBE

BLOWTUBE C STAND HEIGHT
MOUTHPIECE ADJUSTMENT

Figure 9–2 Blowtube

pany. It remains soft for approximately 30 minutes, so be sure you do not make up the hits until they are needed for the take.

First, spray the inside of the mold with a mold release such as kerosene. Then heat the stearic acid in a metal container until it melts. Pour it into the mold and leave it standing for approximately five seconds. Pour away the excess material. Once the mold sets, check the thickness of the wall of the projectile to ensure that it remains about $1/32$ inch.

Using an eye dropper, drip a blood mixture into the mold, keeping the blod level around $1/16$ inch from the top. Top it off with an additional droplet of stearic acid and wait until it's hard. Then trim all the excess from the bullet tip. Loosen the screw at the side of the mold and gently tap until the hit is free. Make sure you do this carefully, as the slightest pressure will crack it. These delicate bullets should be protected in a cotton-lined box until you need them.

Delivery Systems for Nonpyrotechnic Projectiles

There are three basic delivery systems: blowtube or air bellows, compressed air, and gun.

Blowtube

When using a blowtube, it is important that the diameters of both the projectile and the aluminum tube correspond to the caliber of the projectile. To deliver the hit, slip it into the tube, attach the tube to a grip stand, and clamp it down (Figure 9–2).

Aiming at the target is done by barrel sighting, that is, through the barrel itself. For optimum accuracy place the tube about 6 to 8 feet from the target. Put a small dot on the target and sight that mark through the firing barrel. First lock the blowtube down and then find that same dot through the sighting barrel by adjusting the knob on the front of the barrel. When they match, you are ready to load the bullet hit. Once it is loaded recheck through the sighting barrel just before shooting.

A good-looking shot can be achieved when the camera is in closeup on the target and then cuts away a split second after impact. You can do blowtube hits while the target is moving but accuracy suffers.

Air bellows rather than lung power can be used to propel the bullet, but it is rarely used (Figure 9–3). **Caution:** *Under no condition* should compressed air, gas, or an air hose be used with the air bellows. The velocity is much too high and can be extremely dangerous.

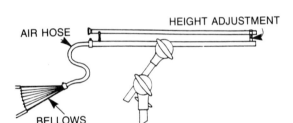

AIR HOSE HEIGHT ADJUSTMENT

BELLOWS

Figure 9–3 Bellows-powered blowtube

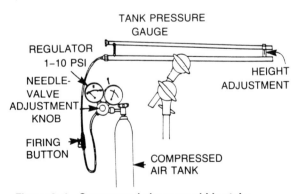

TANK PRESSURE
GAUGE

REGULATOR
1–10 PSI

NEEDLE-
VALVE
ADJUSTMENT
KNOB HEIGHT
 ADJUSTMENT

FIRING
BUTTON

COMPRESSED
AIR TANK

Figure 9–4 Compressed air-powered blowtube

Compressed Air Delivery

Although compressed air cannot be used with an air bellows, it can be used with a low-range air regulator if 4 to 7 pounds pressure is used (Figure 9–4). Remember to test the shot on your hand first as a safety precaution. Never have more than 4 to 7 pounds of pressure when firing. This pressure level can be achieved with a good low pressure regulator. As always, be sure to test your setup prior to the shot on a piece of cardboard as a safety precaution.

Since a wind or breeze often affects the accuracy of the light stearic acid hits, it is obviously important to compensate for wind conditions during rehearsals to avoid time consuming, and therefore expensive, reshoots caused by misses.

Nonpyrotechnic Projectiles

Figure 9–5 The Sweeney gun, the most accurate and expensive gun made, is fully automatic and .68 caliber.

Figure 9–6a .60 caliber machine gun for round hits. Fires 20 air- or nitrogen-powered rounds.

Figure 9–6b Ball hit gun. .68 caliber pump rifle fires 20 air- or nitrogen-powered rounds.

Gun Delivery

Aside from blowguns, air bellows, and compressed air delivery systems, there are several gun delivery methods for nonpyrotechnic bullet hits, such as compressed air guns, carbon dioxide, or nitrogen guns. Three of the most widely used are discussed below.

Sweeney Gun A Sweeney gun is used to shoot dust hits, spark hits, glass hits, or steel balls (Figure 9–5). The difference between a Sweeney gun and a capsule gun (discussed below) is that the Sweeney gun fires .60 or .68 caliber steel or two-piece plastic ball bullets while the capsule gun fires steel balls and no. 13 gelatin capsules.

Capsule Guns and Ball Hit Guns These weapons are used to propel no. 13 gelatin capsules and steel balls fired by compressed air or nitrogen supplied from a separate tank. The gas pressure is delivered to the gun through a high-pressure hose and controlled with an adjustable regulator. These weapons are manufactured in semiautomatic, automatic, and pump action models (Figure 9–6a and b).

For optimum accuracy, the gas pressure needed for glass hits and blood hit capsules is between 40 to 60 psi (pounds per square inch). Dust hits require 65 psi, while 90 to 100 psi is needed to break glass with steel balls.

Capsule and Round Ball Hits

The following projectiles are those most commonly used and are adaptable to countless situations. Whether you use a capsule or a round ball depends on the delivery system you are using and what it requires (see Figures 9–7 and 9–8 for a comparison of capsule versus round ball hits).

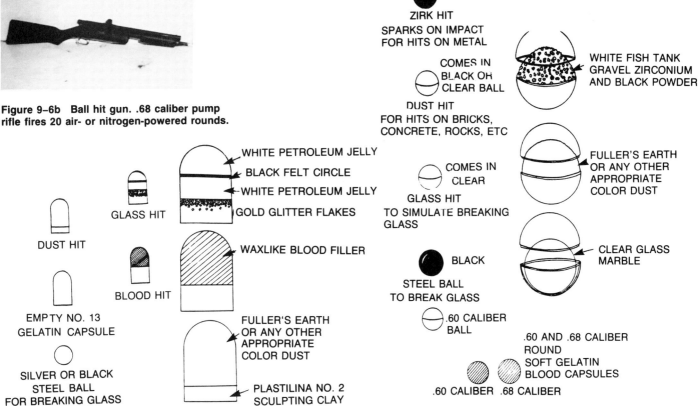

Figure 9–7 Capsule hits

Figure 9–8 Round .60 and .68 caliber hits

107

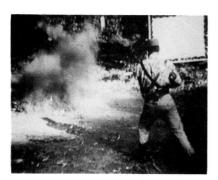

Figure 9–9a Trailing dust hits

Figure 9–9b Air driven machine gun for dust-blood and glass hits

Dust Hits A dust hit is a round ball fired from a compressed air, carbon dioxide, or nitrogen rifle. On impact with the target, the ball explodes in a puff of dust that looks amazingly like a bullet ricochet. This is very effective when targeted on rocks, asphalt or dirt roads, sand, brick, and stone. The dust in the hit must approximate the color of the target but not match it exactly. Rather, it should be several shades lighter for contrast and definition.

Air-powered automatic and semiautomatic capsule guns are often used to fire dust hits, particularly in strafing, trailing, or "running bullet" camera shots (Figure 9–9a and b). For a more detailed discussion of how to achieve the look of "running bullets," see Box 9–1 on the next page.

Zirconium Spark Hits These are manufactured with a product called Zirconium (Zirk). Spark hits or Zirks are used to simulate a bullet ricocheting off metal, only in the rarest instance off any other surface. You've seen the effect in thousands of movies such as *Die Hard, Lethal Weapon,* and so on.

The round ball is made in either .60 or .68 caliber depending on the weapon used. A small amount of Zirk (approximately the size of a match head) is mixed with enough fine fish tank gravel to fill the two halves of the plastic ball. The two halves are then glued together (Figure 9–8).

It is important to always fire a Zirk so that it strikes the target at an angle. If it hits the target straight on, it will stick to the surface and continue to burn with sputtering sparks for several seconds, ruining the effect. **Caution:** Exercise extreme care when handling Zirconium. Never use or make these hits unless you have been thoroughly trained. They are very dangerous. *Never* aim the weapon or fire a spark hit at actors or animals.

Steel Balls Steel balls are often used in Sweeney guns to break glass, pottery, lamps, and various breakable props. You must be particularly careful to clear the set of unnecessary personnel before using steel balls. Not only do they cause shrapnel, but they also commonly ricochet around a set as if it were a pinball machine.

Glass Hits Glass hits or gel caps simulate bullets punching through glass. In reality, no penetration or damage is caused by the gelatin capsule. The residue of gelatin and petroleum jelly can be wiped from the windshield or glass, and the shot can be redone in seconds.

These hits are simple to make. Fill the bottom of a gelatin capsule with a quarter inch of petroleum jelly. Next insert a pre-sized piece of black felt on top of the jelly. Then add another layer of jelly until nearly full. Add a sprinkle of fine silver or gold glitter (see Figure 9–7).

When fired, the "bullet" hits the glass, and the glitter and jelly fan out into a large circle, leaving the black felt in the center. This gives the look of bullet shattered glass. It is important to fire a glass hit straight at the target. Otherwise it will slide on impact and look more like a splattered bug than a bullet hole.

Knives, Arrows, and Spears

Launching Methods

How you launch the knives, arrows, or spears called for in a scene depends upon the needs of the film, who's doing the shooting, and the

Figure 9-10a Body armor chest plate

Figure 9-10b Body armor back plate

Box 9-1 Running Bullets

On an esthetic note, it is interesting that logic is often thrown away when it comes to "trailing" or "strafing" a target, known as the "running bullet" shot. When possible, the director should consider the nature of ballistic trajectory when laying out a shot.

A commonly seen motion picture convention is a profile shot wherein either a stationary or moving target is trailed by hits along the ground and then is hit in the body or upper torso. Common sense dictates that a weapon firing at a target parallel to itself will produce a flat trajectory and therefore is constant, unless there is relative aim or target compensation. If no change in aim or position (i.e., upright or prone) of the target occurs, the target would have to be struck in the ankles.

A possible solution is to indicate multiple weapons being fired with some bullets falling short (hitting ground) and others aimed high and striking the target. This strategy was effectively demonstrated in *Platoon* during Willem Dafoe's death scene.

When a single weapon is used, an imaginative way of indicating a compensation in aim is to have the hits strike in back and front of the target and then traverse back at a raised elevation. The raised elevation can be shown by wall or tree, hits at the actor's chest, or by judicious editing.

There are two types of guns used for trailing a target, the .60 or .68 caliber automatic or semiautomatic ball weapons. The bullets themselves are the two-piece plastic balls, filled with fuller's earth and sealed with glue. Occasionally, the glue prevents the balls from fitting in the weapon's barrel. In these cases, the ball can be fired with a slingshot. Always size these projectiles before loading them in the gun as even a relatively slight deviation will cause a stoppage. These balls can also be filled with stage blood and used for body shots. But be aware that they are hard, more so since they are being fired from a gas-pressured weapon. An inaccurate shot can cause serious injury. Instruct the actor or stunt professional to wear body armor of metal with leather padding for protection. Various pieces of armor are designed to protect the chest, back, arms, and legs, depending on what is needed for safety (Figure 9-10a and b).

range to the target. Arrows, knives, and spears can be launched by slingshots, bungee cords, mouse traps, surgical tubing, knife guns (air or nitrogen powered, wireless arrow guns (also air or nitrogen powered), wire-controlled arrow guns, or wire-controlled knives and spears. We'll discuss the last three devices.

Wireless Arrow Gun The wireless arrow gun operates on compressed air and fires a free-flying (that is, unguided) projectile. The arrow contains a small piston at the rear that is depressed by the compressed air, thus launching it (Figure 9-12). It should only be used by people who are excellent shots.

Recently I worked with Martin Mull on a shoot that required that he be hit with an arrow. I elected to use the wireless arrow gun.

The scene called for Martin to be hit and fall into a pond. When he was shot with the arrow he fell into the pond, but we had to redo the shot several minutes later.

Naturally, Martin was wearing a steel chest and back plate with the regulation 1½-inch hard wood lined with leather and sheep's wool padding so that he was well protected.

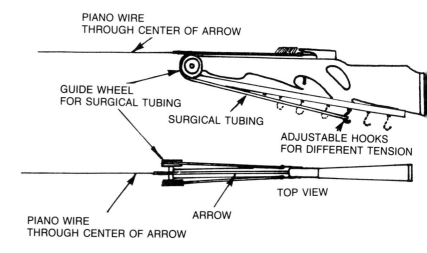

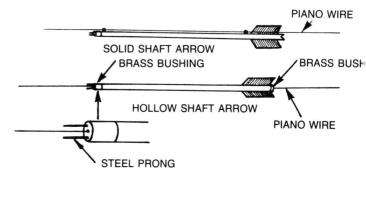

Figure 9–11 Wire arrow gun

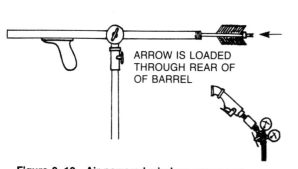

Figure 9–12 Air-powered wireless arrow gun

I was about 12 feet away from him when I fired the first arrow. When it came time to redo the shot, I fired again, the director called for a print, and we avoided another retake. A few minutes later Martin bounded out of his dressing room and strode over to me thrusting his protective body armor at me.

"Take a look at this!" he demanded, jabbing his finger at the plate.

"What's wrong with it?" I asked somewhat surprised.

"Look," he said, "there's only one hole in this plate! You shot two arrows, didn't you?"

"Yeah," I said, "but I'm an excellent shot!"

The second arrow had gone into the exact same hole as the first. Pure luck, but I didn't tell him that.

Wire-Controlled Arrow Gun Simply stated, wire arrow guns shoot arrows along a wire. They are very similar in construction to a crossbow without the bow. Using a shock cord or surgical rubber to provide the thrust, an arrow (most often hollow in construction) is fired toward its target. The arrow can also have a solid shaft.

The wire is inserted through the center of the arrow and allowed to slide easily in order to enable the arrow to slide smoothly. The fittings on either end of the arrow enhance its smooth flight (Figure 9–11).

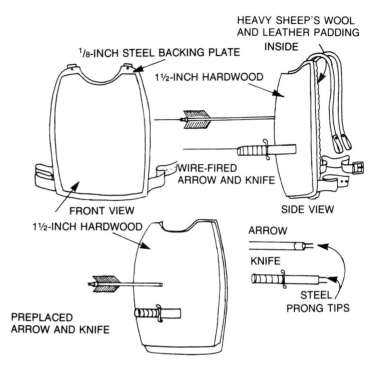

Figure 9–13 Protective armor for wire arrow and knife or air-fired arrow

One end of the wire is attached to the bow and the other to a hole in a steel plate that is worn by the actor. Fronting that steel plate is a 1½-inch section of hardwood (Figure 9–13). It is into this that the arrow will stick. The end of the arrow itself has two steel prongs at the tip.

When the arrow is shot down the wire, the operator must make sure that the wire is as taut as possible. If the actor is moving, the operator must move along with him or her keeping the proper tension. An excellent example of this technique can be found in the film *Red River*. During the Indian attack on the wagon train, Joanne Dru is hit in the shoulder with an arrow. The effect was both startling and subtle, and heightened the impact of the sequence.

This effect can be set up so that as the arrow hits its target, the guide wire is cut and the actor or object can fall naturally. Even during a closeup shot, the wire is almost entirely invisible. The wire can be darkened using gun blueing if greater masking is necessary.

Box 9–2 Making Arrow and Spear Projectiles

There are several different types of arrows utilized in special effects. Two of the most common are hollow arrows and solid shaft arrows. Either arrow shaft, hollow or solid, can be used virtually interchangeably except in one particular instance. When an arrow is guided by an interior wire, the hollow shaft must be used. Both require different preparations.

To prepare the solid shaft arrow or spear to shoot down a wire, install small eyelets on the front and back of the shaft and affix those to the wire.

For the hollow shaft arrow, replace the tip with small brass fittings. Have the holes drilled in the center and put the wire through. Both arrow types are launched the same way.

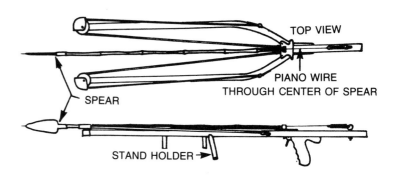

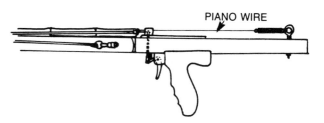

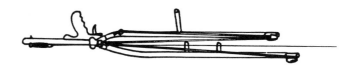

Figure 9–14 Wire spear gun

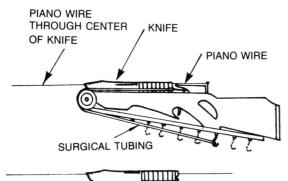

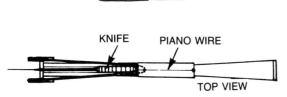

Figure 9–15 Wire knife gun

Wire-Controlled Spears and Knives When working with spears and knives, a similar wire construction is attached to the plate worn by the actor. A wire is run from the plate through mountings on the projectile and attached to a holding device or stand. A wire knife gun, wire arrow gun, of wire spear can also be used (Figures 9–14 through 9–17) with a slingshot. The slingshot can then be used to propel the knife down the wire into the plate. The point of the knife should be cut off about 3 inches from the tip so that when it hits it looks as if it has penetrated the target.

Variety of Knives, Arrows, Spears, and Guns
Nonpyrotechnic projectiles come in various shapes, sizes, and designs, all of which are used extensively in the business.

1. *pop-out knives and arrows:* These spring-loaded devices are designed to pop out from beneath a costume. They are masked from the camera and activated by the actor on cue. Split-second timing is crucial so that it appears that the actor has actually been struck by the arrow or knife. Often, however, there is some crossover with regard to timing. This is not especially crucial since much of it can be picked up in the editing room. Additionally, the sequence happens so quickly it is impossible to see the actual action of the arrow or knife in the spring-loaded device (Figure 9–18).

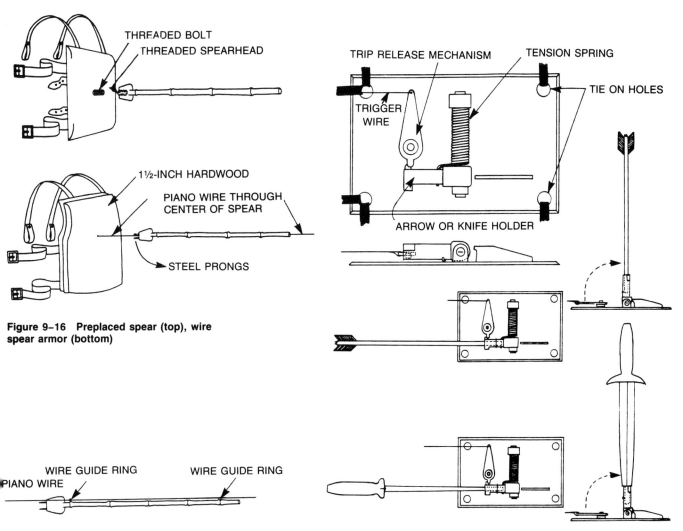

THREADED BOLT
THREADED SPEARHEAD

1½-INCH HARDWOOD
PIANO WIRE THROUGH CENTER OF SPEAR
STEEL PRONGS

Figure 9–16 Preplaced spear (top), wire spear armor (bottom)

TRIP RELEASE MECHANISM TENSION SPRING
TIE ON HOLES
TRIGGER WIRE
ARROW OR KNIFE HOLDER

WIRE GUIDE RING WIRE GUIDE RING
PIANO WIRE

Figure 9–17 Solid shaft spear

Figure 9–18 Pop-up device (top), pop-up arrow (middle), pop-up knife (bottom)

2. *rubber knife:* A most familiar prop, a rubber knife is made out of pliable rubber (Figure 9–20a).

3. *telescoping knife:* The blade (in some cases only the tip) of the knife retracts into the handle (or blade) to simulate penetration (Figure 9–20b).

4. *preplaced knives, arrows, and spears:* These devices are permanently mounted onto a plate and strapped to the actor's body. Some of them have a release mechanism that holds the knife to the plate with two small prongs and are released by the actor. Once stage blood is added, you have a victim with a knife sticking into him or her (Figures 9–20c and d).

5. *knife gun:* A knife is positioned into the firing mechanism and fired free hand (i.e., without a wire assist) at a person wearing a chest or back plate of steel, leather, padding, and hardwood (1½-inch thickness).

6. *wire-controlled knives, arrows, and spears:* As previously discussed, these devices are wire guided (Figures 9–14 and 9–15).

7. *reverse pull:* A knife is shot into a wooden plate and attached to a wire. On cue, the knife is yanked out by the operator. In editing, the shot is reversed, making it look as if the knife is going into the actor instead of coming out.

113

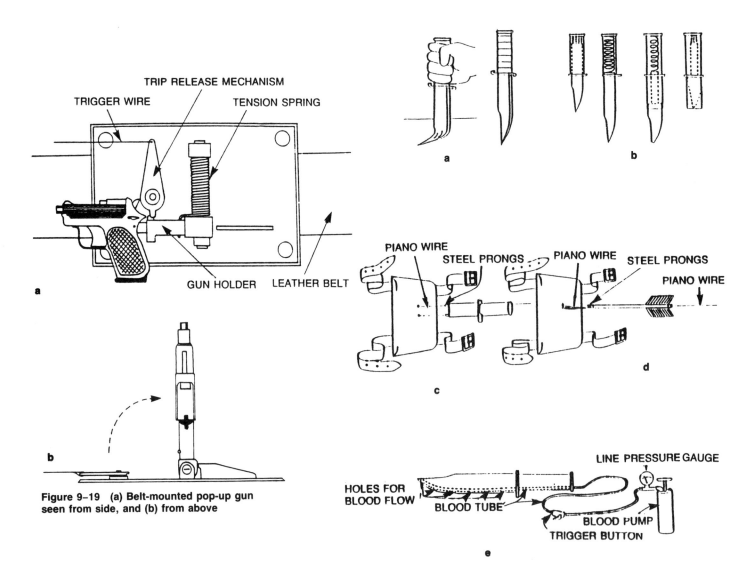

TRIGGER WIRE

TRIP RELEASE MECHANISM

TENSION SPRING

GUN HOLDER LEATHER BELT

a

b

PIANO WIRE

STEEL PRONGS PIANO WIRE

STEEL PRONGS

PIANO WIRE

c

d

LINE PRESSURE GAUGE

HOLES FOR
BLOOD FLOW

BLOOD TUBE

BLOOD PUMP

TRIGGER BUTTON

e

Figure 9–19 (a) Belt-mounted pop-up gun seen from side, and (b) from above

Figure 9–20 (a) Rubber knife (b) Telescoping knives (c) Preplaced wire knife (d) Preplaced or wire arrow (e) Blood knife

8. *knife throwing:* This is not recommended unless you are an excellent knife thrower. The dangers are obvious! The same methods of padding and protection for the actor are used as previously explained.
 Caution: Whenever using any of these devices, it is imperative that body armor and protective plates always be used on your actors and stunt professionals. Safety must be a prime consideration.
9. **blood knife:** A perforated tube is attached to the knife's blade. It emits blood when the special effects person activates a release button on the blood pump. The pump pressure can be preset either to trickle or gush (Figure 9–20e).

Pyrotechnics

Figure 10–1a Large gas explosion

Pyrotechnics are undoubtedly the most dangerous effects to preform safely in the business. It is the nature of explosives that they are always, to a degree, volatile and unpredictable. Though I've done countless pyrotechnic effects, I always approach the gag with the same care, preparation, and respect for the explosive materials as when I did my first pyrotechnic special effect.

During the shooting of *Kill Me Again*, starring Val Kilmer, I did several pyrotechnic effects. Each presented a different set of demands on safety and preparation and each was in its own way extremely dangerous. I remember in particular one of the final gags in which a speeding car crashed into a storage tank and exploded into rolling balls of flame. No fewer than 200 separate steps in rigging, explosive preparation, safety checks, and split second timing had to be taken to guarantee that the shot would come off in one take. Preparation for *The Fisher King* was if anything even more demanding. The specific techniques used in that film will be discussed later in Chapter 14, but the important point here is that no one should ever attempt such complex effects without a thorough knowledge of all aspects of explosives and intensive training in their use.

In this chapter, we will examine the types, methods, and uses of pyrotechnic devices and the creation of explosions and fires for everything from bodies to buildings (Figure 10–1a–e). Don't assume, however, that this will prepare you to execute these gags. Nothing, especially with pyrotechnics, substitutes for training and experience.

Figure 10–1b Burning building

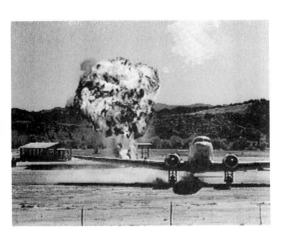

Figure 10–1c Gas drums explode

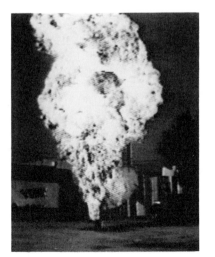

Figure 10–1d Lacapodium explosion

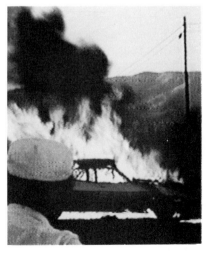

Figure 10–1e Car explosion

Licensing

DOT Regulations

Transport of pyrotechnics is controlled by the U.S. Department of Transportation (DOT). It publishes a handbook on methods of transportation and procedures for pyrotechnics, plus rules and regulations for safety factors and the laws involved.

You are required to have a federal license to use pyrotechnics. Be aware of the regulations and comply with the laws. The regulations and specifications vary from state to state and from country to country. In California, they are set forth in Chapter 2–62, Part 2, of the 24 California Code of Regulations and in the Uniform Fire Code 77.203 and title 19, California Code of Regulations.

BATF Regulations

Explosives and pyrotechnics are controlled by the U.S. Bureau of Alcohol, Tobacco, and Firearms (BATF). You need a federal license to use explosives. The bureau can send you all the necessary information you require.

TABLE 10–1 BATF AND DOT RATINGS FOR SPECIAL EFFECTS

	BATF	DOT
Common photoflash composition	Low	B: Special fireworks
Smoke flash composition	Low	B: Special fireworks
Illumination composition	Low	B: Special fireworks
Atomized flash composition	Low	B: Special fireworks
Two-component	Common photoflash Atomized flash Illuminating composition	packaged for passenger aircraft shipment: 2 ounces
Simulated phosphorus	Low	B: Special fireworks
D-2 sparking granules	Low	B: Special fireworks
Black match	Low	C: Instantaneous fuse
Silver match	Low	C: Instantaneous fuse
Arching match: Light	Low	C: Instantaneous fuse
Medium	Low	C: Instantaneous fuse
Heavy	Low	C: Instantaneous fuse
Safety fuse	Low	C: Safety fuse
Thermalite fuse	Low	C: Igniter cord

TABLE 10–2 BATF AND DOT RATINGS FOR DET CORD*

Det Cord	BATF	DOT
4 grain	High	C: Cord, Detonating
7 1/2 grain	High	C: Cord, Detonating
15 grain	High	C: Cord, Detonating
18 grain	High	C: Cord, Detonating
25 grain	High	C: Cord, Detonating
30 grain	High	C: Cord, Detonating
50 grain	High	C: Cord, Detonating
100 grain	High	C: Cord, Detonating
150 grain	High	C: Cord, Detonating
200 grain	High	C: Cord, Detonating
400 grain	High	C: Cord, Detonating

*Note that *det cord* is an explosive. See discussion of det cord that follows later in this chapter on page 121.

TABLE 10–3 BULLET HITS

Ignition Squibs	BATF	DOT
D-80 series (flat)	Low	C: Electric squib
D-60 series	Low	C: Electric squib
Microhits	Low	C: Electric squib
SD-70 series	Low	C: Detonators, class C, Explosive
SD-100	Low	C: Detonators, class C, explosive
MD-1	Low	C: Detonators, class C, explosive
Z-16	Low	C: Electric squib
Z-16A	Low	C: Electric squib
Z-17	Low	C: Electric squib
Z-17A	Low	C: Electric squib
A-5	Low	C: Electric squib

TABLE 10-4 SMOKE POTS

	BATF	DOT
1 × 9 gray, black, white (squibbed)	Low	C: Smoke pot
Chem orange/yellow	Low	C: Smoke pot

TABLE 10-5 SMOKE COMPOSITION

	BATF	DOT
D 105 White		
D 125 Black		
D 103 Light gray		
D 113 Medium gray		
D 111 Dark gray		
1-pound cartons	Low	B: Special fireworks
4-ounce cartons	Low	C: Smoke pot
Chem orange or chem yellow	NA	NA
Colored smoke	Low	C: Smoke pot

Figure 10-2 Day box for pyrotechnic storage on set

Storage of Pyrotechnics

Very few people in the business store pyrotechnics. They buy them the day before. However, you should have your own storage safe, or *magazine*, and a day box for transporting the small quantities to be used at a specific time on the set (Figure 10-2).

Storage magazines come in different sizes and shapes and are built to different specifications that are determined by local, state, and federal authorities. Requirements for magazine dimensions vary widely. Check with the authorities in the state in which you are working for their specific rules and regulations.

Nonpyrotechnic Materials Used with Explosions

Various materials such as fuller's earth, cork, peat moss, vermiculite, sand, plaster of paris, cement, flour, balsa wood, plastics, Styrofoam, polyesterene, and rigid foam for rocks are used to simulate debris caused by explosions. They present no storage problems.

Pyrotechnics and Weather

Weather obviously affects pyrotechnics. Naturally, during a lightning storm you're not going to be setting charges or working with pyrotechnics. It is much too dangerous. The static electricity in the air alone could prove deadly. High winds or rain don't necessarily prevent the use of pyrotechnics, but additional prep is necessary to make sure you achieve the desired effect. For these reasons, it is not generally advisable to execute pyrotechnics in foul weather unless the script specifically calls for it.

For the most part, general air humidity does not greatly effect the appearance of a pyro nor decrease the safety factor for the F/X person. If, however, there is some doubt in your mind, use a little extra caution and waterproof the explosives or detonators about which you may feel insecure. Flash packs and black powder bombs (see page 119) can be waterproofed by dipping them in lacquer.

Mortars

Mortars are tubes or potlike devices that are used to direct the explosion and debris (Figure 10-3). There are several varieties of mortars and their use depends on the limitations of the location and the requirements of the shot.

Usually a mortar is loaded with a black powder bomb, fuller's earth, cork, vermiculite, and peat moss. Additional materials may be necessary depending on the effect you wish to achieve. When using gasoline and diesel fuel, or gasoline and liquid tar for black smoke, the weight of the bomb's black powder charge varies from 2 to 16 ounces. It may be either "soft" or "hard" wrapped depending on the effect. The difference between the two forms of wrapping is that the harder or tighter the wrap, the greater the pressure built up, and thus the larger the explosion.

Place the bomb at the bottom of the mortar and a plastic bag filled with the desired amounts of gasoline and diesel fuel, plus a bit of liquid tar for dense black smoke on top of the charge. A *flash pack* is placed either on top or near the top of the mortar. A flash pack is made of flash powder, or common photography flash, which comes in four burning speeds: A-B, slow, medium, and universal. A-B is the safest, while the slow speed enables the gasoline to ignite more efficiently. One ounce of powder and a match squib inserted in a plastic bag are all that is needed. The flash pack is then taped to the top of the mortar. The flash pack is necessary because gasoline has the tendency not to ignite when blown by black powder alone. The flash pack ensures ignition of the gasoline following the explosion.

Shotgun and Straight Mortars

Shotgun mortars range up to 3 inches in diameter while straight mortars vary up to 48 inches (Figure 10-4). Both are constructed with very heavy nonferrous-metal walls from ¼-inch up to ¾-inch thick depending on the amount of powder used and the type of charge. Each type of mortar is built accordingly for strength. These mortars direct the charge straight up, so an actor can be fairly close to them with little or no danger.

V-Pan Mortars

The V-pan mortars (either round or square) are employed according to the size and shape of the explosion (Figure 10-5). They are used primarily to spread the explosion up and out and are never used near actors or other personnel because of the wide area covered by their range.

Flat or Pan Mortars

The flat, or pan, mortars (which look like the end of a boiler) are used to spread debris, smoke, or explosives over a wide area and are also used occasionally to hold burning tires used for black smoke (Figure 10-6).

Figure 10-3 Straight mortar

Figure 10-4a Shotgun mortars

Figure 10-4b Large straight mortar with handles

Figure 10-5a Round V-pan mortar

Figure 10-5b Square V-pan mortar

Figure 10-6 Flat or pan mortar

Figure 10–7 Angled shotgun mortar

Figure 10–8a Flash pot

Figure 10–8b Smoke pot firing box for six shots. It has a 12-volt DC external battery.

Figure 10–9a 6-ounce, 8-ounce, and 12-ounce black powder bombs

Angled Shotgun Mortars Shotgun and V-pan mortars can be angled away from the actor in a specific direction. Both can be custom made for specific angles (Figure 10–7).

Flash Pots
Flash pots are very small mortars, often used by magicians and by rock and roll groups on stage. Flash pots create a cloud of smoke and a small bang. A squib is put into a small bag along with a teaspoonful of flash or black powder is poured on top of it. Then it is set off using a 12-volt battery (Figure 10–8). **Caution:** Never use 110-volt power to set off explosives. The wires inside the flash pot can short on the metal mortar (Figure 10–8).

Black Powder Bombs

The most common black powder bombs vary in size from 1 to 16 ounces and can be either soft or hard wrapped. They can be made bigger if needed. The different size bombs and techniques for wrapping both soft and hard-wrapped bombs are shown in Figure 10–9. When making black powder bombs, always insert a double squib so if one should fail, you're not sitting there with an unexploded bomb.

A black powder bomb can be single or double wrapped. Likewise the bombs can be either single- or doubledipped in lacquer to assure complete waterproofing.

Figure 10–9b Wrapping a black powder bomb

Creating a Napalm Explosion

The best technique for simulating the look of napalm is with a compound made from a mixture of gasoline and Ivory soap flakes. Pour them together and stir until the gasoline and soap flakes have a jellylike consistency.

Napalm explosions can be created using lightweight plastic tubing 6 inches in diameter by 12 feet or more in length, 100-grain det cord (see discussion of det cord that follows on page 121), gasoline, Ivory soap flakes, and flash packs. The plastic tubing is slotted with a 2-inch wide cut along its entire length, and then capped on both ends. The gasoline and soap

flake gel is then poured into the plastic tubing through the cut. The plastic tube is then wrapped with 100-grain det cord, leaving a 3-inch interval between each wind of the det cord. Several flash packs are then secured along the top of this pipe. When ignited, it produces a tremendous flaming explosion accompanied by voluminous black smoke. The effect is very realistic and the burning gel will even adhere to and burn anything it lands on. A 12-foot by 6-inch pyrotechnic of this kind will produce a fireball 75 to 100 feet high and 30 to 50 feet wide. War film battle scenes showing an aerial napalm carpet bombing can be made to saturate virtually any size area, from 100 feet to 1000 yards, using only 12-foot tubes.

In combat, bombs dropped from aircraft are usually toggled (i.e., dropped) in a staggered sequence rather than simultaneously to create a broader saturation pattern. In motion pictures, the 12-foot napalm bombs help the F/X person duplicate this pattern in that he controls the individual detonations with a nail board (see page 124 for discussion).

Naphthalene

Naphthalene is nothing more than mothball flakes. These emit a high level of ether fumes, which are, of course, extremely volatile. Many F/X people use it for explosions, but personally I don't care for it. It creates too quick an explosion with no residual effect, that is, afterburn. A firebomb made with gasoline and diesel fuel burns longer and blacker. Naphthalene creates one huge blast, and then burns out. This may be the effect the director is looking for, however, so it does have its place.

The manufacture of naphthalene bombs is relatively simple. Insert 25 pounds of naphthalene into a large plastic bag mixed with 8 to 10 ounces of black or flash powder. Next, wire and seal the bag with four to five wrappings of heavy (cloth-based gaffer) tape. Place the bomb in position and detonate. Variables in this mixture and in the size of the charge can only be properly determined through experimentation.

Tear Gas Effects

I was asked once to do a tear gas effect involving a tear gas shell shot into a field. To get a good-looking effect, we used a product called titanium tetrachloride, commonly referred to as liquid smoke.

This product can only be used outdoors. Keep it away from personnel and always upwind. It is a wicked-smelling chemical and not at all safe. It is a corrosive acid so you must be very careful handling it. In fact, I cannot overemphasize its toxicity.

Place the titanium tetrachloride in a plastic bag, being careful to protect your face, eyes, and hands. Use a breathing apparatus because when mixed with air this chemical turns into a tremendous cloud of toxic smoke.

Place a 2-ounce black powder lifting pack on the ground over the plastic bag of titanium. Get very far away from it before you detonate, and make sure every one is upwind of it. When it fires, there will be a different looking smoke then you normally associate with a smoke effect. It looks much more like real tear gas.

After using this chemical, soak down the entire area with water. Be careful to always stay out of the cloud. This chemical reacts very violently with water, so water it from a good distance.

Blowing Gas Drums into the Air

The method used to blow gas drums is illustrated in Figure 10–10. Remove the bottom from a 55-gallon drum and reinforce the other end with ¾-inch plywood. Place the drum with the open end on the ground. Attach a 1-gallon bag of gas to a wired single-wrapped powder bomb and suspend it inside in the center of the drum. Suspend two flash packs as well to provide a dynamic explosion. The drum, which will attain a great deal of height, must be triggered from a safe distance.

Lifting Mortars

Lifting mortars are small 3-inch diameter by 12-inch-long shotgun mortars with a 2-ounce lifting pack of hard-wrapped black powder placed at the bottom (Figure 10–11). The rest of the mortar is filled with sand and the sand is then soaked with gas. When the mortar is detonated, the sand acts like a battering ram, pushing anything up and out of its way with tremendous force. It is used to lift boxes, barrels, and hoods, trunks, and doors of cars.

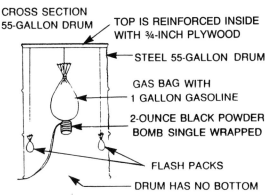

CROSS SECTION
55-GALLON DRUM

TOP IS REINFORCED INSIDE WITH ¾-INCH PLYWOOD

STEEL 55-GALLON DRUM

GAS BAG WITH 1 GALLON GASOLINE

2-OUNCE BLACK POWDER BOMB SINGLE WRAPPED

FLASH PACKS

DRUM HAS NO BOTTOM

Figure 10–10 Blowing exploding gas drum into the air

Figure 10–11 Shotgun lifting mortars

Det Cord

Det cord is a simple, very strong, flexible cord containing an explosive core. When ignited, it detonates along its entire length at approximately 21,000 feet (4 miles) per second.

When detonated, det cord approximates the energy of a blasting cap along its entire length. As a trunk line it can initiate any number of extensions or branch lines through simple knot connections. As a branch or down line, it can detonate all connections or all connected cap-sensitive explosives. In addition, it is possible to load and prime individual charges to ensure an efficient and dependable use of explosives, and any number of charges can be hooked into an in-line sequence.

Det cord is relatively insensitive to premature or accidental ignition. It is less sensitive to involuntary detonation than the main charge of standard explosives.

It is both simple in design and use. The high-explosive core is encased in various protective coverings to withstand most on-site conditions. The difference between the several standard types is essentially one of degree of protection afforded by the coverings. Its ease of use is enhanced by its light weight and flexibility, and record of being nearly foolproof. The construction of the cord has two components: the central (explosive) core and the core encasement.

The center of the cord is known as the raw core, which is encased in a textile braid. Stock det cord contains standard core loads of 25 to 60 grains of explosive per foot, or 3.5 to 8.6 pounds of explosives per 1000 feet.

The explosive core in standard det cord grades is pentaerythritol tetranitrate (PETN), a high-velocity explosive. PETN is a nonhygroscopic, crystalline solid. It is difficult to ignite and will not fire from the end split of a safety fuse or from a flame. PETN is relatively benign but is sensitive to ignition by detonators or detonating energies of other high explosives.

When properly activated, PETN explodes violently. It has a high degree of *brisance* (shock or shattering effect) and is capable of detonating any cap-sensitive explosive.

Figure 10-12 Electric caps taped to the cord

Figure 10-13 Electric caps taped to both ends of det cord

Figure 10-14 Det cord: single-wrap clove hitch

Figure 10-15 Det cord: double-wrap clove hitch

Figure 10-16 Det cord: square knot

Figure 10-17 Det cord: plastic connector

Figure 10-18 Two caps taped to the end of det cord attached to another cord with a square knot

The raw PETN is wrapped with a variety of combinations of materials such as textiles, waterproofing compounds, plastics, and so on. These protect the tensile strength, flexibility, abrasion resistance, extremes of hot and cold, and water and oil penetration. Each of these factors require special qualities to afford protection.

Det cord should be stored with the same regard for safety as all explosives and in accordance with federal, state, and local laws. The recommended practice is storage in a magazine that meets the requirements for dynamite. This material is normally unaffected by seasonal temperature variations and suffers no deterioration; the melting point of PETN is 284°F.

There are always small pieces of cord left over from trimming. These should be destroyed by either detonation or burning. Always conduct burning on the assumption that the explosive may detonate accidentally. Only perform this procedure at a safe distance from personnel and buildings.

String the cord in parallel lines ½ inch or more apart on top of paper or dry straw. Use kerosene or fuel oil to assist combustion if necessary. Arrange kindling material so that the fire will have to burn several feet before reaching the explosives, thus permitting personnel time to reach safety.

Det cord is designed for ignition by blasting caps with a safety fuse, an electric blasting cap, or an SD-100, or an MD-1 mini det. The simplest way to attach the cap is to place it alongside the cord and wrap the two securely together with electrician's tape. The loaded end of the cap must be pointed in the direction of detonation. This is of utmost importance because the directional effect of the detonation wave may not ignite the cord in the reverse direction (Figure 10-12). Equally important is that the explosive core be dry at the point of connection.

Though the blasting caps are dependable, there are instances, particularly when delay caps are used for surface initiation of multiple blasts, when it is good insurance to use two caps at each ignition point. For safety, attach these to short lengths of det cord and then tie them into the main system just prior to blast time. Two SD-100s can also be used, one at each end of the cord (Figure 10-13).

Det cord connections are essential for dependable performance. Improvisations or variations may result in a misfire.

The connections can be made with knots, plastic connectors, or tape. Knots are generally used and recommended for all but special uses because they are simple, dependable, and convenient (Figures 10-14 through 10-19).

The square knot is recommended for connecting extended lengths of det cord, as in a trunk line system. Other knots, such as the double-wrap-hitch, are satisfactory for connecting down lines to trunk lines.

When the down line is Scufflex or a comparatively stiff type, the most dependable connection is a clove hitch. This knot is made in the trunk line, slipped over the end of the down line, distanced by at least 8 to 10 inches, and drawn tightly around it. A simple overhand knot is then tied in the end of the down line.

A special loo-lock or double-wrap clove hitch in the trunk line is advisable when using a Scufflex down line. This knot prevents it from slipping out of the clove hitch in the trunk line due to load subsidence or other tension from the down line.

Pull all det cord knot connections tight to assure positive contact. Keep each connection at a right angle (or as close to a right angle as possible)

Figure 10–19 Det cord: factory-made string tie splice

to ensure that failures from angle cutoff will not occur. These result if the down line slants back toward the point of ignition at an acute angle. Angle failure is caused by the explosive force or fragment of the detonating trunk line severing the branch line before the detonation signal has been transmitted to the connection.

When both the branch line and trunk lines are difficult to tie into dependable knots, use a plastic connector, which is both convenient and reliable. If plastic connectors are not available, use a combination knot and tape connection. Tie the down line to the trunk line with a double-wrap half-hitch knot, pull it tight, and tape the connection securely.

Wet det cord is much less sensitive than dry. However, once initiated, straight lengths of standard det cord will continue to detonate dependably, wet or dry. If det cord gets wet because of damage to the waterproofing coat or from end penetration of water, it cannot dependably ignite by a cap laid alongside (side priming). Moreover, wet det cord cannot be ignited by knot connections, nor can ignition be assured through a wet trunk line. Side prime with one or more caps; all knots and connections must be at dry points.

Cut ends of det cord lying in water will pick up moisture through capillary action. This generally is no problem if the knot is made or caps are attached 8 to 12 inches from the exposed open end. If the extent of moisture penetration is unknown, cut several short pieces from the exposed end and explosive core and examine them. A dry core at the fresh cuts would indicate that side priming or knot connections can be used. If the core is wet 6 to 8 inches from the exposed end, however, assume that water has penetrated by other than capillary action and that the cord is wet throughout. Wet end ignition is only dependable by end priming (Figure 10–20).

Figure 10–20 Det cord: end priming

Cut the wet det cord square and end butt the "business" end of the initiating cap to the exposed PETN. Tape the cap and cord securely in this position.

Booster-type connections are made by placing the down line and trunk line through the booster. The trunk line initiates the booster, which in turn fires the wet down line. Booster initiation of det cord down lines is seldom necessary except for preloaded or "sleeper" charges, where the down lines have been exposed to water for extended periods of time.

When they are required to stand loaded for periods of time, support the upper end of the down line well off the ground where it cannot be submerged in standing water. For prolonged exposure to wet conditions and where no amount of end penetration can be tolerated, det cord with plastic end seals can be applied on site. In instances where the cord got wet and then froze, it will perform in the same manner as wet det cord and is treated accordingly.

Essentially, the effect of oil on the PETN det cord is the same as water. Side ignition with a blasting cap, knots, and all other connections must be at dry points. If the entire core is wet with oil, use end priming or boosters. Once fired, straight (i.e., unknotted) cord will continue detonation regardless of the degree of oil penetration.

Do's and Don'ts

1. Transport det cord in accordance with all federal, state, and local laws.
2. Separate other explosives (cord, blasting caps, electrical blasting caps).
3. Only store det cord in clean, dry, well-ventilated, reasonably cool, properly located, substantially constructed, bullet and fire resistant, and securely locked magazines.
4. Handle and use det cord with the same respect and care given any other explosives.
5. Make up positive primers in accordance with established parameters.
6. Exercise care to avoid damaging or severing the cord during and after loading and hooking up.
7. Make positive and tight connections in accordance with standard procedures. Knot tying or other cord-to-cord connections should only be made when the cord is dry. Wet detonating fuse (explosive) core can be dependably detonated only by means of special boosters or end priming techniques.
8. Avoid loops and sharp kinks or angles that direct the cord back toward the oncoming line of detonation.
9. Connect blasting caps or electrical blasting caps to assure they are pointed in the direction of the line of detonation.
10. Destroy detonating cords in strict accordance with approved methods.

DON'T leave detonating cord or pieces of detonating fuse lying about where unauthorized persons may handle them.

DON'T store any explosive devices with any other explosive devices at any time.

Detonator cord is manufactured by many different companies all over the world. The color code may differ from company to company so always check with the distributor.

Detonating Devices

Wiring Harnesses

Production time can be saved by manufacturing wiring harnesses prior to the shooting date. Fifty-bullet hit harnesses, or 50-bomb hit harnesses, that is with 50 two-conductor wire, is recommended. Each one has two leads and is numbered individually and sequentially from 1 to 50. This numbering is done on both ends so that the numbers on the charges can be connected to the corresponding numbers on the hit board. Color-coded wiring is also a viable alternative if you wish. For bullet hits, use a lightweight wire such as speaker wire. For long runs over 50 feet, use heavier wire like a number 14, 16, or 18 gauge zip cord.

Wiring of bombs and other heavy devices on one wire is determined by how many charges have to be activated on a single line and how long a run you need. Make a careful study of the number of amps for each charge and the length of the run in comparison to the amperage the wire can hold.

Nail Board

One of the devices used to detonate explosives is called a nail board, a name which denotes the simplicity of the mechanism. Two wires are

Figure 10–21a 25-shot bullet hit board with 12-volt DC battery, also called a nail board

attached to separate nails. The hot line of each bomb is connected to one, while the negative lines from all the grounds are attached to a common ground, usually another single nail on the board. The hot lead is connected to a battery and from there to a metal conductor such as an ice pick or a screwdriver, or a large nail. By touching these to any nail on the board, the charge is detonated (Figures 10–21a–e). Other more elaborate devices can be used depending on the budget (Figure 10–21f).

Clunker Box

This box is a 25- to 100-bullet hit board with auto speed control and key lock with a 12-volt DC external power supply. This device should never be used to detonate high explosives. It should be used *only* for bullet hits (Figure 10–22).

Galvanometer

A very important piece of equipment that should be taken on all pyrotechnic shoots is a Galvanometer. This meter is used to test squibs, bullet hits, blasting caps, and similar electrically fired devices prior to use and without the danger of a detonation. With it, your wiring and blasting devices can be checked thoroughly to insure that all explosives will be activated and protect against duds. This piece of equipment is used only for explosives (Figure 10–23).

Fuses

There are numerous types of fuses that can be used in pyrotechnics: thermal, fast burn, slow burn, and black powder fuses. I rarely use a fireworks

Figure 10–21b 6-hit board with external-powered 12-volt DC battery

Figure 10–21d 6-hit board with internal 9-volt battery

Figure 10–21c Single-hit board

Figure 10–21e 12-hit board fired by actor for blood hits

Figure 10–21f Ten-stepper firing box used on Red Knight in *The Fisher King*

Figure 10–22 Clunker 50-bullet hit board

fuse, although I've sometimes found it necessary. It is a black powder fuse wrapped in a paper envelope that burns superfast. These fuses can be connected to either plunger- or turnkey-type blasting machines (Figures 10–24, 10–25).

The decision when and where to use fast burn, slow burn, black powder fuses, and so forth, depends on knowledge and experience. A very broad general rule of thumb is: "Use the fuse that does the job and doesn't burn so fast you become a blob."

Flares

Flares are helpful in explosives to ignite a fuse, to create a chain reaction, or for various pyrotechnic effects. In addition, flares are often used to illuminate sets. Flares are employed in fire scenes as background, with heavy-duty models throwing a light behind the fire scene. By using them you can avoid bringing in awkward heavy lighting equipment to get the same effect.

Exploding Vehicles

To blow up any type of vehicle whether aircraft, bus, truck, or automobile, follow the basic procedures outlined here.

Remove the gas tank and carburetor. Removing the engine is usually not required unless you need more room under the hood for setting the charges.

Some additional work on the automobile is necessary before you proceed. First, if the hood is to be blown into the air, the door blown off, the trunk lid blown open, and windows exploded out, you will have to use shotgun mortars.

Begin with the hood of the car. Unbolt it so it's loose and can be taken off or blown off by the charge. In order to get the force to blow the hood, use a shotgun mortar number 1. This is a mortar approximately 1 foot

Figure 10–23 Galvanometer

Figure 10–24 Plunger-type blasting machine

Figure 10–25 Turnkey type blasting machine

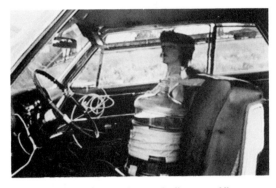

Figure 10–26a Set-up for exploding car: View of the front car seat. A 5-gallon drum is dressed and wrapped in 100-grain det cord. An identical set up is in the back seat.

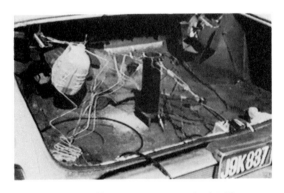

Figure 10–26b Shotgun mortar packed with black powder charge, sand and gas, flash pack, and 1 gallon of gas wrapped with 25-grain det cord.

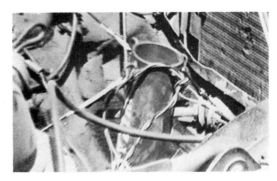

Figure 10–26c Shotgun mortar under hood of car. This setup is the same as the one in 10–26b.

long by 3 or 4 inches across with an extremely heavy wall. Insert a 2-ounce lifting pack of 2 ounces of hard-wrapped electrically squibbed black powder at the bottom of the mortar and top it off with sand. Soak the sand with gasoline. A flash pack, taped to the mortar and electrically detonated, ignites the gasoline.

The physics behind the effect is relatively simple. The black powder and the flash pack are ignited simultaneously. This creates a pressure that forces the sand up through the mortar against the engine hood. At this point, the flash pack ignites the gasoline in the sand creating a high-intensity explosion.

To augment the effect with a ball of fire, use a 1-gallon plastic jug of gasoline, wrapped three or four times with 25-grain det cord, making sure that the det cord is taped to the container and each wrap does not cross over any other wrap. Attach a blasting cap or an SD 100 to the det cord and mount an additional flash pack to the side of the container.

At this point, you have one electrical line running to your shotgun mortar and another to its flash pack. Similarly, a single line runs from the SD-100 detonator onto the gasoline container and a second to its flash pack, all of which are positioned under the engine hood.

It is important that the engine hood, trunk hood, and car doors be attached to the body and frame of the car to prevent them from flying uncontrollable distances. A 50-foot length of ¼-inch steel cable must be attached to the hood, trunk, and doors. Never use less than a ¼-inch diameter cable. If you are in an area where you are some distance from the shot, you need't worry about cabling the hood. In tight areas, however, where a flying hood could shatter windows, cars, or injure people, you should cable accordingly (Figure 10–26a–c).

The Cockpit of the Car

Unless there are extreme personality conflicts with an actor, the director will substitute a mannequin for the actor in an exploding car. The wiring of the interior of a car requires a certain delicacy. Wrap 100-grain det cord around the outside of a five-gallon plastic water jug (plastic milk containers are also fine) filled with gasoline. Do not use a glass container. Two squibs are inserted through the mouth of the container, which is then sealed, leaving the electrical contact wires protruding. Two flash packs are then taped to either side of the jug to produce the explosive concussion needed to blow the doors off. Position in the front seat of the car. Use shotgun mortars; cable or chain the doors to tie them down so that they are not launched by the explosion.

Place a shotgun mortar with a 2-ounce lifter aimed at the door. Once secured, fill it with sand and soak the contents with gasoline. Place one of these on each door, making sure that there are enough flash packs for ignition.

Assuming it's a four-door car, shotgun mortars are also used to blow the back doors off. To hold the doors in proper position, use a section of 100-grain det cord to secure the opposing doors together. When the car blows, so will the det cord, freeing the doors.

Follow the same procedure for the trunk lid. Remove the bolts so that the trunk lid is free, and tie it with cable to both the frame and the body of the automobile.

To blow the doors open, instead of off, simply remove the latches, pull the doors closed with a piece of monofilament, and tie the doors closed. At the moment of detonation, the monofilament will melt and the doors

will open. Make sure the door latches are completely off. If you want the doors to blow completely off, you must remove both latches and all hinged bolts. Use more monofilament or a piece of polyurethane or det cord to tie the doors closed. Do not use cable because it might not break. The same applies to the trunk lid. A gallon of gas in the trunk wrapped in det cord, a flash charge, and a shotgun mortar will complete the effect.

Caution: Be aware of the volatility of gasoline. One gallon of gasoline has the same explosive power as three sticks of dynamite.

Wiring the Charges

This wiring is next hooked into your board. Be sure to use heavy-gauge wire from the car to the firing device. All charges are connected to one or two lines unless you're going to blow individually. If your sequence of explosions runs from front, to middle to back, for instance, you will need three heavy lines, as you will be firing five or six ignitors at once. Always use heavy wire from your battery to the board so you can fire them either sequentially or in unison. In most cases when a car explodes, it fires in one shot, unless the director specifies otherwise.

When blowing up cars, trucks, buses, or other vehicles, the procedure is basically the same. Explosions can be made larger by putting a jug of gasoline under the car so that a blast of flame comes from beneath at the same time that the other charges are ignited.

When blowing an airplane, be sure you purchase it inexpensively! Use the same basic technique as previously discussed.

It is important to remember to shunt all the lines before you fix the charges. *Shunting* means taking the two wires (one positive and one negative) coming from an explosive device and twisting them into one single strand. This procedure shorts out the charge rendering it harmless. The following is not only the proper procedure, but in my opinion, the only procedure for hooking up the explosion to the main firing board.

1. Run the wire from your ignition position to the object being blown.
2. Shunt your ignition wires until you are ready to make a final hookup.
3. Shunt all individual sets of wires and keep them that way until you're ready to make your final hookup.
4. Connect the individual sets of wire to your main ignition wire.
5. Unshunt the main ignition wire and attach it to your firing device.
6. Hook up your battery, but *only* when you are ready to fire.

Always keep the firing device and the battery ignitor off the set until you are ready to detonate. If your board has a locking device, such as a key (which inactivates the system), keep that key in your pocket until you are done loading your devices. Never allow anyone on the set to smoke or use radio devices of any kind when working with pyrotechnics because they may cause premature detonation.

Exploding Buildings

Building explosions require a specialized technique. Structures prebuilt specifically for explosions are constructed of a much lighter material, such as balsa wood, plastic, Styrofoam, or cardboard, than real housing, but the procedures for blowing them are identical. The step-by-step procedure is as follows:

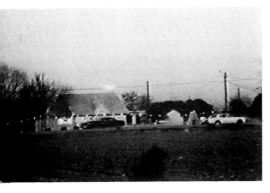

a

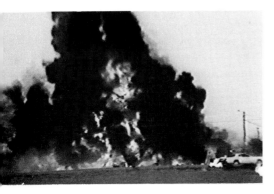

b

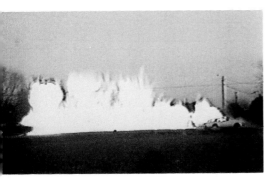

c

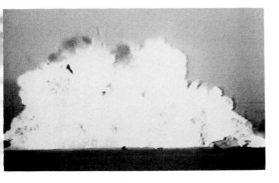

d

Figure 10–27a–f Explosion of a building, shown in sequence (continued)

1. Drape the walls with 200-grain det cord in a serpentine fashion and affix it with gaffer's tape. Staple the tape as well. If beams are present, drill through them and string the det cord accordingly. Roofs, doors, or anything you wish to explode with det cord should be laced also.

2. For the building interior, you'll naturally want a tremendous fire with billowing smoke. The size of the structure will determine the amount of gasoline used. This can vary from 5-gallon jugs to 55-gallon plastic barrels. Ten to 15 wraps of 100-grain det cord are wrapped around the containers along with two flash packs for each gas container rigged to explode simultaneously or sequentially. The wiring procedure and safety rules are identical to the previously described methods. The effect, however, is different because the building will be completely blown apart, and the explosion will be accompanied by a tremendous fireball and smoke. There will also be residual burning.

3. Adding diesel fuel to your gasoline or liquid tar creates huge clouds of black smoke. If electrical short circuiting is needed, add in spark hits in various sizes and shapes depending on what is required in a specific building area. Make sure you are well away from the building because the debris will scatter in all directions. In addition, make sure there are no vehicles, equipment, or people in proximity to the explosion. A good rule of thumb is to keep people at least 300 to 400 feet from the site, depending on the size of the explosion. The shot can always be tightened in camera with the lens and needn't be close by. Occasionally a high-speed camera is used in close proximity to explosions thus creating slow motion. Ironically, because of motion picture stylization, this technique actually makes the effect appear more realistic. Have you ever noticed that nothing ever blows up only once? It is always several explosions. In reality, it is usually one explosion shot from many different directions or angles.

4. It is important to always get a minimum of three or four angles of the shot, with as wide a framing as possible. A tight shot will print as nothing but a large whiteout or redout in film. It is better to have five or six angles of the same explosion. The editor will cut this way in order to create visual impact (Figure 10–27).

The basic products used for pyrotechnics are gasoline, diesel fuel, liquid tar, black powder bombs, flash powder packs, lifting packs, naphthalene, and squibs, which serve as detonators. Only occasionally are classic explosives such as dynamite employed.

Kickers

Kickers do exactly what they say: kick things around. They thrust a 4 × 4 ram, which is driven by a mortar charge. The 4 × 4 is positioned against a wall or platform, and when detonated, the platform, which is loaded with debris, is kicked down, scattering the debris. Kickers are also used when abutted to a wall, forcing it to collapse (Figure 10–28).

Blowing Out Doors and Windows

These explosions require a somewhat different setup, which can be done in several ways. Nonpyrotechnics can be accomplished with air mortars with debris in the mortars. Using 300 pounds of air in the air mortar with a mortar of debris and firing it at a door will definitely blow it down.

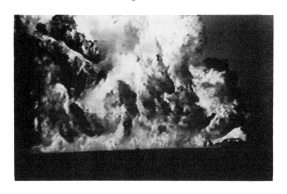

e

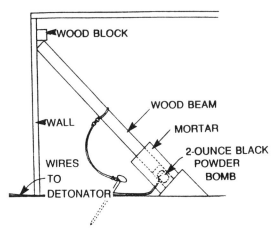

f

Figure 10-27 (continued)

The same principle applies to a wall or breakaway window, either going in or out. If you're going to blow a window in, naturally you put the mortar on the outside of the house. If you need a column of fire shooting straight out of a door or a window or a long column of fire straight into a building, 100- to 150-pound pressure mapp gas or propane can be used in the air mortar instead of air and in conjunction with another air mortar fired at the same time. Place a high-volume flame directly in front of the mortar with the gas in it to ignite the gas (Figure 10-29).

Strafing Bullet Hits

You've probably seen an airplane strafing a field with a double line of explosions on either side of an actor. What we use for .50 caliber bullet hits is an SD-100. This is a det cord charge, which is very dangerous and can blow your hand off.

You will understand the installation and design of this particular system by examining Figure 10-30. The reason that these charges are sunk into the ground rather than left on the surface (other than their obvious visibility) is that when fired, they act like mini-mortars shooting into the air with puffs or gusts of pieces of dirt and look like bullets chipping into the earth.

Blowing Safes and Boxes

Blowing anything that's sealed can be tricky if you're not careful. The best way to blow a lock, for example, if someone is shattering it with a pistol

Figure 10-28 Kicker

Figure 10-29 Air mortar setup to blow out door

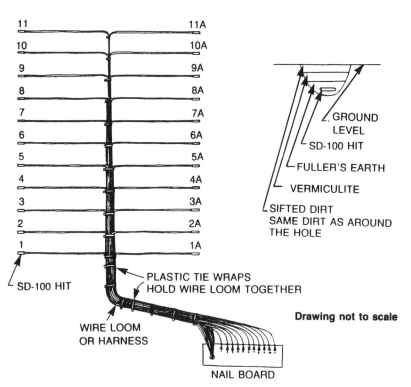

Figure 10-30 Strafing bullet hit run; detail on right shows section of hit in place

shot, is to use a breakaway lock made of either balsa or plastics. A charge placed in the lock or hasp creates the effect.

When blowing a safe (where the scene requires holes to be drilled in the safe and stuffed with an explosive charge) use a concealed charge not unlike a mortar. Naturally the door must be unlocked, otherwise the safe could very well blow apart, shooting lethal shrapnel. Make sure the door is easily opened on the hinges or spring devices. Place a charge inside the safe and over that charge put a piece of monofilament to hold the door closed. When the charge is fired, the monofilament releases the door and pressure blows the door open and causes billowing smoke.

Rockets

We've often used rockets and bazooka shells for explosives. Using an ordinary Estes rocket motor design, construct a lookalike rocket shell from a lightweight material such as cardboard, balsa wood, or plastic. Mount it on a wire and thread it through the bazooka. When fired the rocket travels along the guide wire and hits the target. Once the rocket is fired and hits the target, the explosion is set off. This effect requires a second rigging of an explosive device to the target. You can also fire rockets free hand, but there are no guarantees.

Cannon Cars

Cannons are used to explode moving vehicles that are either hit by a shell or gunfire, causing them to flip into the air, spin around, and drop back to earth. When the cannon is built into the car, the car is a common car (Figure 10–31a). The cannon itself is a gigantic motor approximately 2½ feet long with an extremely heavy wall ½-inch thick. It is welded into the frame of the car (driven by a stunt professional) and is fitted with a special roll cage mounted in the cockpit of the car and attached to the cannon. The cannon is charged, depending on how far you want the car to fly, with anywhere from an 8 to a 16-ounce hard-wrapped black powder bomb (Figure 10–31b).

Figure 10–31a Photo of a cannon car in action

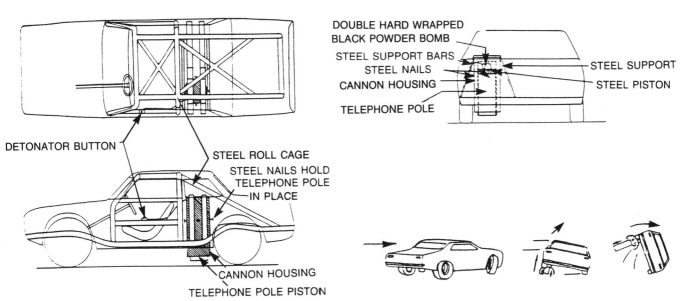

Figure 10–31b Schematic of cannon car

The cannon employs a metal piston positioned after the bomb is placed, leaving the bomb a very small area inside the cannon. The piston is then attached to a section of telephone pole and nailed in through holes in the side of the cannon so that it rests about 2 inches off the ground beneath the frame of the car. Usually, it is mounted on the right rear side of the driver and fired by the stunt professional. The explosion drives the telephone pole into the ground, forcing the car up and flipping it over.

There are nonpyrotechnic cannon cars that are fired with nitrogen rams. These are nitrogen cylinders that do the identical job: pushing the ram into the ground, forcing the car up, and flipping it. It's just as effective and often much safer.

Blowing Up a Tree

Often I've been asked to blow off part of a tree or a telephone pole so that it looks like it's been struck by lightning, blown down in a heavy wind, or demolished by a shell hit. The most effective way to do this, depending on the tree's dimension, is with det cord. If it's a small tree, say no more than 6 inches round or across, it needs no more than eight wraps of 200-grain det cord.

In affixing the det cord, never let it contact or overlap another piece. Use SD-100 (which has a self-contained detonator and can be used alone or in conjunction with a separate detonator) to insure ignition. Eight wraps around a tree will blow it apart.

When working with a tree more than 6 inches in diameter, drill holes through the trunk, lace the det cord through the center of the tree, and then wrap it around the circumference. With heavier trees, use heavier det cord up to 400 grains (Figure 10–32). To represent a lightning strike on a tree, use flash ribbon as well as det cord.

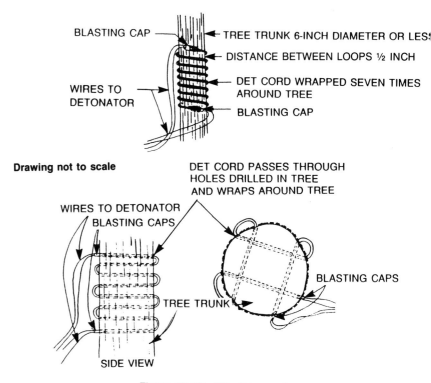

Figure 10–32 Blowing up a tree

Blowing Bullet Holes in 55-Gallon Water or Gas Drums

A common visual in a gunshot scene is to follow the path of the bullets on the surrounding scenery. A most effective trick is to see the bullets hit a water drum and jets of water spray out. For such a shot, there is no need to actually fire bullets into the water drum. More effective and much safer is to set the drum up ahead of time with the holes already punched into it, positioned as you want. Figure 10–33 shows the method of accomplishing this gag. Plug the holes with Plastilina and the D60-6 squibs as shown in the detail of Figure 10–33. Remember to place the Ping-Pong balls in the holes as the water reaches the hole level and hold them there until the water pressure keeps them in position. Then you're ready to detonate the squibs whenever the director is ready.

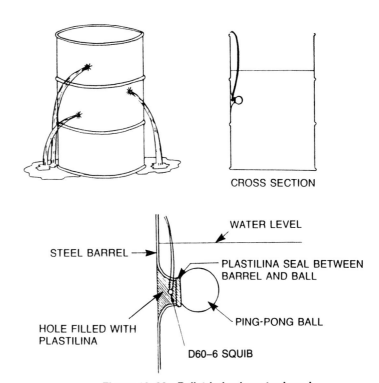

CROSS SECTION

WATER LEVEL

STEEL BARREL →

PLASTILINA SEAL BETWEEN BARREL AND BALL

PING-PONG BALL

HOLE FILLED WITH PLASTILINA

D60–6 SQUIB

Figure 10–33 Bullet holes in water barrel

Blood Hits on the Body

Bullet hits come in many forms. Those used for the body are called flat hits. It is important that body armor or a hit plate be used for protection. This technique enables single or multiple hits to the body areas with little or no danger. In addition, it allows for freedom in positioning the camera shot for the greatest effect. A good deal of preparation is required prior to the shoot. The construction, while not complex, is time consuming.

Using a glue called 77 Spray, attach a squib to either the body armor or the plate. Over this glue a *blood pack.* Blood packs used to be made by filling a condom with makeup blood or by concocting your own blood (note: Use corn syrup and red food coloring). The newer method is to use a plastic bag. Using this method, you have access to any size bag you need

Figure 10-34 Blood pack using plastic bag machine

for the effect (Figure 10-34). Some specials effects people glue the hit on top of the blood pack. I have found by putting the blood pack over the hit it eliminates the flash given off by the squib. Glue the entire device to the inside of the actor's shirt with the squib side facing the camera gaffers. Then glue tape over everything to ensure it cannot move or shift (Figure 10-35).

You can obtain different effects by placing the blood pack over or under the squib and by positioning the squib itself on the blood pack in the high, middle, low, front, or back position. Experiment with this technique to discover how to achieve the maximum effect.

Finally, string a wire from the squib down the performer's pant leg to the ankle, at the base of which is a connecting wire to the firing box. A device known as *breakaway wire* is employed when a director requires a full-length shot to take place immediately after the victim is hit. The wire breaks away from its connection when yanked, thereby effectively removing the wires from the actor's ankle (Figure 10-36).

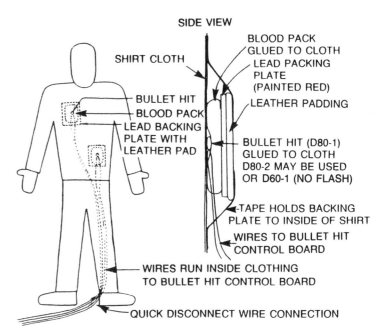

Figure 10-35 Bullet hit setup with blood

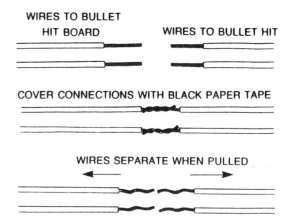

Figure 10-36 Breakaway wire: quick-disconnect wire connection

Blowing Someone's Brains Out

Figure 10–37 illustrates this procedure. Basically, a plate is held against the back of the actor's head. On one side of the plate is heavy foam and sheep's wool padding to protect the actor, the other side is a pack of wired blood and sponge. When the actor is "shot" in the head, the pack of "brains" is detonated.

Creating Sparks

A fast sparking device of any size can be purchased to produce spark hits, including continuous showers of sparks coming from a specific area when required. Metal cutting wheels work well as do metal chop saws that when they cut through a heavy piece of steel can throw a shower of sparks 10 to 20 feet away. Another way to get a lot of sparks is with a welding machine.

Attach a rasp (metal file) to either a negative or positive line of the welder and a separate piece of metal or a carbon rod to the opposite line. Run the metal or carbon rod across the hasp to achieve massive sparking effects. You can also use a welding rod to create the required sparking when you run it across the rasp.

Always wear protective gear such as a welding mask, heavy gloves, and fire protective clothing. Sometimes a director will want sparks dripping down from overhead. Get this effect with an oxygen acetylene torch cutting of piece of heavy metal.

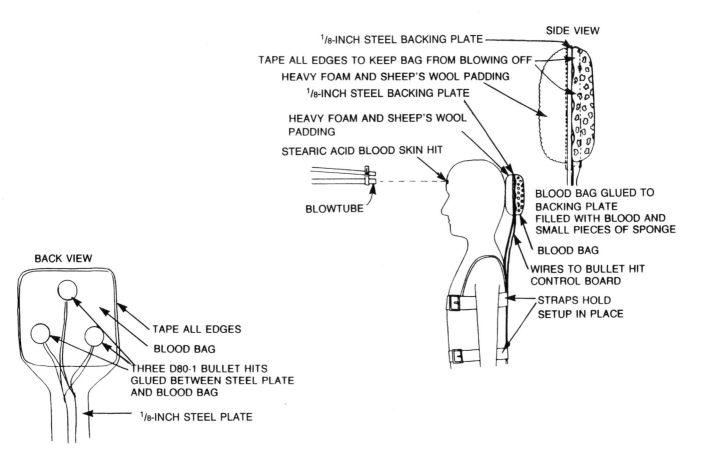

Figure 10–37 Blowing someone's brains out

Continuous Columns of Black Smoke

There are three ways to create continuous columns of black smoke: burning tires, burning diesel fuel, and smoke comps. The cheapest way is with an ordinary automobile tire. Place it in a metal pan and set it afire. Unfortunately, tires are not only very hard to start burning, they are equally difficult to stop burning. I use a brush burner or flame thrower to start them. Do not use carbon dioxide to put them out. Water is the best way to ensure extinguishing. Make sure that the tire is in a metal pan to ease later cleanup.

The smoke from burning tires is toxic and thus the method should only be used as a last resort. Substitutes on the market are *smoke comps*, or smoke composition powder, very effective but also very expensive.

As always, make sure you have permission from the authorities before attempting any pyrotechnics. Be aware that the laws and rules vary with the local, state, and federal authorities. Without permission from the right source, you are not protected.

Figure 10–38a Underwater explosion

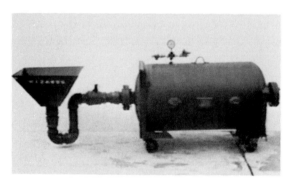

Figure 10–38b 300-pound capacity air mortar setup for underwater explosions

Underwater Explosions

Underwater explosions are a desired and quite dramatic effect. They demand a great deal of preparation and careful attention to detail.

Mount a black powder bomb, sealed in plastic to ensure waterproofing, on a small floating ramp or raft. For the sake of example, let us say we are setting five charges in a row. Attach cables to the raft and run them down from underneath the platform and anchor them to the water bottom. Level the platform at approximately 1 to 1½ feet below the surface. Then run the wires detonating the charges to your firing position. It is imperative that this underwater structure cannot be seen when you fire the charges. Use some form of masking or camouflage to hide the platform.

Note that an explosion goes to the least point of resistance. If your charges are too far under the water surface, the effect will be diminished. Experiment with different size charges to determine the exact size and shape of the explosion. Such charges come in sizes of 2 to 16 ounces. When using explosives under water, you should not use a common ground for a set of charges. Use a good waterproof electrical line going to each charge and make sure it is watertight. You should have an individual ground and an individual hot line to set off these explosions.

Salt water presents particular problems because of electrolysis, that is, the production of chemical changes by the passage of an electric current through an electrolyte. Your intention may be to set one charge off when in fact all of them could go off at once if you use a common ground. Do not underestimate the difficulties of underwater explosions. Not only are you dealing with explosives and their particular variables, you are also coping with electrolysis. Caution is the watchword (Figure 10–38a).

Underwater Explosions without Using Explosives

Another way to create water explosions is to use air mortars or air cannons (Figure 10–38b). Fill them with 200 to 300 pounds of air pressure and then position them approximately 4 to 5 feet under the surface. When fired, they gush water 200 to 300 feet in the air, depending on the pressure. With 200 pounds of pressure, you will probably get a height of 150 feet; with 300 pounds, a water spout of 300 feet is not unreasonable. Another

variable to consider is the diameter of the air mortar since the height of the water spout varies in direct proportion to the diameter of the mortar and air-valve release system, given that the amount of air pressure is a constant.

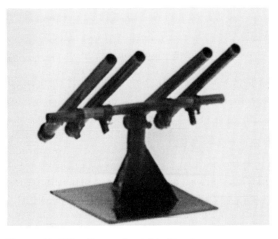

Figure 10–39a Single Trunion gun

Figure 10–39b Four adjustable Trunion guns

Trunion Guns

Trunion guns are devices used to blow out car windows or glass. They are especially useful if the actor is inside the automobile when the back or side windows are blown out.

In appearance they look like little guns mounted on plates adjustable to different angles (Figures 10–39a and b). When loaded with an appropriate squib, they fire a glass or steel ball through the window, leaving a round hole like a bullet. Trunion guns can also cause the window to disintegrate if tempered glass is used. Lexan, a bulletproof clear plastic, should be used between the actor and the glass being shattered.

Glossary of Pyrotechnic Terms

Bullet Hits Used to simulate bullet hits. The color-coded squib chart on the back cover indicates the different sizes and shapes. The D-80 series are commonly used as body hits. The D-60 series are stronger and completely flashless. They are used frequently to simulate bullet hits along a wall, and so on. The SD series are very strong hits used mostly to simulate bullet hits on the ground. The Z-16, 16A, 17, 17A, and M-17As are very effective in simulating ricochets. They produce a small amount of sparks.

Directional short circuitors Quite similar to the omni short circuitors. The directionals can be pointed in the direction you intend for them to go to produce sparks that are like the omni's. The directionals come long or short, the long producing more length to the sparks and the short producing more width.

Flash powder Flash powders come with two components so they can be shipped very easily. They are very safe because you only mix the two bottles when you are going to use them. They come in a variety of colors and speeds. There has also been developed a type of flash powder that sparkles when ignited, called sparkle flash, which comes in red and green.

Fountain effects Produces sparks that shoot off and look like fountains. They are designed to spark for different lengths of time and in different sizes.

Igniters Used to ignite materials that are squibbed when a large flash is not wanted. They are used quite frequently to ignite bombs and smoke.

Match Arcing match is used to create sparks. Basically, it is a type of fuse with gerbs, or sparkling devices, placed at intervals so that you get the effect of the fuse burning and sparking at regular intervals. Blackmatch is simply used to ignite various pyrotechnics, as is the thermite fuse, which burns faster. The silver match is a type of fuse that is almost like a flexible sparkler. It is more often used as a visual effect than as an igniter.

Omni short circuitors Produce sparks for explosions and electrical effects. The larger the short circuitor, the more sparks. The omni short circuitor produces 360 degrees of sparks.

Reduplicating material Used for duplicating props, parts of bodies, or wall sections. It can be made to disappear in seconds when ignited with a minimum amount of smoke.

Smokes Smokes are very dense and true in color. They can be bought in various colors and can burn for various lengths of time. They are sold in bulk or in smoke pots. The smoke pots come squibbed, fused, or in pull-tab form. The squibbed smokes are ignited electrically and the fused are ignited with a match. Except for the white, black, and gray exterior smokes, they present no hazards. However, some people do have lower tolerances to various smokes than others and could experience minor throat or eye irritation over an extended period of time of exposure. Use smokes in a well-ventilated area. The black, white, and gray exterior smokes should be used outside only.

11

Fireworks

Spectators love fireworks. A well-down fireworks display adds excitement to live performances, motion pictures, and television productions. Fireworks, however, are extremely dangerous even in the right hands. There are probably no more than a dozen truly qualified firms in the country that design and construct these pyrotechnic displays and also have the experience to run the show; though there are many more licensed to do them. It is a highly specialized field that requires years of experience, to the extent that some of the best companies in the field are family-run with a background going back several generations. It is not simply putting a match to a fuse.

Specialized terminology has been defined in the glossary though I don't pretend it is complete. Often you will find that highly technical fields such as this develop a verbal shorthand, incomprehensible to the uninitiated.

This chapter addresses terminology, safety procedures, and use of fireworks. The material in this chapter is from the *Film Industry Fire, Life, and Safety Handbook* and is reprinted with permission of the California State Fire Marshal.

Specifications of Fireworks Apparatus and Devices

Mortars

1. Mortars should be made of Shelby (brand name) seamless steel tubing or equivalent strength steel having a smooth bore and a steel bottom plate, at least equal in thickness to the tube wall, welded continuously around its inside diameter rendering it weatherproof.

2. Mortars normally used for the firing of *salutes* and other *single break shells* may be made of spiral or convolute-wound chipboard or draft paper tubes. It is suggested that tubes used for firing 3-inch shells and ordinarily used in finale racks have a wall thickness of not less than ½ inch and tubes for 4-, 5-, and 6-inch shells have not less than ¾-inch walls. All paper tubes shall have a wooden base plug in good condition with a thickness not less than the inside diameter of the tube. The base plug shall be securely glued and nailed to the tube.

3. The minimum inside length of mortars shall be not less than *five times* their inside diameter for mortars up to 7 inches in diameter and not less than *four times* their inside diameter for mortars having an inside diameter greater than 7 inches.

4. *Salutes* must never be fired from metallic mortars.

5. Where the shooting site contains soft ground or sand, all mortars except 3-inch finale batteries shall be set upon a heavy plank or timber footing and be buried in solidly tamped clean earth. Not less than 75% of the mortar bore length shall be below the normal surface of the ground. A continuous row of sand- or earth-filled bags shall be laid against the firing side of the mortars. The upper surface of the sandbags shall be level with the mortar tube muzzles. Sandbags shall also placed similarly at both ends of each line of mortars.

6. All mortars other than those in aboveground finale racks and sandboxes shall be separated from each other by not less than *four times their bore diameters.*

7. Where it is impossible to bury mortars in suitable clean earth or when the authority having jurisdiction has declared that public safety will be increased thereby, mortars may be set for firing in approved sand-filled containers; in these instances it is suggested that troughs be constructed of heavy boards in accordance with the following details of construction.

a. The width of the trough should be not less than *three times* the diameter of the largest mortar.

b. The depth of the trough must permit burial in wet sand of each mortar to within 1 inch of its muzzle. Heavy wood blocking shall fill the space between the bottom of the mortar and the container, and in every case there should be a minimum 2 inches of thickness of board under each mortar.

c. The length of the trough should permit spaces between all mortars and between the first and last mortars and the ends of the trough equal to the diameter of the largest mortar. These spaces shall be filled with blocks of wood. Board shall separate troughs into compartments not more than 6 feet in length.

d. The sides, ends, bottom, and any boards required to limit compartment length to 6 feet shall be sturdy lumber in good condition and nailed securely. The ends of the troughs shall be set 6 inches in from the ends of the side and bottom boards, and two ½-inch threaded rods used to bolt the sides in place at both ends of the trough just outside of the trough ends.

e. The container shall be set and the mortars blocked and secured at the angle determined as safe for firing. While heavy drums in place of the described troughs are authorized in several states, their use is not encouraged.

f. Finale batteries composed of mortars no larger than 3-inch inside diameter are normally limited to ten mortars per unit. Such battery mortars must be made of paper since they are not buried. Wooden racks of stout construction are used to support the mortars. Batteries may consist of as many ten tube units as required for the display, but each unit should be independently set, braced, and secured, as indicated by wind direction and velocity predicted for the firing time. After the mortars are loaded and quick match connected, a narrow piece of tape should be placed over the muzzle of each tube. This is a valuable safety practice because after the display it allows the operator to easily recognize a mortar containing a misfire.

Shells

1. Shells are measured and classed only in terms of the *inside diameter of the mortar* from which they are designed to be shot, not circumference, for example, 3-inch shells are only for use in 3-inch-diameter mortars.

2. Quick match leaders should be long enough to allow not less than 8 inches of fuse to protrude from the mortar after the shell has been inserted.

3. The length of exposed black match on a leader should not be less than 3 inches, and the fuse should have a total minimum firing delay time of not less than *four seconds* from ignition of leader to initiation of the lift charge, in order to allow the operator to retreat to safety.

4. A *safety cap* shall be installed over the exposed end of the fuse and removed by the operator only at the time of firing.

Before the Display

Site Selection and Preparation

It is important to the safety of spectators and the general public that the operator in charge of a display carefully plan for proper security and crowd control. The shooting site and fallout zone should be guarded before, during, and after the display. This is important in order to protect against theft, accidental ignition, and injury to the public. Fencing off the shooting area is always a good idea and makes security somewhat easier. There is a tendency, however, for people to believe that all danger is over after the final serial shell is fired. Of course this is not the case, and dud shells can explode at unexpected and dangerous locations. Security guards must prevent people from entering the fallout area *even after* the display is over. If possible, a fallout zone with limited access should be utilized. Natural boundaries, roads, fences, or areas well marked with signs, ropes, or flagging are all useful in designating a fallout area. Flammable materials such as dry grass, shrubs, and piles of trash should be watered down thoroughly immediately before the display. Such watering can save much worry by preventing small fires, which detract from the smooth operation of the display. Although the fallout zone will ideally have limited access, it should have suitable access for emergency vehicles. The type and number of pieces of equipment required may be determined by the authority having jurisdiction, but in every case it must be adequate to cope with any fire that can be reasonably anticipated.

Consideration of Wind Velocity

High wind is damaging to the success of a display for several reasons. The primary disadvantage of high wind velocity is that fallout can be carried outside the intended fallout zone. What might be a smoldering piece of shell casing in still weather can become an open flame that can ignite other fireworks, grass, trees, roofs of buildings, and so on, during high winds. Strong winds can also influence the trajectory of a shell and the shape of its burst. It is always a good idea to fire at least one test shell to check the trajectory. Although the performance of a *test shell* does not guarantee that all shells will behave in the same way, such testing provides valuable information on the location of the *actual* rather than the intended fallout zone. Wind also destroys subtle or delicate aerial effects and reduces the beauty of many kinds of shells. There can be no single recommendation on the maximum wind velocity at which safe firing may take place. This decision depends on the site and the hazards in the area. Local fire authorities normally have the final say and some may not permit displays when the wind velocity is as low as 10 mph. Here it is well to remember that a pyrotechnist who has perhaps spent months preparing a single night's display is very easily tempted to fire that display in spite of a strong wind. Such a decision, however, should be carefully weighed and should be discussed with others, since judgment on such matters is easily clouded.

Determination of Distances from Spectators

The distance from the firing site to the spectators is one of the most important safety factors to be considered in the planning of a display. It is generally recommended that mortars and rocket launchers be at least 300 feet

from spectators. Greater distances may be advisable not only for safety but also because very large shells or elaborate shell arrangements can best be appreciated at distances greater than 300 feet. However, displays consisting, for example, of only two dozen 3-inch star shells do not require as much distance between the shooting site and the spectators or as large a fallout zone as a larger display containing more numerous or very large shells. Some situations, such as sporting events at stadiums, may necessitate somewhat shorter distances from spectators. Mortar or rocket launchers should be positioned so that serial devices will not come within 25 feet of any overhead object. Optimally there should be a minimum of a 300 foot long by 300 foot wide or larger fallout zone that is free of spectators. At no time should the trajectory of shells pass over the heads of spectators. It is also recommended that the firing site be at least 600 feet from health care and penal facilities and from storage of hazardous materials (such as petroleum products).

Ground displays consisting of lances and nonmoving set pieces should be no closer to spectators than 75 feet. It is the responsibility of the operator in charge to discern and meet all special requirements of the local authorities involved. As a general rule a lancework with pyrotechnically driven moving parts, wheels, large elaborate set pieces, and large cracker strings should be separated from spectators by a minimum of 150 feet. Low-level serial fireworks such as mines, class C shells, and comet barrages, or other multiple tube devices should be placed a minimum of 200 feet from spectators. These distances, of course, may be increased by local authorities or insurance companies. They represent a realistic appraisal of the relative hazards of these devices to spectators but of course cannot absolutely guarantee safety in every instance. For this reason, pyrotechnic operators must familiarize themselves with all the devices they use in a particular display and make an appropriate assessment of the potential risks to spectators.

Selection of Shells

If the display site has a small fallout area, multiple-break shells must be avoided if possible. Shells with significant fallout debris (such as whistles, tourbillions, serpents, and other special effects) should also be avoided if the fallout area includes parking lots or other areas where damage to people or property might result. While large fallout zones are desirable, there are times when it is simply not possible to ensure such areas will be totally free of people and vehicles. When large fallout areas are not practical, a careful selection of shells can help compensate for a less than optimal fallout zone. Single-break star shells and salutes normally result in relatively harmless fallout. This is not true of multiple-break and many special effect shells.

Inspection of Shells

In preparation for the display, each and every aerial shell should be inspected carefully. All shells should be removed from individual wrapping and any rubber bands on the leaders should also be removed, so that the shell is ready to load without delay. Leaders should be inspected for breaks or tears. Tears in the paper covering of the quick match can be mended with a short piece of tape if the black match is intact. Most importantly, shells must be examined for damage to the shell body and the paper enclosing the lift charge. If any powder is found to be leaking, the shell should be put aside and not used. Inadequate lift can cause a low burst or result in a shell bursting on the ground endangering personnel and unig-

nited fireworks. Shells should be carefully sorted by size (diameter) and arranged in the order of firing. It is good practice to place shells (and mortars) of dissimilar diameter size adjacent to each other to help avoid mixups. Thus, 5-inch and 3-inch and 6-inch and 2-inch shells might be placed adjacent to each other. If, for example, a 3-inch shell is loaded into a 4-inch mortar, a low or ground burst will result. Such mixups must be avoided. Salutes must be recognized as such by both loader and shooter, since they represent greater hazards as a dud, misfire, or hangfire. Salutes can be conveniently marked by taping a short piece of colored ribbon or Day-Glo surveyors' flag tape onto the leader just past the safety cap before the salutes are placed into the ready boxes. Salutes should be fired only from paper mortars. Should a salute explode within a metal mortar (even one properly buried), dangerous pieces of flying metal are likely to result.

On-Site Storage of Shells

Before any firing begins, the entire complement of shells should be brought to the firing site and stored in ready boxes at a point not less than 25 feet distant and upwind from the nearest mortar. A ready box is a substantially constructed container of wood, heavy cardboard, or plastic. The ready box should be positioned with its bottom facing the mortars and arranged to open away from the mortars. A flameproof water repellent canvas cover should be used to protect all ready boxes during the display, except that the cover may be lifted when shells are taken from or returned to the boxes. Shells must be protected against accidental ignition, and most importantly theft. Black match should always be covered with safety caps.

Operation of the Display

Operator Responsibility

The term *operator* is frequently used to refer to the pyrotechnist in charge of a fireworks display. Often the operator is also the *shooter* and actually ignites the shells or other devices. The operator is responsible for the entire show. Duties normally include preparing fireworks for transportation, safe storage, and providing all supplies necessary for the safe firing of the show. Equipment such as eye, ear, and head protectors, flashlights, tools, and protective clothing must be made available to personnel. The positioning of mortars, establishing the layout of the entire firing site, inspecting all devices before the display, and generally maintaining safe conditions at the firing site are also the responsibility of the operator. The operator is fully in charge during the actual shooting of a display and devices are normally ignited only on his or her command. It is the operator's responsibility to make corrections in mortar angles to adjust for wind changes and to ensure that all bursts occur in the unoccupied fallout zone. The operator is responsible for the successful completion of the entire display.

Loading Aerial Shells into Mortars

Shells should not be carried by their leaders. Loaders should be equipped with a flashlight or a headlamp and fuse or portfire never used for illumination. Shells should be placed into the mortars without placing any part of the body over the muzzle. The leader must check to be sure the shell has dropped to the bottom of the mortar. Except for very large shells (those above 5-inch diameter) this may be best accomplished by a gentle

tug at the leader, which will lift the shell briefly off the bottom of the mortar. Large shells can be similarly checked, but a cord or string provided for lowering the shell into the mortar is tugged instead of the leader, which might be damaged if the shell is too heavy.

Firing Aerial Shells

In general all personnel who are involved with firing the display should wear protective clothing as well as protective eye, ear, and head equipment. Flame retardant cotton coveralls or the equivalent should be worn as opposed to nylon, rayon, or other synthetic material that could cause or aggravate injury in the event of fire. Good quality earplugs and protective shatterproof eyeglasses or goggles, as well as safety helmets, such as hard hats or motorcycle helmets, should also be worn.

In manually fired displays, the crew is usually divided into three units: the magazine tenders, the loaders, and the shooters. The magazine tenders are responsible for keeping the loaders supplied and for safeguarding the ready boxes: They must protect the ready boxes from sparks and should never open more than one box at once or lift the protective tarp covering the boxes on the side facing the mortars. The loaders place shells in the mortars, making sure that the shells are properly seated and keeping track of the load shells by type. The shooter then removes the safety cap from the leader and fires the shell.

Aerial shells are best ignited with a portfire or fuses securely attached onto a dowel or rod. The operator first removes the safety cap from the leader and then carefully applies the flame from the portfire to the very end of the exposed black match. He or she should then turn away from the mortar and quickly retreat. At no time should any part of the body be positioned over the mortar, and the operator should keep low as he or she approaches and retreats from the firing line. Used portfires, which may contain hot embers, must never be discarded in the area between the mortars and ready boxes. Personnel at the firing site should maintain close observation during the display in order to detect and report misfires and duds.

Recommended Safety Precautions for Pyrotechnics and Fireworks

1. When using an electric firing board, you must have a master key lock to prevent unauthorized use or have an equivalent means of safety.
2. Always put the key in your pocket before plugging in the controller. Keep it in your pocket during setup and loading or until firing.
3. Don't allow any smoking or open flames in the vicinity of pyrotechnic materials. This caution applies to both mixed and unmixed powders, in or out of the device. Do not reload a device immediately after firing. Let it cool.
4. Wear safety glasses during the pyrotechnic materials mixing and loading operations.
5. Always test-load and fire the devices outdoors in a clear area before a performance to determine proper loads. Never exceed the maximum recommended load.
6. Always mix the pyrotechnic materials according to instructions. Different chemicals could cause cross contamination that may result in misfires or dangerous mixtures. Not all flash powders burn at the same speed.

7. Make sure that security personnel are present during shows. This measure is necessary to prevent members of the audience from suddenly approaching the pyrotechnics during a performance. Observe the crowd clearance distances written in the device instructions.

8. Be certain that the person firing the flash powder has an unobstructed view of the effect and its fallout area, if any.

9. Never put your face over a loaded device.

10. If a misfire occurs, put the controller key in your pocket and empty the device. Dispose of the powder (no more than 1 ounce at a time) by flushing it down a toilet.

11. Appoint only one person to be responsible for loading effects equipment to avoid loading the same device twice.

12. Concussion mortars can have considerable recoil; place the mortars on a substantial floor during firing.

13. When positioning devices, take into account the distances from sets, scenery, cast, crew, and audience. Follow the manufacturer's instructions for distances from spectators.

14. Be sure that stage decorations are fire resistant and approved by the local authority.

15. Test the ventilation system against maximum smoke production.

16. Ensure that smoke detectors and other fire alarms are not affected by pyrotechnic display. If they are, smoke production must be reduced or ventilation increased.

17. Run smoke production tests using pyrotechnics or approved smoke bombs. Tests must be made before spectators are allowed in the area.

18. When in doubt, do not fire the pyrotechnic. Call the manufacturer or the local authority.

19. Static or induced electricity can ignite a squib. Squibs must be shunted during handling and loading. If a control or firing cable must be run across other current-carrying cables, shield it.

20. Make sure a fire extinguisher is immediately available when transporting, handling, or firing pyrotechnics, regardless of all other safety procedures or protective clothing available.

21. Lock up all pyrotechnic compositions in approved storage when not in use.

Glossary of Fireworks Terms

Aerial shell Cylindrical or spherical container containing stars or other effects, quick match fuse, and lift charge.

Battery Collection of fireworks devices designated to be shot within a short period of time, for example, a group of mortars (finale batteries) or a bundle of Roman candles (candle batteries).

Black match Cotton wicking or cord impregnated and coated with black powder, used for conveying fire to fireworks devices.

Black powder Mixture of finely powdered potassium nitrate, sulfur, and charcoal. Commercial black powder may be granular or finely powdered. It serves as a propellant and in a wide variety of other uses in fireworks. It should not be confused with smokeless powder, which is nitrocellulose and not suitable for use in fireworks.

Comet Solid pellet of composition that is propelled from a mortar shell and is designed to produce a long-tailed effect. Comets may or may not

burst at their zenith. Large comets or comets fastened to shells are sometimes referred to as *stickless rockets* because of the similarity of their effect, not their design.

Composition Mixture of ingredients in a device or a component of a device.

Detonation Powerful and loud explosion that occurs inside a mortar in which the entire contents (or nearly the entire contents) of a device are consumed. Little or no visible burning material leaves the mortar because the compositions are totally destroyed in the explosion. A detonation usually damages the mortar and may disturb the positions of adjacent mortars. Several causes are possible. The most common are the use of unsafe formulations in stars, poorly designed or constructed shells, and impurities in the chemicals used in manufacture.

Driver Strong paper case with a nozzle or choke. The case is charged with a fierce burning composition and is used to propel wheels or other mechanical devices. Drivers are sometimes called *wheel pushers* or *pushers*.

Dud Shell that leaves the mortar but fails to break (burst) and falls to the ground. It may explode upon hitting the ground or later on.

Fallout zone/area Area or ground onto which dud shells, shell components, and shell fragments fall during a display. It is important to prevent spectators from occupying the fallout zone.

Finale Fireworks designated to be fired at the end of the display. By tradition, this is usually an especially spectacular assemblage of devices and is usually fired in a short period of time.

Flowerpot Shell that bursts within the mortar, producing a shower of ignited stars and other material. Flowerpots have numerous possible causes: the most common are a fire leak into the shell or a weak or damaged shell casing.

Fountain Identical to a gerb except that fountains usually have wooden or plastic bases and are designed to be placed on the ground instead of fastened to a set piece. See *gerb.*

Fuse Long-burning flare, usually red, commercially used as a railroad or highway warning light but also used to ignite fireworks. When used to ignite fireworks, it may be referred to as a *portfire.*

Gerb Device that releases a jet of sparks or spray of fire, usually used on set pieces.

Gunpowder See *black powder.*

Hangfire Fuse that continues to flow or burn slowly instead of burning at its normal speed. Such a fuse may suddenly resume burning at its normal rate.

Hatch See *black match* or *quick match.*

Heading Portion of a skyrocket that is released at the zenith of its flight.

Lance Small paper tubes (¼ to ⅛ inches in diameter) charged with composition and used for making outline pictures in white or colored fire.

Leader Length of quick match attached to a shell.

Lift charge Granulated black powder positioned beneath a shell, which when ignited propels the shell into the air. Lift is normally enclosed in some shells, in plastic) and is ignited by the leader.

Line rocket Case with a nozzle or choke, charged with a fierce burning composition and attached to a cord or rope. The devices follow the rope instead of flying freely. Line rockets and their elaborations are sometimes called *flying pigeons* or simply *pigeons*.

Lowburst/break The shell explodes below the prescribed height—on the way up or down.

Meal (meal powder) Finely powdered black powder.

Mine Device designed to project *ignited* stars and/or other effects into the air. Compared with shells, mines generally produce visual effects that are seen at lower altitudes. A minelike effect is produced by a *flowerpot.*

Misfire Shell in which the quick match burns away after being lighted but nothing else happens, leaving a live shell in the mortar.

Mortar Tube of metal or cardboard from which aerial shells are fired.

Multiple-break shells Aerial shell designed to produce more than one explosion in the air. There are several different commonly used designs; however, all of these result in an increased risk of a dud falling into the fallout zone. Shells containing numerous small shells are often called *shells of shells, Puppadella,* or *many small flowers.*

Muzzle burst Shell that bursts just as it leaves the mortar, scattering stars and burning material in all directions at ground level.

Operator Pyrotechnist in charge of a display or in charge of the ignition of shells and other devices.

Portfire Paper tube charged solidly with composition that is used for lighting other firework devices. Portfires are best securely fastened to a length of dowel or other light board for use.

Priming Slurry usually made of gunpowder, a binder, and water or other solvents and used to ensure the ignition of devices.

Quick match Black match enclosed in paper wrapping.

Racks Sturdy wooden frames used to support paper tubes in an upright position above ground.

Ready boxes Sturdy fire-resistant boxes used to store shells or other fireworks during a display at the display site.

Report Loud explosion, normally much louder than the explosion of a star shell. Sometimes used synonymously with a *salute* (the fireworks display itself). A report, however, is the sound actually produced by the explosion.

Roman candle Cardboard tube designed to shoot stars of special effects periodically and repeatedly into the air.

Safety cap Tube of heavy paper or cardboard that fits over the bared black match at the end of a quick match leader and is removed just before ignition by the operator.

Salute Shell containing a powerful composition (usually a flash powder) that explodes violently, producing a loud report with very little visual effect other than a bright flash. *Titanium salutes* are similar except the loud report is accompanied by a large cloud of white particulate fire.

Set piece Ground display such as lances, wheels, gerbs, fountains, and/or other devices that perform at ground level.

Skyrocket Cardboard tube solidly charged with gunpowder (or other

propellant). The tube is attached to a stick that gives it guidance during flight and prevents it from spinning end over end. The *nose* or *heading* of a skyrocket may contain a salute, stars, or special effects. After completion of its flight, a rocket tube and its stick fall back to the ground intact with the potential to do damage to people and property. Rockets are seldom used in commercial displays because they are more dangerous than shells and less efficient in getting large payloads several hundred feet into the air. Skyrockets are not commonly used in American commercial displays because of their unpredictability.

Special effect shells Any shell that contains something other than a salute or simple stars. Such shells usually include *whistles*, which are cardboard or plastic tubes filled with special whistling composition; *serpents*, which are small tubes charged with fierce burning composition that jet and shoot about in the air; and *tourbillions*, which are tubes charged with fierce burning composition but have the exhaust hole in the side of the tube so instead of jetting like serpents they spin like small wheels. Numerous other special effects are to be found including small shells that explode several seconds after the large shell bursts, curious class C items such as firecrackers and jumping jacks, and *comets*, which if they explode are called *Crossette comets*.

Stars Small cubes, cylinders, or balls of composition that are discharged from shells, mines, Roman candles, or other devices and burn while in the air.

Special Effects and Stunts

Quite often you'll work side by side with stunt professionals. Effects such as slingshot cars, car explosions, pyrotechnic jump ramps, and body burns all require the greatest degree of cooperation between the F/X and the stunt professionals (Figure 12–1). This is probably the most interdependent, credent, and symbolic relationship that exists between two people, outside the military. Nowhere else does one person so completely and emphatically trust their life to the judgment of another. Granted, both the F/X and stunt persons have their own areas of responsibility, but they are so intertwined as to be virtually indistinguishable.

To make it completely clear, I personally knew three stunt people who died recently because *someone* made a mistake. Most often it was the stunt person or the stunt co-ordinator who made the mistake. This is a personal warning *to you*, however, that injury or death should never be caused by an F/X foul up.

Body Burns

The body burn requires a stunt person to catch on fire and perform some activity such as running down the road or thrashing about in a room, all the while engulfed in flames. This effect is dangerous because of the flames but can be made fairly safe.

The stunt person wears several layers of Nomax underwear, which is flameproof, a burn suit over that, special fireproof headgear, and a special mask and headpiece. In addition he or she carries a two- or three-bottle air supply. Since the fire takes all the oxygen out of the air and superheats it, the stunt person must have a self-contained air system to facilitate breathing.

None of this protective clothing is donned until immediately prior to the shot. The insulated gear is hot and perspiration can turn to steam and cause injury.

In addition to the clothing, the stunt person applies stunt gel to hands, head, hair, neck, and so on. The gel keeps the person cool and protects the skin from any flames that may inadvertently penetrate the suit.

Once the performer is suited up, he or she has only six to nine minutes of air supply, so you must work quickly and accurately. With either rubber cement or pyro gel, brush a coating on the entire front and back of the costume, but avoid putting any material under the arms or between the legs. When this step is completed remove any remaining chemicals from the set.

Five to six crew members should always be standing by with carbon dioxide fire extinguishers in addition to a large hand-held blanket (of a weight used by movers) that has been soaked in water. As a further safety precaution, *always* test the carbon dioxide extinguisher immediately prior to the shot. One safety person should always stand by to look at the over-

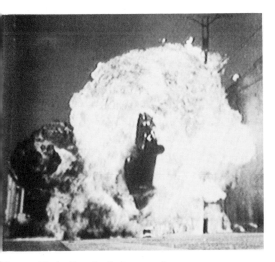

Figure 12–1 Pyrotechnic ramp jump

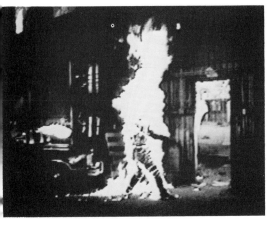

Figure 12–2a Body burn

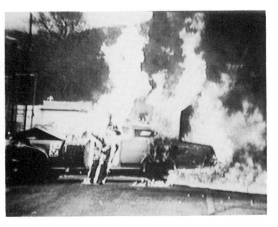

Figure 12–2b Car fire and body burn

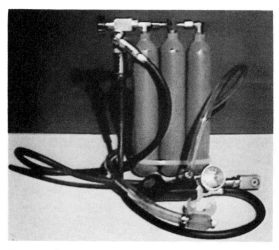

Figure 12-2c Air breathing system worn by stunt professionals during body burns

all picture especially when the safety crew is putting out the person burning to make sure that the flames aren't reignited from other sources.

When the camera rolls, the performer is ignited and executes the stunt. The cue for extinguishing is always given by the performer! Only the person involved can judge the timing and limitations of the equipment and the situation accurately. The cue to put the stunt person out is indicated by the performer falling face down with outstretched arms. The safety crew then dashes in immediately with the carbon dioxide. If for some reason the carbon dioxide fails (almost impossible), the backup wet blanket should be wrapped around the performer. As part of the setup safety procedures, pull the locking pins from the carbon dioxide bottles prior to the shot and test them with a burst from each one. Very rarely have I seen a stunt person injured when doing a burn gag if wearing proper garments, but don't ever take shortcuts with safety procedures (Figure 12-2a-c).

Car Fire Stunt Explosions and Ramp Jumps

Burn suits are also used by drivers in car burns and explosions, fire traverses, jump ramps, and motorcycle burn gags (Figure 12-3a-c). Cars involved in rolls or jump ramps are specially built with reinforced frames and interior roll cages. The gas tanks are removed and replaced with a fuel cell that carries approximately 1 gallon of gasoline. The driver is strapped into a heavily padded roll cage and secured with a five-point safety harness.

Most action movies have a sequence in which a car involved in a high-speed chase suddenly flies into the air, spins over, and rolls on the ground. This is called a cannon car (see Chapter 10, page 131).

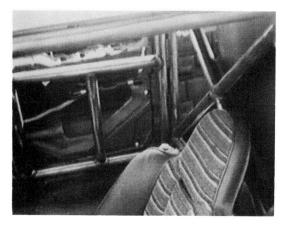

Figure 12-3a Roll cage inside stunt car

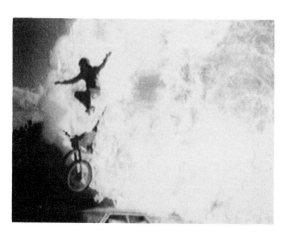

Figure 12-3b Motorcycle burn and jump

Figure 12-3c Stunt professional Kevin McCarthy in Kevlar burnsuit with Nomex hood prepping for body burn

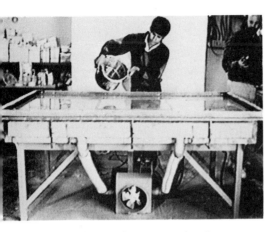

Figure 12-4 Table used to prepare breakaway glass

Breakaway Glass and Tempered Glass Effects

Breakaway glass and tempered glass are used for different effects. Breakaway glass is usually limited to sizes 4 by 6 feet (Figures 12-4, 12-5, 12-6). Anything larger is difficult to handle unless you are making it on location. When larger dimensions are needed, I use tempered glass, often in sizes 8 by 10 feet and larger for sliding patio doors, picture windows, and storefronts. I employ *glass breakers* to shatter the glass (Figure 12-7). These small sharply pointed metal devices are positioned at the base of the window on both sides and are either spring loaded or laid with squib hits and attached to the glass. Tempered glass requires nothing more because it is quite delicate. A simple scratch will literally cause it to collapse and shatter into a million pieces about the size of dimes.

In stunts where a person is required to jump through a window, squib charges are set and detonated a split second before the performer plunges through, and the actor "pushes through" the fragments of glass. Good timing is absolutely necessary for this effect to work. If you are off by a split second, expect the stunt person to bounce off the window quite hard. This is a relatively safe stunt but should never be attempted by untrained people.

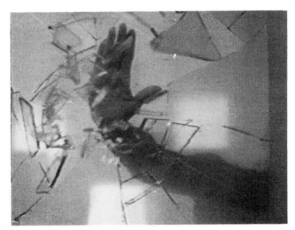

Figure 12-5a Hand through breakaway glass in door panel

Figure 12-5b Assorted breakaway bottles

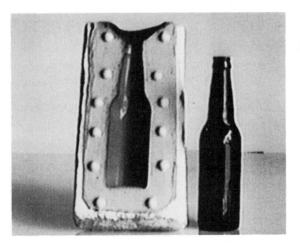

Figure 12-6a Breakaway bottle and mold

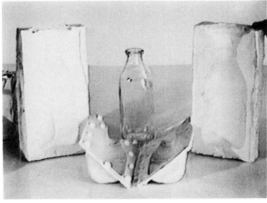

Figure 12-6b Two-piece silicone milk bottle mold

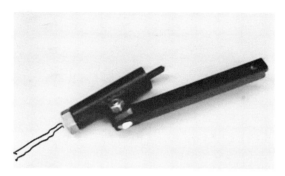

Figure 12–7 Pyro-type glass breaker to break tempered glass

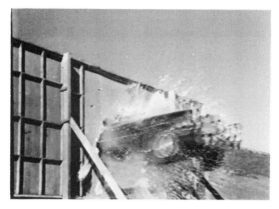

Figure 12–8a Slingshot car

Figure 12–8b Slingshot car

Slingshot Cars

The slingshot is a device to propel a car, airplane, truck, motorcycle, or any other kind of wheeled object off a cliff, through a building, or any other place the script requires (Figure 12–8). First remove the gas tank, carburetor, motor, and transmission to reduce the vehicle's weight.

Beneath the front end of the car, preferably mounted on the frame, weld a heavy-duty pin at a 45-degree angle facing the rear of the automobile. Then attach a heavy-duty ring to a $^3/_8$-inch cable that in turn is hooked to the pin and taped to prevent it from slipping off. This cable runs forward to a large steel sheave that is attached to a second cable running to a 4 × 6-foot post buried approximately 4 feet in the ground. This post is known as a *dead man*. It is buried at the conjunction of the sheave and a 4 × 4 truck that serves as the power or thrusting force for the slingshot. The sheave must be kept snug to the ground and anchored to provide proper leverage for the pull.

The 4 × 4 truck has another ring mounting fixed to its rear that can be jettisoned by a trip release. The trip release is there if for some reason the ring or the cable should get fouled and it is necessary to break the connection between the two vehicles.

A guide track is then laid out consisting of 2 × 6s and 2 × 8s that serve to control and guide the direction of the vehicle being launched. This track steers the car to the exact position you want it to be launched off the cliff. Without this guide track it is much too risky and dangerous, as the vehicle could swerve wildly. (There are other mechanisms to control the steering of the automobile without the guide track but they are less reliable.)

The speed of the vehicle to be launched is determined by the length of the cable used. As an example, if 30 miles per hour is required for launching, then a 150- to 200-foot cable is required. Naturally, the longer the cable, the higher the speed.

Assorted Special Effects Equipment

Fans

Fans and the wind they produce can be dangerous. See Box 12–1 for safety tips. There are several types of fans used in the business.

Box 12–1 Safety Tips

Remember that wind can be very dangerous. It can blow large quantities of debris, which in turn may be sucked into the fan and injure people. Be especially careful when you're using heavy-duty wind machines at high speeds. Always check the blades. Make sure they're secure and that nothing is loose or rattling around the cage.

Never shoot debris through the wind machine blades. If you have something to release, do it in front of the blade and let the wind blow it onto the set.

If you feed snow, breakaways, or pieces of debris or dust from the back through the machine, you can damage the blade. If anything gets inside the cage, you'll have to take it apart and clean it.

Never shoot smoke through a wind machine. Smoke is greasy and coats the propeller, which in turn will pick up dirt.

1. squirrel cage (Figure 12–9a).
2. E-type 21 fan (Figure 12–9b).
3. Red Bird (gasoline-operated engine with a wooden airplane propeller; Figure 12–9c).
4. the Ritter (big AC/DC operated fan): very quiet and therefore good for set work, except at high speeds. But rarely is a wind set quiet. Wind makes noise (see Figure 1–9c on page 3).
5. hurricane fan: enormous fan that can produce 120 mph winds. Its engine can be gasoline or electrically powered. It has a single airplane blade. It also has an adjustable pitch so you can create more or less wind. The blade is about 13 feet long and tremendously powerful. The fan is normally transported on a low-bed trailer, though it can also be transported on a truck if the height of the truck doesn't prevent folding the safety cage in half to minimize the total height (Figure 12–9d).

Wind Machine Attachments

Wind machines can have several attachments built onto them. If it's a gas-operated machine, you can build a smoke device using your exhaust system. To get a hurricane effect, put a rain ring on the wind machine and turn it up to very high speed. For snow, a foam spinner is placed on the wind machine. A combination of foam and water regulated in the proper amounts will give you a dry foam that looks like snow or wet foam for a slushy effect. It can also be used for falling snow effect (see Figure 1–4 on page 2).

Dump Tanks

Dump tanks are devices built to hold as much water as required (Figure 12–10). I've built dump tanks that contained 20,000 or 30,000 gallons. (On stage though, you'd never use more than a 400- to 900-gallon tank.) For a wave effect, they can be dumped all at once. Dump tanks can be operated manually, remotely, electrically, pneumatically, or hydraulically.

You can also put dump tanks on platforms with a chute in front of them. Depending on the angle and width of the chute you can create many different effects. Put a lip on the chute. It will allow you to vary the direc-

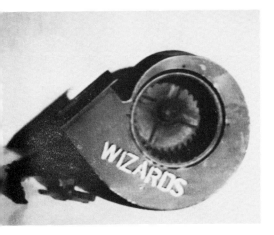

Figure 12–9a Squirrel cage

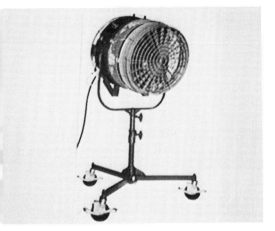

Figure 12–9b E-type fan

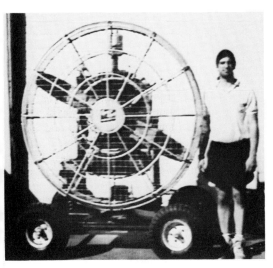

Figure 12–9c Red Bird fan

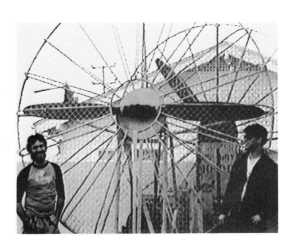

Figure 12–9d Hurricane fan

Figure 12–10 750-gallon dump tank

tion, degree, and height of the splash of the water. The lip should be adjustable to facilitate changes in the angle, height, and width of the flow.

Always remember that water is very heavy and very dangerous, so be very careful when using a dump tank, especially around actors. For instance, a 450-gallon dump tank (roughly about 3 × 4 × 5, or 60 cubic feet of water) weighs about 3700 pounds. This is a tremendous amount of weight to put up in the air, so be sure your platform supporting your dump tank is strong enough to hold it. Before putting a dump tank on a platform be sure to strongly brace the scaffold to accommodate the weight of the water.

Making Waves
There are several ways to make waves in a tank. You can use a wind machine, feed box, an offcenter revolving drum, an outboard motor, an air cannon, a dump tank, or an air-driven wave machine (Figure 12–11). If you're working in a stream and are asked to increase the flow of water in a sewer or stream, there are many different ways to do this: for example, use a fishtail nozzle, water pump, fire hose and nozzle, or an outdoor engine.

Cobwebs

There are three pieces of equipment used for making cobwebs:

1. cobweb spinner (Figure 12–12a)
2. paint spray gun
3. hot glue gun and air tube (Figure 12–12b)

The cobweb spinner is used widely because it does a good job and is easy to operate. It has very few working parts: a drill motor with an attached fan blade and a material spinning cup with a removable top mounted on a shaft in front of the fan. This cup fits very tightly to the mechanism. A thin slot approximately ½ to ¾ inch is cut into the top of the cap about .0002 inches deep. The material is spun out of the cup through the slot and blown by the fan onto the object you are cobwebbing. *Note:* There's a wire cage around the cobweb spinning machine to provide protection from the fan blades.

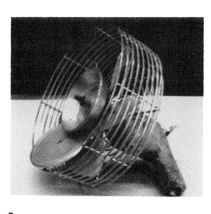

a b

Figure 12–11 Pneumatic wave machine: front-view (top), side view (bottom)

Figure 12–12 (a) Open cobweb spinner, side view (b) hot glue gun and air tube

Figure 12–12c Dust gun

There are two types of materials used for cobwebbing. One is Saran 121 resin and the other is methyl ketone, which is rubber cement and rubber cement thinner. The 121 resin is used most often and is the safest, though both it and the rubber compounds are flammable. Rubber cement is used when the 121 resin is unobtainable. Both give an equally realistic effect; however, the Saran 121 resin is a better material to work with.

To make the cobweb brighter and more authentic looking, use a plant duster with fuller's earth or white baby powder to achieve an even coating. Build up coats of dust through a series of applications rather than a single heavy one (Figure 12–12c).

There are several models of dusters available in hardware stores for dusting roses and trees, but all work with either a pumped device or sprayer very similar to that used for bug spray. The duster is easily recognized by its long handle and a glass jar located underneath.

In constructing cobwebs that cover large areas, use a very thin monofilament as a supporting structure. Once your design is completed overlay the spray webbing. For dusting an entire set with heavy dust, use a sandblasting gun with fuller's earth or white powder.

Bubble Machines

Bubble machines made Lawrence Welk famous. The machine uses a bubble fluid, which is nothing but a liquid detergent soap. You can make several sizes of bubbles with this machine merely by changing the size of the holes on the revolving wheel that dips into the bubble fluid and passes in front of a blower which blows the bubbles into the air.

Mirror and Reflection Effects

During my career, I've probably heard one phrase a thousand times: "They must do it with mirrors." Well, that's not too far from the truth because I've often used mirrors and reflecting devices when performing as a magician or doing special effects for television, motion pictures, and at Disney's Epcot Center.

The oldest system is the *image splitter* (sometimes referred to as the Schuffton shot, after the inventor who popularized the process in the 1880s), which affords an effective method of creating composite shots. The image splitter is a four-cornered box, open on three sides (Figure 12–13). A 20% front-silvered mirror is mounted rigidly inside. The mirrored surface must be maintained at a perfectly plumb 90 degrees vertically; horizontally it is positioned on a 45-degree plane to the optical axis of the camera lens. This mirror is commonly referred to as a two-way mirror. It is semitransparent and serves to both transmit and reflect light.

Once these procedures have been followed, the camera is locked down and shoots through the mirror, photographing the actor positioned on its opposite side while simultaneously recording objects or activities positioned at a 90-degree angle to one side or the other of the camera and whose images are simultaneously overlaid in camera and with maximum optical quality.

An example of this technique can be found in a scene requiring a person to be standing unprotected in a burning room. In actuality, he or she is placed in an empty room and the fire is some distance away at a 90-degree

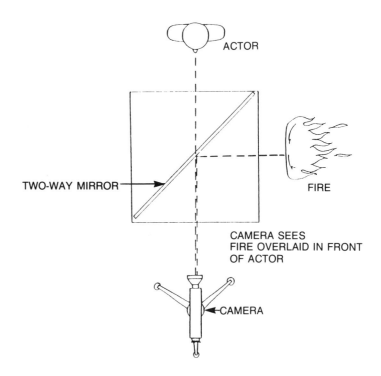

ACTOR

TWO-WAY MIRROR

FIRE

CAMERA SEES
FIRE OVERLAID IN FRONT
OF ACTOR

CAMERA

Figure 12–13 Schematic of an image splitter

angle to camera. These two separate images are combined in camera and give the appearance of being one.

Clear glass (mounted and angled identically as the silvered mirror) is used to overlay or superimpose apparitions such as ghosts, floating heads, and so on. By increasing and decreasing light levels on the "spirit," these apparitions can be made to appear or disappear, slowly or quickly, as images are reflected off the mirror and into the lens.

There are two vital elements to be considered when using an image splitter. First, both the primary subject behind the mirror and the reflected secondary object must maintain the exact identical distance in relation to the focal plane of the camera. In other words, if the primary subject is 15 feet from the focal plane, the secondary object must be too. Neither subject nor object can deviate from the relationship of 90-degree angles from each other or the camera.

Secondly, a light loss occurs due to the 20% front-silvered mirror. The difference between the darker subject and brighter reflected object requires an exposure compensation of 3½ to 4 stops. Make sure that the camera operator takes this into account.

On "The Jackie Gleason Show," we often used the famous "Busby Berkeley" overhead shot. The June Taylor Dancers executed formations while lying on the floor and created an endless variety of designs with their arms and legs. It appeared to the viewer that the camera was mounted in the flies, shooting directly down on the performers, though it was not. In fact, the camera was attached to a pipe mounted on a platform with the lens shooting through a 100% front-surfaced silvered mirror. This mirror was adjustable and could be angled to conform to the directed shot.

Scent Cannons

A scent cannon looks like a cannon, but shoots scents instead of shells. I created several interesting scent cannons for Epcot Center.

On several of the rides, the Disney designers wanted passengers to experience both the sights and smells of the location. For instance, in a swamp the smell should suggest the fragrance of jungle vegetation and flowers as the riders passed. An erupting volcano should assault the senses of smell, sight, hearing, and give off heat. It should be a combination of the visual, auditory, and olfactory. Thus fragrances were incorporated into the rides to create as total an experience as possible.

Though the degree of perfection and technical innovation of such a system has never been attempted or equaled, the Epcot Center did not originate the concept. It was first tried in several specially equipped movie theaters during the late 1960s and dubbed by some as "Smell-O-Vision."

Basically the scent cannon uses a round tube approximately 4 to 5 feet in length. At one end is a cannister containing a particular fragrance that is fired onto a special wick sealed in the cannister. As a car full of people passes by, a trip lever sends a signal to the cannon. It slowly opens and a squirrel cage blower forces the scent through the tube to the audience. To prevent contamination (i.e., intermixing of fragrances), special charcoal filters and exhaust fans suck out and purify the air and then return it to the room. We had no problems of cross contamination even with fragrances separated by as little as 6 feet.

Tornados

Tornados are one of the effects I had a lot of fun with while working for Disney. I was asked to create a tornado effect for the Imagination Pavilion at Epcot Center. I had to do the drawings and plans within two weeks and the entire effect had to be finished in two months. One week later I had the effect built and ready to be shown (Figure 12–14).

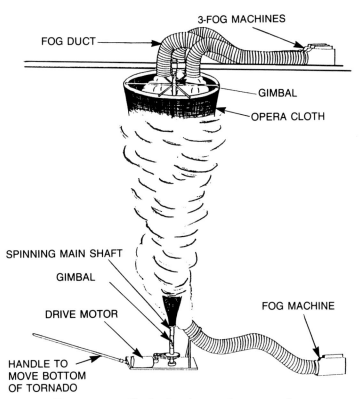

Figure 12–14 Mechanism for creating a tornado

We used a combination of fog machines to create a giant mechanical tornado (centrally a funnel) made with several layers of various size opera cloth. Heavy fog was pumped through the center of the tornado. As the tornado turned and spun, the heavy fog would seep through the cloth effectively masking it, and then turn it to a solid fog. It was a walling layer of fog in the shape of a tornado with excellent shape and dimensions. The effect was back lit, which gave even more realism.

Volcano

While I was at Disney working on the Epcot Center project as special effects and magic design consultant, I was asked to create a volcano. This was not just an ordinary volcano, but a volcano that would run continuously, erupting with hot, flowing, smoking lava carrying rocks and burning debris with it.

It was to be so realistic that the heat from the flowing hot lava could be felt as well as seen. In addition audiences had to experience the actual smell of the volcano. Finally, the volcanic eruption and explosion of lava had to be done on cue.

This was quite a challenge. It took almost a month to build the set, using a combination of liquid nitrogen, steam, mechanical pumps, plastics, ultraviolet (UV) lights, UV dyes, and a hair gel that was an inert material but when specially treated would maintain the viscosity of lava. To this we added various UV dyes. This concoction was illuminated by UV lights from beneath a clear plastic lava trough. The UV lights emphasized the pigmentation of the lava and made it appear to glow red hot. From both sides of the set, we then shot in steam and strategically spaced injections of liquid nitrogen to create a flow of fast sparking smoke. Scent cannons were added, and hot air blowers provided the sensation of heat when the audience passed by. Pumps were then cued to shoot up a liquid impregnated with UV dyes from the mouth of the volcano. This liquid glowed red hot on anything it landed on or touched (Figure 12–15).

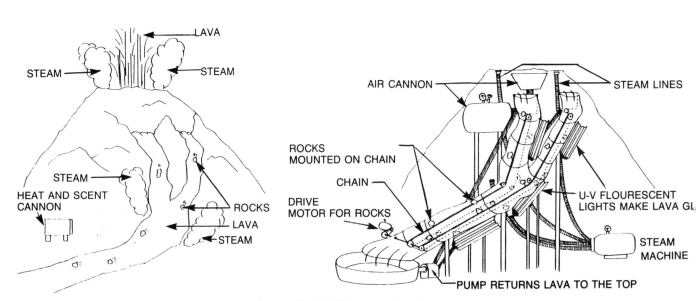

Figure 12–15 Volcano mechanism

Rocking Cars, Airplanes, Boats, and Rooms

The expensive way to rock large objects uses hydraulics, air rams, and large heavy steel frames. But you can economize and just use truck tire inner tubes (Figure 12–16).

Fill the inner tubes with a small amount of air (approximately 30 pounds) stacked two high, lace them together with rope, and stabilize them in the center with a post. Build a platform on top of these inner tubes and put the object that is to be moved on it. In each of the four corners mount
4 × 4s that extend out approximately 6 feet. By manipulating these you can create an up-and-down movement. Mount two more 4 × 4s at the nose of the platform to make the side-to-side movement. The proper balance of the object being rocked is achieved by centering its weight on the platform and securing it to the platform.

Obviously it's much cheaper to do the effect this way as all it requires is a bit of human labor. On the TV show "Supercarrier," we mounted the body of a jet aircraft on a mechanism like this and it worked perfectly.

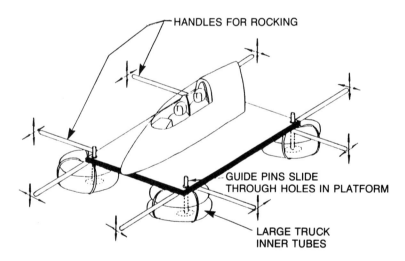

HANDLES FOR ROCKING

GUIDE PINS SLIDE
THROUGH HOLES IN PLATFORM

LARGE TRUCK
INNER TUBES

Figure 12–16 Mechanism for rocking a car, boat airplane, room

Spinning or Tilting Room

On "The Ernie Kovacs Show" many years ago we built a tilting room. The skit involved Kovacs sitting at a long table either in the center or at one end depending on the effect he wanted.

The camera was stationary mounted to the platform itself and thus it maintained a constant, visual perspective between it and Kovacs, regardless of how the platform itself moved. Since the visual relationship remained constant the camera didn't "see" the tilt. If, for instance, Kovacs would pour from a bottle, the liquid would seemingly defy gravity and miss the cup and flow either parallel, downhill, or uphill for no apparent reason responding to the degree of the platform tilt. We got all sorts of effects like this by varying the tilt to different degrees.

Though I had nothing to do with Fred Astaire's famous dancing on the ceiling number, I have built similar spinning and tilting rooms that

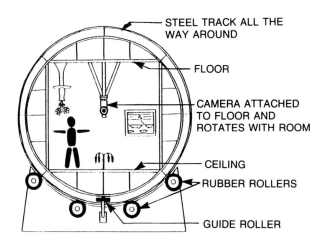

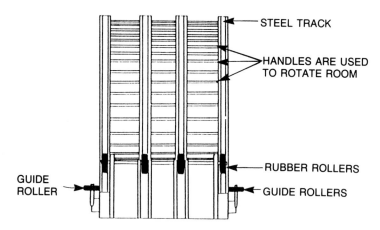

Figure 12–17 Spinning room

enabled a person to walk and dance on all four surfaces of the room. The same technique was employed in the video *Dancing on a Ceiling.* The spinning room can be built to any size depending on your budget.

I once built a spinning room with two gigantic circles made of 4 × 12-inch wood. One was positioned in the front section and one in the back section of the room, both of them on the outside of the set. Essentially it was a square inside of two circles. These were on gigantic rollers with guides that enabled the room to be pulled around by three men (Figure 12–17).

Blowing Smoke through Small Hoses or Pipes

Attempting to pump smoke through a small hose or pipe as small as ¾ inches using only the force supplied by the fog or smoke machine will do nothing more than create a very messy backup. A Venturi device (named after the nineteenth-century Italian physicist) is necessary to accomplish this effect efficiently.

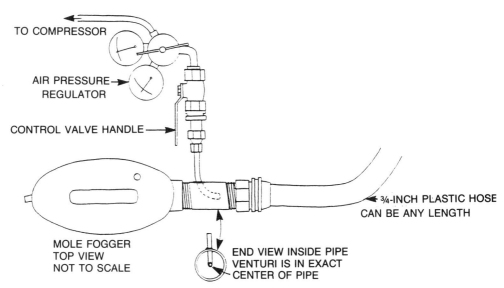

TO COMPRESSOR

AIR PRESSURE REGULATOR

CONTROL VALVE HANDLE

MOLE FOGGER
TOP VIEW
NOT TO SCALE

¾-INCH PLASTIC HOSE
CAN BE ANY LENGTH

END VIEW INSIDE PIPE
VENTURI IS IN EXACT
CENTER OF PIPE

Figure 12–18 Mechanism for passing smoke through a long hose

A Venturi system creates a permanent air flow through the piping even when you are not pumping smoke through it. In turn, this airflow pushes the smoke through the conduit and out the other end. The device provides a goodly amount of smoke through the small diameter tube. In addition to the smoke machine, an air compressor, air line, and a regulator are required to modulate the speed of the smoke flow into and through the hose (Figure 12–18).

Blowing smoke through tubes or confined areas is always troublesome. You have to have a Venturi for large round flexible tubing (say a foot in diameter) in order to be able to delivery accurately over distances to pre-designated areas. Without the airflow created by the Venturi, the smoke tends to remain calm and stationary. A smoke machine alone does not have the power output to accomplish a smoke throw of any confined distance. A squirrel cage blower is best for use on tubes 2 feet and larger.

Popping Champagne Corks

This effect can be safely done with the bottle in hand or when it rests on a table or is being chilled in an ice bucket. Likewise, the corks can be designed to pop individually or in rapid succession. For example I recently did a commercial that required six champagne bottles to pop their corks in a row.

To prepare the bottle, drill a ³/₈-inch hole in the base to accommodate a glass tube that you then insert and glaze or epoxy securely in place. Trying to drill a hole through the bottom of the bottle is a hit and miss project at best, so you are well advised to have a glazier or glass blower perform the operation.

Connect a rubber pressure hose to the glass tube and then hook a button valve to the air regulator and then to an air tank. When the tank is turned on the resulting air pressure propels the cork on cue when the button valve is pushed (Figure 12–19).

It is important that the cork not fit tightly. It should be shaved down and well greased for easy removal.

TRIGGER BUTTON

AIR PRESSURE
REGULATOR

COMPRESSED
AIR TANK

Figure 12–19 Popping the cork out of a bottle

161

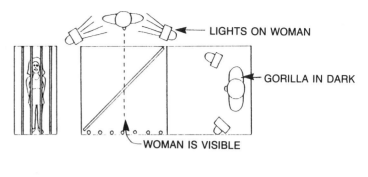

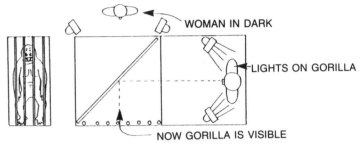

Figure 12–20 Changing a woman into a gorilla

Changing a Woman into a Gorilla

For many years, magicians have used mirrors and glass devices in their illusions. Probably the most famous of these tricks is the transformation of a woman into a gorilla (Figure 12–20).

For this illusion a magician chains a woman into a box. As the lights dim onstage, the woman begins to struggle frantically. Gradually there is a faintly perceptible metamorphosis as she fights against her restraints. Hair begins to grow from her body, her face assumes the visage of an ape, arms elongate and legs stiffen and shrink until this beautiful woman has been transfigured into the daughter of Kong. When this illusion was first performed, audiences ran screaming from the theatre, not realizing that what they had seen was the effective and imaginative use of an image splitter.

Pressurized Smoke through Musical Instruments

Recently Michael Jackson wanted a voluminous cloud of smoke to pour from the end of the guitar played by one of his musicians. We accomplished this by using carbon dioxide through a high-pressure ½-inch hose. A special nozzle cone was hidden behind the neck of the guitar. On cue from offstage the carbon dioxide was fired, giving the effect of a cloud of white smoke coming from the end of the neck of the guitar.

Remember when using carbon dioxide that it is under heavy pressure. All the lines used must be rated for high pressure.

Fireballs from Musical Instruments

A few years back I was creating effects for Emerson, Lake and Palmer on their show. Keith Emerson wanted fireballs to shoot from the end of his guitar. This was accomplished with a tiny device called a fire shooter that I invented many years ago for magicians.

We used flash paper inside two narrow pieces of copper tubing at the end of which was placed a small model aero plain spark plug that was fired up by a 1.5-volt battery. When the button was pushed on the unit, the flash paper ignited, shooting out the end of the tube and kept burning for about 30 inches or more. By pushing the second button the same effect could be accomplished.

It was a compact unit, so much so that we were able to build it into the instrument and run it off a battery pack containing two 1.5-volt batteries and have as many as six shots. Separate buttons were used to fire individual fireballs on cue. When Emerson pushed a specific button, a fireball would shoot 40 to 50 feet out over the audience, vanishing in midair. These are dangerous devices so care must be taken.

I initially conceived this idea based on an effect I had created years before when performing as a magician. It is similar to what magicians do who shoot fire into the audience. I created this effect for Lou Tannen many years ago and have since sold hundreds of them to magicians all over the country. The solution for the Emerson, Lake and Palmer effect was to simply combine five or six of these devices and build them into the guitar.

Breakaways

There are many types of breakaways: furniture, glass, bottles—practically anything and everything. The aim is to make them safe. Breakaway furniture is made in most cases of balsa wood, but be aware that all balsa wood is not soft. You must choose the specific wood for your furniture carefully.

The furniture is constructed in the design of the prop to be duplicated. This is time consuming and very expensive. Styrofoam and different types of plastics are used to make bricks, rocks, and certain breakaway furniture in addition to items such as falling ceiling pieces.

Breakaway bottles and glass are made with a product called Pyco-Tex or Pyco-Lastic. Contrary to popular belief, sugar glass, or candy glass, hasn't been used for years.

These plastics are heated very slowly in pots at exact temperatures and using precise methods. The exact formulas and methods of making breakaway is a trade secret.

The table is heated in the manufacturing process and in turn heats the plastics. A cellophane covering is draped over the table and the predesigned and constructed wooden forms executed in the size and shape of the glass being made.

Once this ensemble has been covered with water-soluble cellophane, it is placed on the heating table. The mixture of plastics is heated in a large enough pot to make the required size sheet of glass. It is then poured into the cellophane-covered mold. This is very slowly cooled down to prevent bubbles in the glass and cracking. If bubbles do appear in the glass they can be removed simply, but then again that would be telling a trade secret. Pyco-Tex and Pyco-Lastic come in a crystalline form, so the hardness or

density of the glass depends on how much of the materialis used in the formula.

For clear glass add a speck of blue or green dye for proper coloring when heating it or it will turn yellow. For breakaway bottles, add in a brown dye. You can reuse the breakaway glass by remelting it, but you can only reuse it for brown bottles because it discolors when reheated.

There are other methods of making bottles that require a special mold. Pour your mixture into the mold and allow it to settle before you pour out the excess. Once cooled, you can easily extract the bottle. These molds provide a limitless number of shapes, sizes, and colors and can be employed for everything from bottles to breakaway telephones.

There are other materials that can be used for these breakaways such as plaster of paris, rubber, or other types of plastics. There are many different products of this nature on the market today and innovations are coming forth everyday.

Prompting and Image Splitters

Years ago television employed cue cards. While they served their purpose, it was readily apparent to viewers that the performers' eyes were moving back and forth or that their heads tilted slightly in the direction of the cards held by the prompter.

Today, teleprompters are used. When they were first developed, they had to be placed above or below the camera lens in order to be useful, thus causing the eye line (i.e., eye contact or focus) to be broken from the lens. The problem was solved using an image splitter. Made from a simple piece of plate glass, it is angled to reflect the actor's or broadcaster's lines directly onto the lens. Because of the optics involved, these lines are invisible to the lens and therefore invisible for the viewer.

The Haunted House

The haunted house exhibit at Disney World employs dozens of distortion mirror effects. At Epcot Center, a variation called a vibrating mirror was created. The primary difference between the two is that in the first instance, the person moves to create the distortion while in the second the mirror vibrates, changing the viewer's shape.

In Disney World's haunted house, there is an unusual ghost room that is viewed by the audience from above and designed on the glass reflection principle. Looking down, the audience sees a room filled with demons, hobgoblins, and ghosts flying through the air, oozing from a pipe organ, or seeping from wall crannies.

If you have the opportunity to visit the venue, notice there is an almost invisible piece of glass separating you from the room below. It is on this that the images are projected from below and controlled by lighting adjustments that provide the image-splitting effect.

The Gleason Years

My 12 years of working with Jackie Gleason were probably some of the most rewarding and artistically liberating in my career. The hours were always outrageously long and the time to invent and perfect the effects ridiculously short, but the pure excitement of doing a one-hour live show every week with a great gentleman and talent has never been equaled.

One of my favorite Gleason characters was Reggie Van Gleason III, the outrageous playboy and imbiber who was always willing to take on any of life's challenges as long as it was preposterous. More often than not, these skits were blackouts, or one-joke skits, as opposed to fully developed scenes, and so rarely required a great deal of development or integration into a main show storyline. Three that I particularly remember are the Weatherman, Rocket Sled, and Electrical Man.

Reggie the Weatherman

Reggie as the weatherman appears on stage with map, pointer, globe, and so on (Figure 13-1). During his report, he describes how beautiful the weather is and since it is Florida, it will continue to be so. Suddenly the wind starts to blow at hurricane force and everything, including Gleason, is blown off the stage (Figure 13-2).

For this effect, I had to construct a special machine consisting of a 6 × 6-foot squirrel cage blower driven by a 40 hp motor. Until this time, I'd always somewhat cynically assumed that manufacturers tend to overrate their products. In this instance I was proved wrong. The blower not only cleaned the stage of props and Gleason, but also raised the scenery 1½ feet off the floor with the updraft it created. Ironically, a real hurricane hit Miami not 48 hours later, wreaking havoc throughout the city and forcing us to rent massive electrical generators in order to do the following week's show.

Figure 13-1 Reggie the weatherman describes how beautiful the weather in Miami will be.

Figure 13-2 Without warning, a hurricane strikes.

165

Reggie and the Rocket Sled

Reggie was an adventuresome sort when faced with impossible challenges and fortified with considerable libation. In this instance he was Stuntman Reggie who intended to ride a rocket sled through a glasshouse, barn door, and brick wall (Figure 13-3). I rigged this much like the human cannonball stunt (below) using pull cables on a sled mounted on 80 feet of rail. A dummy was substituted for Gleason at the last second, with the much used and abused Gleason staggering out after the impact (Figure 13-4).

Figure 13-3 Reggie prepares to break through a glass house, barn door, and brick wall.

Figure 13-4 Gleason's stunt dummy breaks through the glass house.

Reggie the Electrical Man

Reggie as the Electrical Man was more gaff and gimmick than gag (Figure 13-5). Jackie was strapped to a massive electrical board and charged, whereupon he was able to run fixtures, a vacuum cleaner, and so on, with his body by simply plugging the appliances into his mouth. The finale featured him lighting a giant American flag with accompanying fireworks display, sparklers, and smoke.

Shooting Gleason Out of a Cannon

During the seasons working as the special effects director on "The Jackie Gleason Show," I wrote special effects skits. One of the most exciting was a variation on the old circus trick called "The Human Cannonball." The technique I used for him, however, was quite different than used in the circus.

Usually a circus cannon is designed on the principle of a giant slingshot with the thrust being provided by giant springs. The flyer lies on a cradle-like seat and is flung from the crotch, not shot by the feet. If his feet or legs were to absorb the sudden acceleration they probably would be broken.

A carriage is fitted to a tube and slid into the cannon muzzle. A padded hook is wrapped around the body almost to the flyer's crotch and he is then slung from the cannon. I believe Zuchini was the inventor of this mechanism and its accuracy is truly amazing.

Figure 13-5 Reggie gets charged as the Electrical Man.

Figure 13–6 Reggie checks the cannon before firing. Note the dummy hidden from the audience at the back of the cannon.

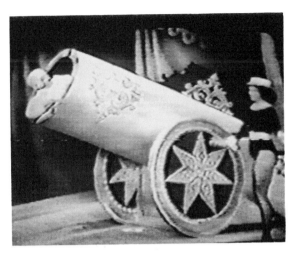

Figure 13–7 Reggie climbs into the cannon.

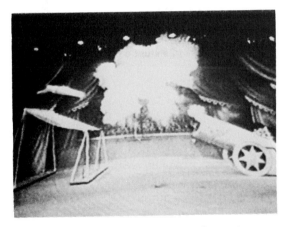

Figure 13–8 Reggie flies past the safety net.

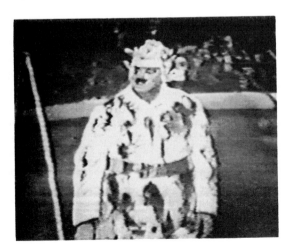

Figure 13–9 Reggie after the landing

With Gleason (a large man who was never one to be insulted by the offer of a meal), the problem was to fire this weighty and valuable projectile across the stage. In this instance, discretion was the better part of valor and a substitute for Gleason, specifically a dummy, was made of Styrofoam and stuffing. A pipe ran through the center of the dummy. Through the pipe, rollers, and guiding devices ran a $1/16$-inch steel cable. The dummy was attached and positioned on the upstage side of the cannon, masked from the audience (Figure 13–6). Gleason then got into the cannon, slid down the barrel and through a concealed trapdoor, exiting out the other side, totally unseen by the audience (Figure 13–7). He then made his way backstage, crossed to the opposite side, and waited for his cue while special makeup was applied.

When Jackie slid down the cannon, there was a stall for time by the girls who loaded the gun. They then stuffed the barrel with wadding, began the big countdown and finally lit the fuse.

With the explosion, Gleason's dummy hurled from the mouth of the cannon flying up and offstage, or course missing the net (Figure 13–8). The dummy was pulled by guide wires attached to a grid wire than ran up to a sheave and down to the floor. Attached to that guide wire was a 200-pound sandbag that was activated by a trip release. When the cannon was fired, the sandbag tripped and dropped to the floor, pulling the dummy of Gleason up to the grid. The sandbag on the floor served as a catch device holding it up on the grid. Seconds later Gleason came back on stage, blackened with soot and gunpowder, his costume torn to shreds (Figure 13–9).

The punch line was that too much gunpowder had been used in the cannon and consequently Gleason had missed both the net and the studio and kept going. It became a classic bit that was used two or three times a year, every year.

Gleason's Floating Cloud

This effect was performed first on the Gleason show one season and was discovered by accident while I was experimenting with a foam machine in the parking lot behind the Miami Beach Auditorium. The stunt that I was working on called for a room to be entirely filled with soapsuds. This effect presented peculiar problems such as filling a room on stage with soapsuds (on cue) and removing the suds quickly so as not to interfere with the next scene. Remember, this was a live show.

Basically, the gag called for Jackie to install a washer and dryer in his basement. While testing the machine, he unknowingly knocks a full box of detergent into the washer. After starting it, he leaves the basement, closing the door behind him. On returning and opening the door, a wall of soap cascades out and buries him.

When I began experimenting, I tried a new type of foam machine, because I was worried about what method I could find to remove the suds quickly after the shot. Where there was no difficulty in creating a giant mound of suds 10 or 12 feet in height and circumference, I had no idea whatsoever how to get rid of it. While puzzling over the problem, I happened to lean against a fan I had just built and was going to test for another bit. By pure accident, I turned it on in the direction of the foam mound that was about 20 feet across and 15 feet high. The resulting gust caused an updraft that lifted the foam into the air in one solid piece. Surprisingly, it just hung there floating around the parking lot for about 45 minutes. It was *Fantasia*. It was the most unbelievable effect of a closeup floating cloud that I had ever seen. Accidents, as well as necessity, can also be the mother of invention.

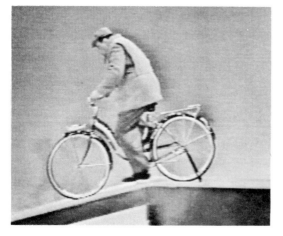

Figure 13–10 Jackie Gleason on bicycle ramp, preparing to crash through a brick wall.

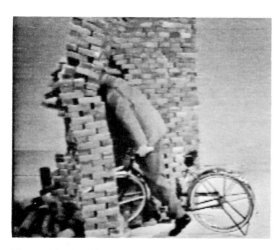

Figure 13–11 Gleason goes headfirst into the wall.

Jackie Gleason, the Bicycle, and the Brick Wall

One of the most famous skits on the Gleason show was Jackie crashing a bicycle through a 2-foot-thick brick wall. Of course the wall wasn't really made of brick, only Styrofoam that looked like bricks.

It was actually Gleason's idea to use a brick wall. We built one 2 feet thick by 10 feet wide by 10 feet high and encased it in a portable crate so it could be moved without falling apart. We removed the front, back, and sides after spotting it on its marks prior to the bit. All Jackie had to do was get up speed and power through it.

In the first rehearsal, Jackie rode on stage on a two-wheel bicycle and tried to ram through it. But he only made it halfway and got stuck. As a result he requested a ramp be built that I thought, at the time, was too high. I was afraid he would gain too much speed and lose control, but he insisted the ramp be 4 feet high dropped down to zero over 16 feet. I also thought this was a little too steep. After all, a big man like Gleason wasn't used to riding a bike and, to make matters worse, he didn't want to rehearse. He said, "Let's just do it live on the show." Gleason was always a hard gentleman to get to rehearse; he always said, "Go for it."

Well, he came flying down that ramp and when he hit the bottom, he was out of control. The bike hit the wall, the front wheel pitched to the left and bent his wrist beneath the handlebar, and the impact cracked his wrist. He went through the wall all right, but he got hurt in the process. I still believe that had he rehearsed and practiced, the accident would never have happened (Figures 13–10 and 13–11).

Reggie Walking over Hot Coals

This was another gag I wrote and designed for Gleason. It was Jackie Gleason as the great Reggie Van Gleason III (the famous fire walker).

The bed of hot coals was so realistic that Jackie didn't want to step on it when he first saw it. In actuality, the coals were plastic that looked like real charcoal, colored in degrees from black to bright yellow with orange and red highlights, lit from below with flickering lights and different colored gels. The whole contraption lay on a 12-foot sheet of heavy-duty plex. Holes were drilled to allow smoke to ooze up through as if emanating from hot coals. It gave a very realistic effect both to the audience and to Gleason.

At first sight, Jackie gave one of his famous double takes. "Wait a minute, McCarthy," he said, "you walk across it first! I want to make sure it works." I did. Jackie hesitated for a moment, then with evident distaste gingerly followed. You see, though Jackie trusted me, he also knew that I actually did walk on hot coals as part of my former magic act (Figures 13–12 and 13–13).

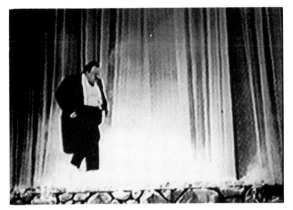

Figure 13–12 Gleason walking on hot coals.

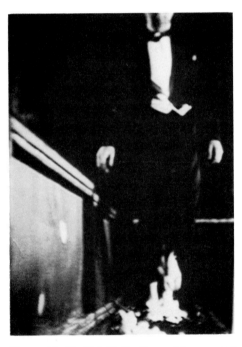

Figure 13–13 Bob McCarthy walking on *real* coals.

The Poor Soul and the Wilting Flower

On the Gleason show I created a flower for the Poor Soul, one of Gleason's most famous characters. The flower sat on a table center stage. It was a delicate, beautiful red rose that interacted intimately with the character. The flower would follow him with its "face" as he moved about the room, shake and shiver and move toward him when he left it, and lovingly react to his gentle affectionate petting and careful watering.

One evening Gleason returns to his apartment with a woman. The rose's head tilts down and begins to shake, tears streaming from its petals, and finally in dispair falls over, wilts, and dies. This may not seem like such an extraordinary effect, but it became a classic, particularly the way Jackie played it, earning him a standing ovation.

I was under the table manipulating the rose with a brass rod that ran through a plastic tube. This tube was attached to the flower that had been weighted with tiny dollops of lead to help in maneuvering. By pushing the brass rod up the tube the flower would stand upright; by removing the rod from the flower it would tip over and down.

A third piece of tubing was inserted inside the other tube providing a water source for the tears on the leaves. By gently blowing water from my mouth through the tube, I could simulate tiny teardrops when the rose cried.

I was under the table for the entire length of the scene, but of course the audience was unaware of it. I watched Gleason through a tiny monitor and thus was able to see his reactions to the flower, allowing us to work back and forth with each other.

As I said, Jackie's performance in this skit blew the audience away. During his ovation he walked over to the table, unbeknownst to me, and raised the tablecloth saying, "And here's the guy who really created this effect, Bob McCarthy" (while still on live TV). There I was sitting dumbfounded watching a tiny TV set and surrounded by rods and a mouth full of "tears." It was one of the many times I "acted" with him.

Jackie was a dear man who was unstinting in his praise for work well done and always acknowledged it to others. That scene worked because of his performance and for no other reason. His talent was such that he could have created a relationship with a shoe. He didn't have to lift that

tablecloth, but he did and I cannot describe how touched I was by his generosity.

Comparisons and Memories

Live TV severely limits preparation time, and the pressure increases with the realization that if the stunt is not carried off on the first shot, there are no retakes. Film, on the other hand, allows a more leisurely approach for planning and prep and affords a greater latitude for retakes. It is undoubtedly the least pressured atmosphere to work in. Commercials require the greatest degree of perfection, entail the most retakes, and are by far the most expensive to produce per second of film time. Considering that an average 30-second commercial commonly costs $1 million to produce, in motion picture terms this would extend to a cost of $80 billion, an inconceivable sum.

Personally I have always preferred to work in live TV. The time limitations are positively insane, the prep time absurd, and the pressure unrelenting, but to me this only adds to the excitement of the challenge. This was nowhere more true than when I was the special effects director on "The Jackie Gleason Show." In all my years in the business, I can honestly say that I've never enjoyed myself more than the nine seasons spent with Gleason. Those were the best. He was highly unusual as both an artist and a man.

Without a doubt, Jackie was demanding. With him, perfection was expected. It was the norm against which everything was gauged. It was only when you exceeded that level that you gained his respect, but once having done so, you became more than you ever thought you could.

I want to make it clear that Jackie was not a difficult man to work for. I have never been treated better or appreciated as much. He was extremely creative but never egotistical, always eager for innovations and receptive to suggestions. He never restricted my artistic freedom and certainly never restricted my budget. To Jackie, money was meant to be spent to make the show as good as possible. No corners were cut.

I was always excited by the crazy way he challenged me, having a mere three days to prep and construct absolutely outlandish effects for skits we devised together. I always felt stretched and driven to my limits, but never pushed. More often than not, I would realize later that a goodly amount of the stretching I'd done myself. He just gave me my head and I ran. I sometimes wonder if he didn't just sit back and laugh to himself, wondering if McCarthy hadn't bitten off a bit too much that week.

Equally important to the artistic challenges and stimulation was that Jackie was probably the most generous man I've ever known. Ego never got in his way when credit was given or acknowledgments made.

Over the years I've often thought back to a very special moment in my life. It happened at the banquet given following the premiere of the show in Miami.

It had received a standing ovation, and naturally I was elated. It was technically the most difficult show I'd ever done, and it had gone perfectly. So I was riding a crest when my wife Carol and I attended the dinner. We found our table off in one corner and watched as the governor of Florida, mayor of Miami, and the cast and other department heads were seated, all of us waiting for Gleason's entrance. As usual, he made it in grand style and with an accompanying ovation. As he wended his way past the guests, I was surprised. He was, as always, courteous and polite

but didn't stop at any table. I watched as he continued by the cast and director, the department heads, the mayor, the governor, and only stopped when he reached us. He flashed his charming smile at Carol, welcoming her, then turned to me thrusting out his hand. "How ya doin', pal." He was beaming as we shook hands and he sat. "A great show, pal."

Jackie was a man of few words and that night those words were pure gold. For 20 minutes he sat with us, virtually ignoring the other guests. I was floating—flabbergasted and charmed at being singled out.

That was like Jackie Gleason. He (maybe only he) would ever show his appreciation like that. When he passed away, I felt that my loss was heaven's gain. I know he's making the angels laugh, and that quietly under their breaths they're still calling him "The Great One."

14

The Fisher King

This chapter details my work on the film *The Fisher King*. It is a typical example of the types of difficulties, large and small, that confront special effects people during the course of a production (Figure 14–1).

Each film presents its own unique set of problems and conditions but shares one common denominator: solutions must be found that are visually impressive and cost effective. Simply stated, you are limited only by imagination and budget.

Even assuming that this is a profession that you love as much as I do, the bills still have to be paid. I have never felt that simply because I've received so much personal satisfaction in my work that I should go unrewarded. My talent, training, and imagination are my living, and I have been able to do this for more than 30 years because I thoroughly understand the professional definition of one word: budget. The budget must include initial costs of raw materials, construction crews' salaries, research and development, preparation expenses, and the work force and human requirements for the actual execution of the effects on the set or location.

The Fisher King was directed by Terry Gilliam. If you are familiar with his earlier film *The Adventures of Baron Munchausen,* you know his penchant for spectacular special effects. He was no less creative for this movie.

When I was approached in early 1990 with *The Fisher King* script, I saw immediately the many challenges of the project. They became even more apparent during the first production meeting held at Columbia Studios in Culver City.

Gilliam was looking for four specific special effects designed around his main fantasy character, the Red Knight: (1) A giant flame was to shoot from the top of the helmet of the Red Knight; (2) Billowing white smoke was to surge from the nostrils of the knight's horse as it snorted; (3) Clouds of red smoke had to flush from specific sections of both the knight's and horse's armor on cue; and (4) The eyes of the knight had to appear to flash and glow from the interior of the helmet like a searing hot caldron of burning coals.

As always, my first consideration was safety, especially since we were to employ fire, smoke, and high-pressure devices. I knew for instance that both the knight and horse would require special fire protection and also extra safeguards from the smoke. In the case of the horse, it would need protection from the white smoke emanating from its nostrils; the knight would probably require some sort of independent breathing apparatus while wearing his helmet even though the smoke in both cases was nontoxic. It was also evident that the special effects could not be run by remote control. Somehow all the effects had to be self-contained and activated by the rider himself. Duplications and backup systems for all the devices would be required in case of malfunctions. Due to the confining nature of the costumes for both horse and rider, fitted fireproof undergarments would be necessary in order to protect both characters in the eventuality of a fire.

Figure 14–1 A fully armored Red Knight in Central Park

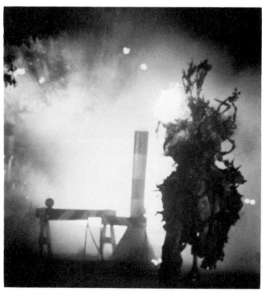

Figure 14–2 Red Knight fires the flamethrower while riding through a gigantic ball of fire and smoke.

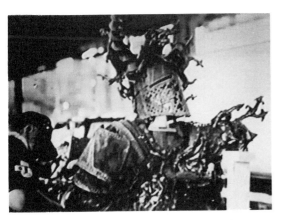

Figure 14–3 Bob McCarthy preps costume for for Red Knight.

Figure 14–4a Side view highlighting the flamethrower in the helmet of the Red Knight.

Figure 14–4b Flamethrower helmet seen from the front.

Since the Red Knight was an independent self-contained and self-activating unit, he would need a power source for the various devices that were connected to both him and the horse by cables, hoses, and wires. For safety's sake these connections would need to be breakaways, so that if the rider had to dismount quickly for any reason he would not be hindered or bound by the various connections. To further complicate the situation, all of these units had to be readily transferable from one horse to another in case some malfunctions occurred. Additionally, this switchover would have to take place in a matter of minutes in order not to hold up production. Furthermore, some form of arming and firing devices had to be provided to the rider so that he could control the effects.

As I continued to analyze the script, problems continued to arise. Chemicals that were safe for both horse and rider had to be used. The armor covering both had to be very lightweight and not cumbersome, allowing ultimate mobility. At the same time, Gilliam wanted a white, ambient smoke that glowed, making visibility extremely difficult. It was necessary to find a way of diffusing it while still giving the same effect. Finally the horse itself was to be a very specific shade of red.

None of these problems proved to be insoluble. Fire protection for the horse and rider was provided by the extensive use of fireproof Nomex and Kevlar materials built right into the armor plating covering them (Figure 14–3). The knight's helmet from which flames were to shoot out was likewise insulated and a specially built flamethrower was designed to fire directly through the top of the helmet (Figure 14–4a). It was fitted with a pilot light and fed by two propane hoses that ran down the back of the helmet through the actor's costume to the saddle. On the side of the saddle two saddlebags were mounted containing small tanks of propane, one of which was used for the pilot light while an additional six fed the flamethrower. The hoses were then hooked up to valves. A spark plug inserted at the nozzle of the flamethrower and next to the pilot light served to ignite it, and then the flamethrower itself. The spark plug was ignited by a wire that ran to a coil and then to cables running into a saddlebag.

The saddlebags were compartmentalized for each unit. There were two of them, one on each side of the horse. Wires were strung up through the arms of the rider's costume and then attached to the triggering devices. These triggering devices were simply ignition buttons built into the sword of the Red Knight, his saddle, and even his gauntlets. His buttons were positioned for easy access and maximum control. Due to the necessity of extreme mobility and severe constraints on the size of the saddlebag units, everything had to be miniaturized—motors, relays, control boxes—and all had to be run on a 12-volt DC gel cell battery. Of course all of these units, wirings, or connections had to be invisible on camera, so the setup presented a very special set of problems, not the least of which was finding the necessary equipment.

Once the equipment and rider were in place, wires were strung through the arms of his costume and to the buttons. When a button was pressed, for example, for the flamethrower, the spark plug was ignited while at the same time the gas for the pilot light was immediately turned on and lit. A second button triggered the flamethrower, which by adjusting the pressure could be fired for as far as 20 feet.

The white smoke snorting out of the horse's nostrils was a bit of a problem as we had to run high-pressure hoses stemming from the saddlebags beneath the armor that covered its entire body and along its neck to its nose. The pressure hoses terminated at the tip of the nostrils, which had been covered with a special plate to prevent any smoke fluid from touch-

ing its skin and causing possible injury. A special adjustable brass nozzle was devised for the snort effect and delivered a spray that could be adjusted from very fine to very wide. We tried several concoctions to get this effect and while experimenting discovered we couldn't use regular smoke because it did not provide sufficient pressure for the snort. Carbon dioxide turned out to be unsuitable because the back pressure upset the animals, causing them to jerk their heads and become somewhat uncontrollable. Our alternative was a refrigerant called Rycon 22, which employs less pressure (approximately 150 pounds) and worked extremely well.

The clouds of red smoke provoked special problems: Very specific sections of the knight's and horse's body had to be sequentially timed, last for approximately 60 seconds, and then gradually diminish. In addition, Gilliam requested that the smoke be a very deep almost rust color. We went to DeLamar Engineering, a major supplier of F/X pyrotechnic devices, and after several meetings and a few weeks of work we developed the right color, the right timing, and the right size. These small smoke pots were no larger than 2 inches by 2 inches, about the size of half a C cell battery. They were manufactured with directional covers so that the smoke could be controlled when it first came from the body of the knight or horse.

It should be obvious at this point that with as many as ten different smoke devices built into the horse and the rider, along with the flame-thrower, that we were entering into an area of extraordinarily complex wiring. There were too many buttons for the knight to press, so we created a step relay system of firing. By pressing a button one time, the rider fired the correct smoke pot on cue and the system advanced itself. A subsequent pressing fired another smoke pot, and so on in sequence. The smoke pots on the horse were identical and controlled in the same way with buttons punched by the knight. All of these were fired by 12-volt nickel cadmium batteries built into the saddlebags.

The saddlebags themselves, while large, could not be detected in the film because the horses were so large and were completely costumed in armor. Originally they were *white* Percherons weighing about 1800 to 2000 pounds each.

Not the least of my concerns centered on the burning coallike eyes of the knight. I decided on using fiber optics, which consist of thousands of individually programmable plastic glass fibers that, depending on the program, can be designed to change colors, move left to right, right to left, and so on. In a sense they are not unlike miniature light bulbs, each one serving a specific purpose. The problem confronting me with fiber optics was heat generation. The bulbs were 750 watts and drew tremendous amounts of energy, limiting us to six or seven minutes of full power from the batteries we were using before light intensity began to drop off. We maintained 50 nickel cadmium 12-volt batteries on continual charge and after each shot replaced and recharged. (It was decided later on during the final prep day that because of a lighting problem in daylight we would kill the fiber optics and go to black.)

The white ambient smoke presented constant lighting problems and could only be controlled by an expert with a refined technique of manipulating the machinery. For the red smoke emanating from the body and helmet of the knight, we designed a special breathing apparatus for the rider (Figure 14–5). The system was quite similar to that used by scuba divers and consisted of three tanks that provided three minutes of air each and were built into one saddlebag. These could be charged very quickly,

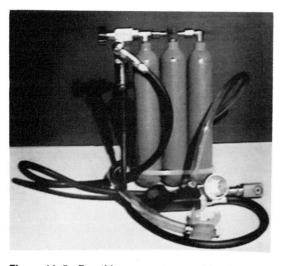

Figure 14–5 Breathing apparatus used by the Red Knight

within a few seconds, while the rider was in his costume. A special valve control enabled us to pressurize his air system from a single portable heavy-duty tank.

This system was very expensive. The control or regulator inside the saddlebags delivered air through a tube positioned beneath his costume and affixed to a mouthpiece. It was a completely separate apparatus and proved to be most effective.

To fully understand the complexity and difficulty in constructing such a system, you must understand that in addition every air or propane gas tank, electrical cable, and hose and wire had to be fitted with a quick automatic disconnect trip release device in order to ensure the safety of the rider. In addition, in case of a quick bailout, not only did the disconnections need to be made automatically, but all gas tanks had to be shut down immediately. Without these safety features built into the system, the role of the Red Knight would have been much too dangerous for anyone to attempt.

To further emphasize our concern with safety, we always carried fire extinguishers and were close to the working set, so in the event that anything did happen, we would be in position to handle the emergency immediately. Even though the system appeared to be fail-safe and every possible device to prevent a mishap was in place, there was always that 1% chance that something might happen.

When the project first began, the producer was faced with the problem of finding horses that were large enough to do the job and that also could be trained to adapt to the smoke, fire, and other effects they would encounter. Eventually we used two Percheron horses. They were used to crowds and noise and partially used to smoke and fire because they had worked in the circus. The training on the East and West Coast ranches took us several weeks.

I met the horses for the first time on a ranch in California. On that day I brought with me a small flamethrower, a few standard black smoke bombs, and carbon dioxide extinguisher. I began with the black smoke bombs, probably the most horrible smelling of all, because I wanted to see what their reaction would be. I used a small mortar to start with and tried to get one of the horses near it. Naturally he wanted no part of this nonsense and refused to move within 100 feet of it. In fact, he took off running. Next I brought out the flamethrower and fired it from 100 yards away. Horses may be a bit dimwitted, but they are not stupid, and these proved no exception; if I wanted to play with that fire thing it was fine, but they did not. The carbon dioxide extinguishers seemed to bother them the most, probably because the gas has a lot of pressure behind it and makes a great deal of noise besides being very cold. When I fired it near one horse the blast of carbon dioxide drifted toward him, and he made his decision: "This crazy Irish human might like to play with noise and fire and cold stuff, but not me. I am a sensible horse." We expected all this to happen, although after speaking to the trainer and working with the horses for about a week, we were able to get the rider close enough to the horse so he could shoot off the flame over and around the horses and they did not bolt. The same gradual approach worked with the smoke, and we were eventually able to bring them to the smoke pots and almost have their heads directly in the pots without bothering them. The carbon dioxide took a little longer because of the combinations of smell, noise, and cold.

One of the ways we eventually got the horses used to it was our method of training. Horses are very trusting, and if they see a human doing some-

thing like allowing themselves to be sprayed with carbon dioxide, they will gradually acclimate themselves to it and accept it as harmless. Similarly with the smoke—by handling it myself these animals gradually became confident that it presented no danger. Once the animals became accustomed to the flame, smoke, and carbon dioxide, we designed the appropriate apparatus to be mounted on them and the rider.

This process of research, development, and refinement consumed several weeks conducted during preproduction at ranches on both the East and West coasts. Ironically, with all this attention to detail and planning the one difficulty that we failed to forsee was that these brave and noble steeds might become considerably unstrung by New York City traffic, which we discovered somewhat belatedly once we got on location. It was only after several days that they became citified.

Similarly, New York presented climatic conditions that required considerable adjustment on our part. Variable winds coming off the East River created havoc with directional controlled flames and smoke effects. Such changes in wind direction required constant and oftentimes consuming and therefore costly adjustments. It was not uncommon when faced with fluctuating gusts of wind to be constantly reigniting the pilot lights, the smoke machines, and flamethrowers while modulating pressure flows in order to achieve the effect.

If you are at all familiar with Manhattan traffic flow (more accurately described as gridlock) it is not difficult to imagine the problems inherent for major productions shooting in that city, even with the fullest cooperation of film commission officials, "New York's finest" and of course the ASPCA, which kept a close eye on the horses' safe treatment.

As with anything designed by humans there is always the possibility of glitches, which was no less true on this shoot. To quote Murphy's law, "If anything can go wrong, it will." Our concentrated preparation kept these difficulties to a minimum, but on a minor scale they did inevitably arise.

The system installed in the saddlebags on the horses allowed the knight to activate the effects, which allowed us to double-check it before the shot. Due to the nature of the emergency breakaway system necessitated by horse and rider safety, there was always the possibility of a malfunction. This was further aggravated by the often physically demanding choreography. The jarring, often rough and tumble action occasionally caused a malfunction, but due to its unique and basically sound design, the saddlebag system could be quickly removed and repairs effected.

Though I have often used the personal pronoun throughout this chapter I would be remiss if I did not give credit to the many people with whom I worked. In addition to the four members of the special effects crew, ten others in addition to wardrobe people were totally involved in dressing the Red Knight and his horses. Once we were given the go sign, it took a full 1½ hours of costuming, loading, and checking the special effects and other preparation before the shot began.

The result of all this work proved worth the effort. Every shot the director and producers wanted was executed to their satisfaction. Every effect worked. The extensive preproduction planning enabled the effects to come in on budget. Most importantly, *there was not one injury to either the stunt riders or any animals used in this film*, something which you may find difficult to believe when you see it (Figure 14–6).

There were many other effects used during the course of the film such as rain, ambient smoke, special rigging, fire, and in one scene a very large fireball explosion created using four large Lacapodium pots and a wall of

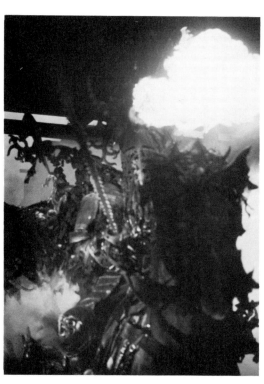

Figure 14–6 Mounted Red Knight fires the flamethrower.

smoke that made it appear to the viewing audience that the Red Knight had ridden literally through the middle of the explosion. But no effect was more challenging than the rigging of the Red Knight and his horse.

A Note to the Reader

After studying this mass of material you probably feel one of two things: overwhelmed, or secure in your knowledge and capabilities as a F/X person. Unfortunately, this is not quite how it works. Nothing is a substitute for on-the-job experience. You've been exposed to possibly 10% of the knowledge you will need in order to produce any given special effect safely and efficiently. Don't assume that you know the field, only that you know of it. In the 35 years I've been in the business, I still learn something new on every shoot.

There are, to use a cliché, many ways to skin a cat, and what I've presented to you is an approach, a compendium if you will, of the multitudinous possibilities, how I do the "skinning." F/X, however, is a lifetime learning process.

All F/X professionals have their own approach to their work with techniques they've developed (as I have) through years of experience. Methodologies reflect individual personalities. In order to be successful, you too will have to open and expand and mature to the point where you can refine techniques, equipment design, execution, and the honing of your own instincts to work successfully in this highly competitive business. Never be too proud to take advantage of the knowledge of those professionals better schooled in the intricacies of the business, especially when it could very well affect the safety of performers or crew personnel.

Finally, I cannot emphasize safety enough. It is your responsibility! If you don't exercise every possible precaution, adhere to federal, state, and local regulations, you have only yourself and your conscience to live with.

In all of this, it is important to remember that the only limitation and the creativity of a special effects person are self-imposed. As Conrad once wrote, "Only in men's imagination does every truth find an effective and undeniable existence. Imagination, not invention, is the supreme master of art as of life."

For further information, purchase, or rental of any of the equipment mentioned in this book, contact

WIZARDS, Inc.
18333 Lahey Street
Northridge, CA 91326 USA
Telephone: 818/368-5084
Fax phone: 818/360-1462
Email: specialeffects@specialeffects.com
Web Page: http://www.specialeffects.com/sfx

Glossary

Action Order given by the director, once the sound recording equipment and the film in the camera are running at filming speed, to begin the action within the shot.

Assistant director Person who functions as an intermediary between the director and the cast and crew. First assistant director is responsible for the daily operations of the production; the second assistant director is his or her direct assistant and is responsible for the extras.

Backings Large sheets of fabric painted with a scene, foliage, or buildings and used as a continuation of the set. Solid backings are usually black or white fabric and are used to hide the backs of other sets or stage walls where no scenery or set continuation is required.

Back lot Portion of the studio away from the stages and offices. There may be standing sets, storage facilities, or just bare land on the back lot.

Beds (greenbeds) Type of lighting scaffold that is hung by chain over sets on stages.

Best boy Assistant to the foreman of the set lighting department or grip department (a subforeman).

Call (call time) Time for reporting to work. Different personnel or crews may have different calls, and an individual may have several calls in a day (makeup call at 7:30 A.M., set call at 9:00 A.M., etc.).

Call sheet Schedule of work, personnel, equipment needed, and calls for the next day's shooting.

Cameraman Person responsible for lighting the scene and setting up the shots. Also known as the director of photography or the cinematographer. Members of the camera crew report to this position.

Cinematographer See *cameraman*.

Cinemobile Large self-contained motion picture equipment truck.

Commercial fireworks Class B and C fireworks used in religious and public display type functions (firecrackers, sparklers, and small- and large-diameter public display shells).

Construction coordinator Person who supervises the construction of sets in and out of the studio.

Crafts service Personnel who are responsible for cleaning up and doing small chores. They usually handle the coffee and other beverages and snacks on the set.

Director Person with artistic control and overall responsibility for making a film from a script.

Electricians Technicians responsible for connecting lights to the proper power supplies. They work for the gaffer, who is the chief electrician.

Explosive Substance or combination of substances whose primary purpose is detonation or rapid combustion. Explosives are capable of relatively instantaneous or rapid release of gas and heat.

Exterior Any scene shot outside a structure.

Fire chief Chief administrative officer of a fire department.

Fire inspector Member of the fire department responsible for day-to-day inspections and code enforcement.

Fire lane That portion of a street, parking lot, or other driving surface designated to provide rapid and unobstructed access to a building or other area by fire apparatus.

Fire marshal Head of a fire prevention bureau.

Fire safety advisor Term used by some fire departments to define a member of that department (active or retired) who is hired temporarily by the film industry in an advisory capacity to ensure compliance with fire/life safety issues.

Fire safety officer Term used by some fire departments to define a member of that department who is assigned to ensure compliance with fire safety regulations as set forth on the appropriate permit.

Fire/life safety standby Sworn paid person or retired person who enforces fire/life safety requirements per the local department at film location sites.

Fire supression crew Two or more persons provided with protective clothing and trained to attack, control, and extinguish hostile fires using fire extinguishers, hose lines, and related fire service and equipment.

Fire watch Civilian or fire department representative assigned to watch for or react to fire hazards.

Firework Any device containing chemical elements and compounds capable of burning independently of the oxygen of the atmosphere and producing audible, visual, mechanical, or thermal effects that are useful as pyrotechnic devices or for entertainment.

Fireworks, dangerous That class of fireworks defined as dangerous.

First assistant director See *assistant director.*

Flat Section of a studio set, usually 8 to 10 feet high, varying greatly in width, made from plywood and covered with paint, wallpaper, fabric, or metal.

Fog effect Foglike mist produced by using fog juice (i.e., oil) in a special machine.

Four-foot rule Four-foot wide clear space voluntarily maintained around the perimeter of stages for use as an emergency exitway.

Gaffer Foreman or boss of the set lighting department. Also known as the chief electrician.

Gaffer's tape Wide, strong adhesive tape used to secure lighting instruments, stands, cables, and so on, on a set.

Gag Stunt or physical event.

Generator Portable or mobile electric power supply.

Grip Crew member whose responsibility is the placement of the camera, the setting of diffusion between the lights and the set, and the removal of parts of the set to accommodate camera position.

Honey wagon Portable dressing room and rest room.

Key grip Head of the grip department. See *grip.*

License, pyrotechnic Any nontransferable authorization granted by the

state fire marshal to engage in specific activities involving certain types of fireworks.

Loads, full, half, quarter Terms used to describe varying amounts of explosive materials used in blank cartridges.

Location Any site away from a studio used as a background for filming.

Location Manager Person responsible for finding and arranging for the use of location filming sites. The location manager is also responsible for acquiring local authority filming permits, but is not qualified to obtain pyrotechnic special effects permits.

Magazine Box, container, or structure in which ammunition, fireworks or explosives, or special effects materials are stored.

Magazine, class I Permanent structure constructed to standards set forth in codes of regulations and uniform fire codes.

Magazine, class II Box or container, usually portable, constructed of wood or fiber 2 inches thick and covered with 20-gauge steel, or wood 1 inch thick covered with 14-gauge steel. Class II magazines shall be painted red with the word EXPLOSIVES painted on the top and all sides. For additional details of construction, see Title 19, CCR, 989.3. Also see Uniform Fire Code 77.204.

Mortar Tube or potlike device used to direct the explosion and debris into camera's view. Mortars also prevent the explosives from throwing flying rocks.

On a bell Term heard on the set or location indicating that the camera is rolling or about to roll. It is a signal that all activity not related to the filming is to stop and everyone is to be quiet.

Permit, filming Authorization by the local authority allowing for filming in their jurisdiction. Filming permits do not authorize the use of fireworks or special effects pyrotechnics.

Permit, pyrotechnic Nontransferable document, issued by the local authority granting permission for a pyrotechnic licensee to establish and maintain a place where fireworks are manufactured, constructed, produced, packaged, stored, sold, exchanged, discharged, or used.

Pickup shot Reshooting a portion of a scene, the rest of which was filmed previously.

Plugging box See *spider.*

Powder card Traditional industry term for pyrotechnic licenses issued by the state fire marshal. See *pyrotechnic operators.*

Preproduction All activity prior to the first day of filming. This generally includes script writing, set design, budgeting, major casting, and selection of principal locations.

Producer Individual at the top of the film hierarchy who represents the studio and/or investors.

Production manager See *unit manager.*

Prop Movable object used by actors.

Property man Person responsible for all of the small objects used by actors.

Pyrotechnic composition Any combination of chemical elements or compounds capable of burning independently of the oxygen in the atmosphere.

Pyrotechnic device Any combination of materials, including pyrotechnic compositions, which, by the agency of fire, produce an audible, visual, mechanical, or thermal effect designed and intended to be useful for industrial, agricultural, personal safety, or educational purposes.

Pyrotechnic operator/theatrical Person authorized to use special effects, blank cartridges, colored fire, flash paper, composition, and smoke composition in stage or theatrical productions only.

Pyrotechnic operator/theatrical trainee Person authorized to conduct procedures permitted a pyrotechnic operator/theatrical.

Pyrotechnic operator/performer Title restricted to persons who perform before an audience. May include magicians, comedians, and others whose primary interest is in other than pyrotechnics. Such license is restricted to the use of special effects, blank cartridges, colored fire, flash paper, composition, and smoke composition with the production of theatricals and operas before live audiences in theatres, opera houses, television studios, nightclubs, and similar occupancies.

Pyrotechnic operator/unrestricted Person who may conduct and take charge of all fireworks activities in connection with every kind of public fireworks display, whether commercial entertainment, experimental model rockets, missile launching, or motion picture, theatrical, and television production.

Pyrotechnic special effects Pyrotechnic compositions or devices consisting of articles containing any pyrotechnic composition manufactured and assembled, designed, or discharged in connection with television, theatre, and motion picture productions, which may or may not be presented before live audiences. Some of the most frequently used special effects materials are arcing match, black match, black powder lifting charge, dets, flash powder, and squibs.

Quartz light Popular name for tungsten-halogen lamps, which are tungsten filament and halogen gas sealed within quartz. Bulb temperatures may exceed 500°C (930°F).

Red light Light activated to indicate that filming is in progress within a building or area. Also warns personnel not to enter or exit.

Refueler Truck used to transport and deliver flammable or combustible liquids to individual internal combustion engines or portable tanks containing flammable or combustible liquids.

Riggers Crew members responsible for the construction of scaffolding (rigging) on a set and the placement of the lights on that rigging.

Ritter fan Also known as a wind machine. Can be gas or electric powered.

Runaway production California-based film production filmed in another state or country.

Safety director Person in charge of all aspects of life safety relative to the production company, studio lots, and the general public in or around these areas. Also responsible for all aspects of code enforcement and environmental affairs. Liaison between the production company and local governmental agencies.

Safety fuse Flexible cord containing an internal burning medium by which fire or flame is conveyed at a constant and relatively uniform rate from the point of ignition to the point of use, usually a detonator.

Scene Unit of action in filming consisting of one or more takes (shots).

Screenplay Script of a motion picture containing dialogue and description of the action involved.

Scrim Any device placed over lighting to soften the lighting effect.

Second unit Production crew that films scenes not involving the principal actors. Most often used for action sequences, remote locations, background for process shots or matte shots, and so on.

Set decorating Furnishings used on a set.

Set decorator Person who places and is responsible for set decorating.

Shot Point where a camera begins taking pictures (rolling) to the point where it stops makes up a single shot. May include *marker* (information on the camera setup written in chalk on the *clapperboard*) and other material, also referred to as a *take*.

Special effect Any effect produced to create an illusion on film, ranging from pyrotechnic effects to wind, rain, or snow.

Special Effects Materials Pyrotechnic compositions used in connection with television, motion picture, and theatrical productions that have been classified by the Bureau of Explosives as special fireworks Class B, common fireworks Class C, and additional special effects items listed in Table 13-A of Sub-chapter 6, Title 19, California Code of Regulations.

Basic Safety Rules for Chemical Effects

Your laboratory is not a place to play. Experimenting is a serious business, and you have to carry it out in a businesslike way if you are to learn anything from it. The rules below will help you to enjoy your experiments and learn from them without endangering yourself or others.

Do not allow your friends to mix things just to see what will happen. Do not do so yourself. Some combinations of chemicals are dangerous and you might accidentally mix some of these. Perform only the experiments for which you have complete instructions.

Always keep a good supply of tap water on your laboratory table. Unless you are working near a sink, have a wide-mouthed gallon jar filled with water close at hand, as well as several large sponges for wiping up any chemicals that might be spilled.

If an acid or an alkali (base) is spilled on your clothing, skin, or any place in your laboratory, immediately wash the area with lots of clear water.

An American Red Cross first-aid handbook should be part of your laboratory equipment. Refer to it in case of accident, and never hesitate to call a doctor if you are accidentally burned or inhale irritating fumes.

Be very careful of hot glass. It doesn't look hot and it cools very slowly. Treat burns at once with sodium bicarbonate solution. Never put hot glassware down on an unprotected table.

When heating chemicals or chemical solutions in a test tube, do not point the open end toward yourself or anyone else. Keep rotating the test tube constantly with a gentle circular motion so that bubbles forming rapidly in the bottom of the test tube will not force the liquid out of the tube in a dangerous way.

Before using glass tubing, be sure that both ends are fire-polished. To put the tube through a cork or rubber stopper, wet it first. Hold it with a piece of cloth and insert it gently into the hole by rotating it while you apply pressure. Once you have started the tubing through a stopper, never hold the tube from a point more than two inches away from the stopper. Otherwise, the weight of the stopper will make the tube snap. If the tubing is part of a funnel or thistle tube, do not hold it by the funnel for the same reason. Handle thermometers in the same way.

Never use a chemical that is not labeled. It might be poisonous or cause a violent and dangerous reaction. Never return unused chemicals to their original bottles. You may cause contamination or make an error that will spoil future experiments. Throw the unused chemical away in the proper waste container. Only waste paper belongs in the wastepaper basket. Put discarded solid chemicals in an earthen or pottery jar. Later you should wrap them in newspaper and throw them in an incinerator or garbage can. Put liquid wastes into a sink partly filled with water, and then wash them away with the tap water running for at least five minutes. This will dilute them and lessen the effect they might otherwise have on the plumbing.

Never taste or smell a chemical directly. Do not do so at all unless the experiment directs you to. To taste a chemical, transfer one drop to your tongue by means of a glass rod. Wash your mouth out immediately with water. To smell a chemical, fan the vapor toward your nose with your hand. Be prepared to turn your head away quickly if the odor proves to be irritating.

Keep glass apparatus spotlessly clean. Contamination often spoils the results of experiments. When you wet clean glass, it takes on an even coating of water, but on dirty glass the water forms small droplets instead. You can use any good detergent for cleaning, but be sure to rinse the apparatus thoroughly afterward.

Always wear a rubber or plastic apron to protect your clothing when doing experiments; unless you already wear eyeglasses, you should have a pair of plastic goggles or safety glasses to protect your eyes whenever this is suggested in a particular experiment. Asbestos gloves are a good safety factor for experiments involving fire.

Index